# 目錄

# CONTENTS

# 序

翁誌聰 / 臺北市立美術館代理館長

本館策辦艾未未展，在於關注其藝術美學與創意精神。艾未未先生是當代藝壇著名的藝術家，兼具藝術、攝影、建築、電影等多項跨領域創作，近期展於倫敦「泰德現代美術館」（Tate Modern）的〈葵花籽〉即是最佳力作。國內喜愛藝術的民眾對艾未未並不陌生，但多半未能親眼目睹其藝術作品。臺北市立美術館經過兩年的籌辦，從 2009 年由前館長謝小韞女士遠赴東京邀請，期間臺北市政府的支持與協助、本館同仁努力籌展事宜，以及艾未未先生對於本展的縝密思考與規劃，終於在 2011 年 10 月 29 日得以具體展現於本館。

艾未未先生作為一位傑出的藝術家，同時也是一位關懷社會公義的參與者。然而，本館舉辦此展的初衷，在於推介艾未未先生其藝術品本身的豐富意涵與美學價值，以及一位藝術家如何在新的世紀，給予藝術嶄新的定義。這是本館的初衷，更是開展期間，承受各界指正，甚或不同意見批評時的堅定立場。正如倫敦《藝術評論》雜誌（Art Review）主編拉波特所言：「艾未未等藝術家透過活動拓寬了藝術的疆界與定義，艾未未的活動讓人們意識到藝術不應該被局限於藝廊和美術館，藝術家也可以以藝術表達自己的聲音。」

本展「艾未未‧缺席」（Ai Weiwei absent），主要呈現艾未未自 1983 年至今的創作脈絡，在長達將近三十年的時間，艾未未創作媒材包括：攝影、雕塑、陶瓷、大理石、腳踏車、古木器以及錄像等多層跨領域，藝術創意發人深省、隱含諷刺而具幽默感，反映當代社會的各種樣貌。艾未未為本館創作的作品〈永久自行車〉，以 1200 輛自行車構成裝置於 10 公尺高的空間展場，這件作品在佈展期間，由北美館同仁與艾未未工作室人員通力合作，日以繼夜終於在開展前夕裝置完成，自行車創造出層層疊疊的迷陣空間，在展區裡走動穿梭在空間與時間之中，隱喻著社會的變遷與轉動。

「艾未未‧缺席」這個展覽，經由藝術家艾未未的作品，透析檢視其率真而熱烈的藝術生命，具有研究探討藝術橫切面的實質意涵。本展為解讀艾未未的藝術語言風格，特別邀請專家撰文包括：倫敦泰德美術館館長克里斯‧德爾康、大陸藝評家馮博一以及台灣藝評家陳泰松等。本展承蒙藝術家與收藏家以及艾未未工作室的大力協助，並慷慨借展重要代表作品，為展覽提供具體的協助，使展務執行得以順利推展，本人謹致上最誠摯的敬意與謝忱。

# Preface

Weng Chih-Tsung / Acting Director , Taipei Fine Arts Museum

It was an affirmation of artistry and the creative spirit that Taipei Fine Arts Museum presented this exhibition of the works of Ai Weiwei, a renowned figure in the contemporary art world who has been active in many disciplines, including fine art, photography, architecture and film. His large-scale iconic work *Sunflower Seeds*, recently exhibited at Tate Modern in London, was a superlative achievement. In Taiwan, art lovers are by no means unfamiliar with Ai Weiwei, but most have been unable to view his work firsthand. This exhibition was the culmination of two years of preparations, which began with former TFAM director Hsieh Hsiao-yun's traveling to Tokyo to extend the artist an invitation, and moved forward through the support and assistance of the Taipei City Government, the diligence of the museum staff, and Mr. Ai's own attentive deliberations and planning. Finally, these efforts saw concrete fruition on October 29, 2011 at Taipei Fine Arts Museum, with the unveiling of *Ai Weiwei absent*.

Ai Weiwei is both an outstanding artist and an activist concerned with social justice. Yet from the outset, TFAM's objective in organizing this exhibition lay in the rich significance and aesthetic value of introducing the artist, his works and the new definition he has endowed art for a new century. This was our original intention, and it has remained our insistent stance throughout the exhibition period, even as the museum became the recipient of critique, criticism and indeed reproach. As Mark Rappolt, editor of Art Review magazine, said, "Ai's activities have allowed artists to move away from the idea that they work within a privileged zone limited by the walls of a gallery or museum. They have reminded his colleagues and the world at large… that art's real context is not simply 'the market' or 'the institution', but what's happening now, around us, in the real world."

The exhibition *Ai Weiwei absent* presents the overall arc of Ai's artistic explorations from 1983 to the present. Over the course of nearly three decades, Ai has pursued a multilevel, cross-disciplinary approach encompassing such media and materials as photography, sculpture, ceramics, marble, bicycles, antique wood, and video. His art is deeply thought-provoking, with satirical and humorous implications, reflecting a range of phenomenon in contemporary society. The work created by Ai Weiwei specifically for this exhibition, *Forever Bicycles*, is an installation composed of 1200 bicycles filling an exhibition space 10 meters high. TFAM staff and personnel from Ai's studio worked together day and night to install this work in the space, completing it on the eve of the exhibition's opening. The bicycles create an overlapping, multilayered, labyrinthine space, moving and shifting within the space and time of the exhibition area, metaphorically alluding to the motion and the locomotion of society.

*Ai Weiwei absent* is significant in that Ai's artworks allow us to process and examine his frank and passionate artistic life, affording substantive, meaningful study and discussion of a cross-section of his art. In order to interpret Ai Weiwei's artistic language and style, TFAM specially invited several experts to write papers on his work, including: Chris Dercon, director of Tate Modern in London, Chinese art critic Feng Boyi, and Chen Tai-Song. We are greatly indebted to the artists and collectors, as well as Ai Weiwei's studio, who painstakingly assisted and generously lent major representative works to TFAM. I extend my most sincere respect and gratitude for their concrete support, which has allowed this exhibition to be successfully unveiled.

# 伐擊十問

劉永仁 VS 艾未未

**劉永仁（以下簡稱劉）：**
今年四月初，北美館邀請您來台討論，卻發生戲劇性的轉折，儘管我無意喚起你那一段難堪的回憶，但那畢竟是生活裡不平順的危險時刻。請描述當時過境的衝突和感受。這次意外對受邀來本館展出的意志是否有所影響？

**艾未未（以下簡稱艾）：**
4月3日早晨，和以往出國的經歷一樣，我帶著助手早晨7點鐘去北京首都機場T3航站樓，出海關時，被告知進到另外一個房間去，這時我預感到可能有問題，我曾經在北京通關時被攔截過一次，進入那間屋子後，警員告知我被禁止出境，理由是我的「出境將危害國家安全」，之後就發生了我的81天的拘禁。
鑒於當時的情況，首先我知道經香港去臺北談展覽是不太可能了，將來臺灣的展覽能不能如期舉行也是不知道。我最主要的心情是無助感，尤其是當你知道你不允許有律師，家人也不被告知你的去處時。在我被拘禁的81天裡，包括後來出獄在外的時期，我一直都希望展覽能如期按原定計畫完成。這畢竟是我在華人世界的第一次大型個展，在此之前，我沒有機會在中國大陸做我的個展，應該說，我很希望我的展覽能夠舉行，能夠成為一個事實。

**劉：** 你的藝術創作形式非常多樣，借用的媒材包括古文物、現成物和工廠新制產品。作品簡潔利落，兼具藝術與設計的表現手法，其中有的是借古諷今，有的又是調侃或玩笑。這可以說是你的藝術特質嗎？

**艾：** 生活在一個複雜和不斷變化的時期，無論我們的個人經歷還是國家和社會發生的變化，都是變動和不穩定的。我對很多領域和社會事件都有興趣。對我來說生活是複雜多樣而不可測的，它具有巨大的偶然性和難以預料性。我不是一個循規蹈矩的人，我對藝術的主要興趣在於它的未知性和偶然性，以及它能為生活提供多樣性的解釋的可能。這些具體的材質和手法，只是我出於情感流露和現實表達的需要而選擇的媒介和表達方式，這不應該成為藝術家表達的障礙，僅是一種

可能。

**劉：** 從古到今，藝術家探討的對象千百種，但有些通俗題材卻歷久不衰，比如十二生肖。甚麼樣的機緣促使你創作如此巨大的《十二生肖》，是否與政治因素、歷史情感有關，還是有特殊因素？

**艾：** 《十二生肖》是我受邀為紐約市做的一組公共雕塑，我希望能夠做一組讓不同層面不同文化背景的人都能解讀的雕塑，尤其是婦女兒童和那些沒有受過學院美學教育的人。十二生肖是中國歷史文化的一部分，我做的這一組《十二生肖》並不是由中國人設計的，儘管他是來自於圓明園海晏堂，但是由歐洲傳教士義大利人郎世寧在清乾隆年間設計，在1860年被英法聯軍擄走。在近期的拍賣當中，《十二生肖》被當作中國傳統文化和愛國主義行為的一部分，以「國寶」之名被競買。這一奇特現象包含了多重的複雜含義，諷刺、傷痛、陳腐、無知和愚昧。但作為雕塑本身它又為每一個人所喜愛。

**劉：** 你曾經在紐約闖蕩羈旅長達12年之久，形成自由開放的生活態度，終日以相機捕捉無數的人物、景觀和事件，當時是否想過有一天會展出？

**艾：** 我拍攝這些照片完全是因為無聊，沒有目的，以我當時的處境我不認為這些圖片有什麼含義，甚至不認為它們有任何保留的價值，我的照片大多數都沒有經過沖洗，膠捲只是存放在冰箱中，直到我回國以後需要給助手找事情做時才把它沖洗出來，然後在「三影堂」做了第一次展覽。現在看來那些照片保留了某些歷史氣息，但主要表現了我當時的一種無聊、無望的狀態。

**劉：** 近年來中國的建築量已經超過了自己幾千年文明歷史中的建築總和。在城市的發展過程中，古建築如何與時代適應？同時請談一談你對北京城市發展的看法。

艾：我們對歷史的認識，必然來自對今天處境的判斷和對未來的想像，我們今天是誰，面對自己的權利和尊嚴，我們應該如何去認知和想像。在這些問題上，如果沒有美學、哲學和倫理學上的正常的思辨的話，我們是無法認識歷史、理解現狀、想像未來的。所有已經做出的努力，只是類似於一個失去理智的人的荒誕表演罷了。

劉：在透視學系列的攝影作品中，你以「比中指」的手勢朝向世界著名的建築物，強烈的挑釁意味與鮮明的視覺形象突顯批判品格，你是否由此建立你的批判美學？

艾：以中指為主題的攝影只是無聊之舉，是對著名的建築物和各標誌性建築所呈現的政治、經濟、文化的權力屬性的一種調侃和戲弄。作品中是我的左手，右手通常持有傻瓜相機或手機，沒有什麼過多的含義，但它一直顯現出一種個人權利與個人之外在的權力之間的對峙狀態。經過很多年之後我才意識到，無論是在個人的經歷中，還是在今天全球經濟一體化的背景下，這種對峙作為長久的一種實踐所具有的特殊的含義。

劉：拆解、重構、顛覆和對邏輯的破壞，這些理念屢次體現在你的作品中。例如以板凳串成葡萄造型、三條腿的桌子等。這些裝置作品幽默而引人注意。能否描述一下你的構思和工藝過程？

艾：現成品的變動保存和延展了舊物的敘事結構，包括它的過去、它所承載的歷史和它被使用的痕跡。作品所帶來的變化與它的舊物的功能之間產生了巨大的衝突。這個衝突是因為對舊物的主觀認知和盲點的強制錯位和重置所帶來的。變動細節的可靠性和合理性又使得作品成為了一個可以接受的新載體。因此，變動提供給我們一個記憶與投射的新基礎。這個思考過程激發了對於功能、含義、使用方法和觀賞方式的新立場。

劉：在當今中國的政治氛圍下，你的視覺作品和社會活動被認為是一種精神層面的批判和社會雕塑。你是否認為這種對抗體制的行為在今天顯得較為虛幻呢？

艾：我從不認為藝術必須限制在藝術史或對既存美學的延伸上。藝術應該是在此基礎上的新的存在。有趣的藝術必須是對既存藝術結論的質疑或顛覆。任何系統都必須被質疑和反對。沒有反對，就沒有新的可能性。

劉：你的大型裝置藝術作品經常以驚人的規模盤踞整個展示空間，看起來是想壓迫觀者的視覺神經，同時也產生了一個前所未有的規模美學。那麼到底是主觀意願還是展示空間決定了作品的尺度。請以作品《永久自行車》為例談談你的看法。

艾：大多數情況下，比例關係是個體存在和世界的關係之核心。我們說的大和小完全是相對自身而言。換個角度看，大完全不大，小並不一定小。宏觀和微觀只有在與我們自身相比較時才有意義。否則，自然界只是一種自覺狀態。藝術品是做給人看的。通常美術館空間都做得很大。當觀者來美術館參觀時，我不希望他們找不到我的作品，所以我常常將作品充滿展示的空間。

劉：在這次台北市立美術館的"艾未未‧缺席"個展中，你選用了不同時期創作的 21 件作品。儘管你本人不能前來，但你的精神力量似乎通過作品傳遞到了你所缺席的展覽中。對此你感受如何。

艾：在展覽中，藝術家的在席不是必要的。作品的完整就可以將一次展覽呈現。缺席也是對展覽的一次測驗。我們都是華人，有著共同的文化背景，在今天的政治環境中也有很多問題是相互重疊的。我不認為我的缺席會對展覽本身有任何影響，如果有影響，那更說明缺席的必要性。缺席也是我的藝術和我本人的現時狀態，它是我的文化處境的一部分。這種狀態給本次展覽以特殊的意義。

# Getting at the Heart of the Art: Ten Questions

Liú Yung-Jen converses with Ai Weiwei

**Liú Yung-Jen:**
This April, TFAM invited you to Taiwan to discuss your exhibition, but a dramatic turn of events took place instead. Even though I don't wish to recall memories of that difficult period, it was a challenging and dangerous moment in your life. Please describe the conflict you encountered passing through customs at that time and whether it influenced your willingness to present this exhibition.

**Ai Weiwei:**
Early in the morning of April 3, like every other time I had left the country, I went with my assistant to Terminal 3 of Beijing Capital Airport at 7 a.m. When I was going through customs, I was told to proceed to a different room. At this point I felt a premonition that I might encounter problems. I had been blocked from leaving the country before. When I entered that room, the officials informed me I was forbidden from leaving China. The reason was that I would "endanger national security." Afterwards, I was detained for 81 days. Given the situation, I knew that it was not very likely that I could pass through Hong Kong and reach Taipei to discuss my exhibition, and I had no way of knowing whether the Taiwan exhibition would take place at all in the future. I mainly felt helpless, especially when you know that you're not allowed to have an attorney, and your family doesn't know where you have gone.

Throughout those 81 days, both inside and later outside, I hoped that the exhibition would be completed according to plan and on schedule. After all, this was my first major exhibition in the Chinese-speaking world. Before this, I had never had the opportunity to do my own solo exhibition in mainland China. I should say, I very much hoped that my exhibition would take place, that it would become a reality.

**Liú:** You are diverse in your artistic creative process, often using a variety of materials such as antiques, readymade goods and newly manufactured products. The works are clean-cut and expressive of both artistic and design techniques. Some satirizes the contemporary with the old, and some are mischievous and humorous. Would you say this is the artistic quality of your work?

**Ai:** We all live in a complicated era of constant change. Our personal experiences, the country and the society at-large are all going through a period of fluctuations and instability. I take interest in many different realms and events in society. Life is complex, diverse, and unforeseeable. It is greatly influenced by chance and is often unpredictable. I am not the kind of person who conforms to convention. My main interest in art is its unknown, coincidental nature and its ability to possibly provide multiple explanations for our lives. These materials and methods are merely for the articulation of my emotions and reality. They should not become an impediment to an artist's expression, but a possibility for a natural way of communication.

**Liú:** From ancient times to the present day, artists have explored a myriad of subjects, but some common subjects transcend time. For example, the twelve animals of the Chinese zodiac has always been a perennial motif. What led you to create *Circle of Animals*? Was it related to political factors, historical sentiments or some other special elements?

**Ai:** *Circle of Animals* was a set of public sculptures that I did at the invitation of New York City. I wanted to do a set of sculptures that people from different levels and cultural backgrounds could all understand, especially women, children and people who had not received any academic art education. The zodiacs are a part of Chinese history and culture. I did not base *Circle of Animals* on a Chinese design, even though they came from Haiyan Hall in the imperial Yuanming Gardens. They were designed by a European missionary, the Italian Giuseppe Castiglione, during the reign of the Qianlong Emperor, and were looted in 1860 by the British and French allied forces. Among recent auctions, some people have come to consider these twelve animal sculptures a part of traditional Chinese culture and a focal point of patriotic behavior, giving rise to the peculiar phenomenon of competitive purchase as "national treasures." There are many complicated layers of significance to this behavior. It is sarcastic, painful. But as sculptures in and of themselves, they're something everyone loves.

**Liú:** You spent over 12 years in the United States. The environment fostered an attitude of freedom and openness. For a long time, you captured countless people, events and scenes with your camera. At the time did you feel that one day you would have the chance to publish or exhibit them?

**Ai:** I took those pictures completely out of boredom; there wasn't any purpose. At the time, I didn't think that the pictures bear any significance; I didn't even feel that they were worth keeping. Most of the pictures were never developed. I just put the film rolls in the refrigerator. Only after I returned to China and needed to give my assistant something to do, that I had them all developed and exhibited for the first time at Three Shadows Photography Art Centre. Nowadays, those pictures seem to have preserved the atmosphere of a certain period of history, but primarily they express my own purposeless, hopeless state at the time.

**Liú:** In recent years, the number of new buildings in China has surpassed the total number of buildings throughout several millennia of history. In the urban development process, how should we strike a balance between preservation and renewal? Also, please share your observations of the changes taking place in Beijing.

**Ai:** Our understanding of history and our past inevitably comes from the circumstances we face today and an imagination of the future. It is a recognition of who we are today and what our rights and dignity mean to us. If we fail to consider these issues aesthetically, philosophically and theoretically, we cannot truly comprehend our current state or imagine our history and our future. All the hard work we have done is merely the ludicrous performance of people who have lost their reason.

**Liú:** In the photograph series *Study of Perspective*, you used your middle finger to "measure" a number of world-famous buildings, with strong provocative and contemptuous implications. The vivid imagery underscored your critical character. Did you develop for your taste for critical aesthetics through this series?

**Ai:** Using my middle finger as subjects for my photography was only a crude attempt to mock the political, economic and cultural implications expressed by famous buildings and various architectural landmarks. The pictures showed my left hand. My right hand usually held an automatic camera or a cell phone. It didn't carry any meaning in particular, but it manifested a confrontation state between individual rights and the power existing outside the individual. Only after many years had I become aware of the significance of the ongoing confrontation – be it in relation to individual experiences or present-day globalization.

**Liú:** Your work often embody concepts of assembly, re-assembly, subversion of originals and disruptions of logic. For instance, stools were conjoined in the shape of grapes and a table was made to have three legs. These works are humorous and appealing. Can you describe how you conceptualize and produce them?

**Ai:** The alteration of a readymade good preserves and extends the narrative structure of the old object itself, including its past, the history it bears, and the marks it has acquired while being used. A conflict forms between the changes that transpire its own logic and its past functions and uses. This conflict is a forcible mispositioning and repositioning of the blind spot and the angle of our own recognition of things. The reliability

and reason of the details produced by this alteration also cause the object to become a new believable vehicle. Thus, the alteration provides us with a foundation for new projections and memories. This process of consideration evokes a stance regarding function, meaning, methods of use and ways of viewing.

**Liú:** In the current political environment of China, your visual art and social activism have been viewed as spiritual criticism and social sculpture. Do you feel that such actions taken against the system are unrealistic?

**Ai:** I don't believe that art must exist within the confines of art history or be an extension of pre-existing aesthetics. Rather, art is a new occurrence based on these results. Interesting art must subvert or be skeptical of existing artistic conclusions. Without opposition to the system, there is no possibility of something new.

**Liú:** Your large-scale installations frequently occupy entire spaces with astonishing volume, stimulating the optic nerves of the viewer, while also producing an unprecedented aesthetics of scale. Was the scale of your works a subjective idea or inspired by the size of a space? Can you please discuss with Forever Bicycles as an example?

**Ai:** Our relationship with the world is derived from the proportional relationship between individual existence and the world. What we call large or small is completely relative to ourselves. At a change of perspective, large

is no longer large, and the small is not so small. Both macro and micro views become meaningful only when there is a correlative relationship with our own bodily existence; otherwise, the natural world would remain in our consciousness. Artworks are made for people to see. Usually, museum spaces are large. When viewers arrive at a museum, I don't want them to have difficulty finding my works, so I usually create them in proportion to the state of the space.

**Liú:** At the solo exhibition *Ai Weiwei absent* at Taipei Fine Arts Museum, you have selected a total of 21 works from various periods of your career. They seem to project your willpower and spirit despite the distance and your absence at the exhibition. What are your feelings about this?

**Ai:** In an exhibition, the presence of the artist is not necessary. It can be articulated by the completeness of artworks. An absence is also a challenge for the exhibition. As Chinese, we share a common cultural background and overlaps of problems in today's political environment. I don't think that my absence would affect the exhibition. If there's any impact at all, it further explains the importance of the absence. The absence explicates the current condition of my art and my state of being. It is a part of my cultural circumstance. This status endows this exhibition with special significance.

# 艾未未，天生的 "反骨"

馮博一

我最早知道艾未未的名字是在 1979、1980 年的第一、二屆 "星星美展" 上。當時他作為星星美展的參展藝術家之一，並非積極的組織者和骨幹。此展之後，許多參與者相繼遁居國外。1981 年艾未未留學美國，屬於大陸第一批赴美留學的藝術家，從此消聲匿跡。1993 年艾未未回到北京，因為我參與他和徐冰、曾小俊策劃、編輯的《黑皮書》，才初次與他見面。畫如其人，好像是品評鑒賞藝術家的揆度常理之言，但世上偏有常理難揆之事。初見艾未未時，你很難把他與他的藝術、他的行為方式統一起來。單看表面，一副落拓不羈、不修邊幅的 "混世" 模樣，腆著個早凸的肚子，有點橫著走路。但他始終保持著一位前衛藝術家的立場和姿態。他是一個不願與世俗苟同，又極力掙脫政治壓抑和精神困境，嚮往自由的叛逆者，而且帶有某種令人不安的特質與氣場。他無論是在做人還是在創作上都保持著冷靜、疏離的狀態，全身投注於批判意識，吶喊的同時嘗試著藝術表現的各種可能性，甚至是激進而偏執的行為。他獨立思考和判斷，不盲信，不人云亦云。在我看來，他是要過一種充分具有自覺意義的生活，對自己，並由自己而及他人和社會的現象、處境不斷發問，同時也從人的各種能力和所有能做的事情中享受著生活的樂趣。他在《此時此地》一書中說 "可以沒有藝術，但不能沒有生活。生活到過癮的時候，都是藝術。"（見《此時此地》，廣西師範大學出版社，2010 年，第 57 頁）這是一種自我觀照中的自我實現。而他的作品卻是另一副尊容：嚴謹、精製、霸氣，純粹中不乏戲謔的幽默，犯忌的快感，全然不是那一副玩世不恭和散淡悠哉的樣子。再看看他回國近二十年所做的事兒，他在網路的博客、微博，以及媒體採訪中的言論，他的作品，他的展覽等等，就可以窺見在他那大大咧咧外表下掩藏著的是一個執著、負重的靈魂和反思歷史、觀照現實的意識，浸透了他們那一代人的夢想與追求，以及荒誕、扭曲的歷程。而畫不如其人，其人未未，一北京 "頑主" 也。

對當代文化藝術的敏感將導致在藝術觀念和方法論上的改變。而艾未未就是一位相當敏感之人，你不知道他會忽然冒出什麼想法，或是做出什麼舉動。比如，他在北京草場地蓋了自己的工作室，一不留神就成為了著名建築師；他針對社會的弊端與不公，在媒體、網路上尖銳批評並且付諸行動，又成為一位公共知識份子。我們常在私下說起艾未未是 "五陪"——藝術家、策展人、建築師、藝術推廣人、公共知識份子——多重身份地活躍於中國和國際藝術界。由此想到，一般在評介、闡釋藝術家作品時，按以往慣常的方式多是從藝術家創作的本身入手，分析其藝術觀念、風格、形式、語言、媒介材料，並由此延伸到個人的經歷、個性，以及與傳統、現實的文化背景的關係等等，從而對其藝術做出所謂的文化意義與價值的判斷。這是比較老套的研究方式之一。或者說，以這樣的方式品評艾未未的行為和藝術有些勉為其難。因為，艾未未的叛逆性與批判性，他對藝術的態度與立場，他的方式方法與創造性，他對年輕邊緣藝術家的幫助，他對底層民眾的關愛，已經超越了藝術本身的範疇，很難單純地從他作品的線性思維來判斷其作品的當代性體現。也就是說，對艾未未的藝術研究分析，已經擴展並演繹到他的思想、言論和行為方式的整體狀態之中，而作品本身只是其中需要考察的一個環節。我以為這不是他最重要的層面，也不能簡單地按以往的判斷標準來衡量與評介。艾未未不斷引起世界關注，業已成為當代中國公共知識份子的典型樣本。

我和艾未未有過多次合作，其中比較重要的是一起編輯《黑皮書》和策劃 "不合作方式" 展覽。1993 年，艾未未的父親病重，這成為他結束在紐約旅居十二年的理由。經過 "六四風波" 的北京，社會政治氣候很是沉寂、蕭瑟與壓抑。1989 年在中國美術館舉行的 "中國現代藝術展"，可以說是對中國當代藝術的 "85 美術運動" 的回顧和總結，意味著以啟蒙、理性的人文關懷為基本文化情勢、以實驗的繪畫語言方式為主的 "85 美術思潮" 的終結，中國前衛藝術處在一個過渡階段。1990 年初，一批被邊緣，被社會視為另類的年輕藝術家開始利用多媒介方式尋求新的表達，其行為、裝置藝術具有一種樸素的激情和原始的衝動。因為 "前衛" 的意義在於批判性和對未定性的實驗，這種追求也賦予了中國前衛藝術一種崇高的氣質，因其生存的狀態邊緣、觀察社會的視角獨特，以及在意識形態上與既定社會觀念、道德規範

相衝突，使那時大陸的前衛藝術具有了地下的色彩。他們被當時的媒體描述為"流浪藝術家"。他們的作品沒有機會參展，無法實現交流，何去何從的困惑使他們沒了方向。而剛從美國歸來的艾未未和正在北京創作《文化動物》的徐冰，以及旅居紐約的藝術家曾小俊，非常敏銳地感到時代所賦予的某種使命和責任，他們開始籌劃出版中國現代藝術的學術性內部交流資料《黑皮書》，其目的是"為中國現代藝術的實驗藝術提供發表、解釋、交流的機會。通過這種相互參與、交流和探討，為中國現代藝術創造生存環境，並促進其發展。"（見《黑皮書》"編者的話"，1994年，非公開出版物）我被徐冰推薦而成為《黑皮書》的執行編輯，這是我介入前衛藝術的開始。《黑皮書》首次以訪談的方式介紹了旅居美國的台灣藝術家謝德慶的系列作品，以"工作室"的概念刊登了20多位藝術家的作品，並引進了介紹杜象、安迪‧沃霍爾、傑夫‧庫恩斯藝術觀念的經典文獻等。艾未未的作品《閉館》、《告示》、《錄音》也是首次在國內刊登出版。現在看來，這本"非法出版物"的傳播作用還是很大的。比如，大陸的行為藝術一直受到謝德慶的直接影響；張洹、馬六明、宋冬、莊輝、黃岩、廣州大尾象工作組等，他們基本上是被排除在當時比較流行的"新生代"、"政治波普"和"玩世現實主義"等架上繪畫潮流之外的邊緣藝術家，其裝置、行為藝術的作品可以說是第一次在出版物中發表。它的出版對年輕的邊緣藝術家予以了認可和鼓勵，這對於他們創作意識的形成和自信力的增強無疑起到了助推作用。而《黑皮書》，以及艾未未於1995、1997年陸續主編的《白皮書》、《灰皮書》，既是他們早期創作的文獻記錄，也是90年代中期大陸前衛藝術最有影響的地下書刊。2000年時，我們想再次合作，來到曾小俊的大宅子商量此事，圍桌而坐，確定策劃一個叫"怎麼弄都行"的主題展覽。但已全然沒有了九十年代初合作編輯《黑皮書》的那種氛圍與感覺。"怎麼弄都行？""不弄"也是"怎麼弄都行"的一種吧。

2000年，我剛從日本回來，正忙於TOM網站"美術同盟"的創建工作，艾未未找到我希望一起策劃"不合作方式"的展覽。這個展覽的概念可以說是正逢其時地恰如其分。上世紀90年代末，正值中國當代藝術的轉型期，來自民間系統的中國當代藝術表現出一種強烈的自我表達的願望。這是"不合作方式"展覽緣起的背景之一。另一個是90年代末的"中國前衛藝術"活躍于國際展事之時，也隨之帶來了一些值得思考的問題。東方的中國似乎還是要扮演他者的特殊形象，才會引人注目而具有存在的理由和價值。作為強勢文化的西方藝術在中國打開國門之後，已呈長驅直入的難遏之勢，並在中國本土尋找到相對程度的認同與接受，中國已變為一種後現代文化生產的資源，一種與西方文化相異的代碼，並成為大規模文化生產與消費的一部分。因此，中國當代藝術在東、西方新的二元對立關係中，仍處在一種"俯視"或"低視"的被觀看、被選擇之中。儘管中國當代藝術在西方頻繁亮像，但其主辦者及策劃者由於在意識形態上的慣性和偏見，使得中國當代藝術在相似與差異中與西方實現真正的溝通和平等的對話。由此導致了中國當代藝術家殫精竭慮地揣摸西方人的心理，塑造並展示所謂的"當代中國藝術的形象"。甚至炫耀東方"視覺奇觀"的"自我東方主義"，即自我神秘化和自我妖魔化，以及將中國元素、符號濫用。雖然中國當代本土的藝術家在自己的現時的地域空間中難以充分地展示，有其眾所周知的原因，但也不可否認西方的"選妃"方式也是造成"中國當代藝術形象"符號變異了的一種因素。如果說在此前更多的是一種原發的針對中國現行體制的一種衝擊，那麼到了90年代的中後期，已自覺意識到了這一文化針對性的範圍在擴展，直接指向了國際間的藝術體制或系統。2000年11月，由侯瀚如等策劃的第四屆上海雙年展的舉行，意味著大陸官方藝術機構第一次曖昧地認可和接受中國前衛藝術，邀請了一些裝置藝術的大陸藝術家參展，並與國際前衛藝術家作品並列展出。以此為契機，艾未未和我於2000年11月在上海雙年展期間，策劃的"不合作方式"週邊展（展覽的英文題目"FUCK OFF"），成為當時眾多週邊展覽的代表。"不合作方式"展是以46位年輕藝術家為主體的展覽，其作品是以挑戰權力話語、主流意識形態熵述的合法性，其自身旨趣各異，他們或是揭露批判，或是質疑反諷，或是鄙棄官方的現實主義，或是詬病藝術的商業成功，在處境維艱的邊緣狀態中，又始終強化題材的尖銳性與形式的極端性，並以令人眼花繚亂或瞠目結舌的方式來表現的。其中，最受關注與爭議的有朱昱的《食人》、《植皮》，楊志超的《烙》、《種草》，孫原彭禹的《連體》、《人油》等對"傷害的迷戀"的作品。策劃這次展覽的目的就是希望中國的前衛藝術在與中國官方藝術體制和與西方藝術系統的主流及權力話語的"不合作"立場中，生成並確認出一種自為的、獨立的中國當代藝術形態。艾未未提出的"不合作方式"是針對當時的藝術生態處境，強調"藝術生存本身所具備的獨立品格和批判精神"，以一種強勢且明確表明，"與任何權利話語系統的不合作是為永恆。"（見艾未未、馮博一"關於不合作方式"一文，《不合作方式》畫冊，第8頁，2000年，非公開出版物）巫鴻在"'2000年上海雙年展'：一個'歷史事件'的締造"一文中，對這次展覽的評介說"艾未未拒絕把這個展覽看成是週邊或邊緣的行動，而是強調不合作方式所代表的中國當代藝術中的另類身份，和它在這一歷史時刻挑戰權力話語中起的關鍵作用。與之相對應的是雙年展則構成了同化和庸俗化的威脅：參與這種裝點門面的官方展覽只會摧毀這些藝術家的實驗精神。因而他和馮博一對這次官方展覽的拒絕，也暗示著他們對一般性的改良主義觀點的拒絕。"（見《作品與展場——巫鴻論中國當代藝術》第226頁，嶺南美術出版社，2005年第一版）其實，這一基本想法從他的《透視學》系列行為攝影作品中，最能體現和說明他的這種不媚強權和藝術世俗的態度與堅定立場了。

按社會學的理論，人們的行為方式受著兩類制度的約束，一類是正式制度，另一類是非正式制度。非正式制度指的是在社會發展和歷史演進過程中自發形成的、不依賴於權力意識的傳統與習慣。雖然文化是看不見摸不著的，但文化等非正式制度在制度建設和社會發展中起著重要的作用。可以說，中國當代藝術的興起，完全依靠的是民間力量。官方藝術機構文藝政策的壓制和滯後，反而造就了中國當代藝術生態的繁盛。其中，艾未未是建設者、踐行者和主要推手之一。2002年，他在北京草場地設計建造了自己的住宅、工作室和"藝術文件倉庫"。其樣式既有北京傳統灰磚材質的樸實，又有現代混凝土澆築的極簡與大氣風格。現在的草場地到處都是他設計的藝術中心、

藝術家工作室，坊間戲稱他的建築風格為"艾式監獄"。同時，他時時維護著在場藝術家的權益，保全著草場地等藝術區的完整、有序的存在與發展。2010年他為正陽藝術區遭遇拆遷的"維權"行動，最能說明他首先是一個有社會意識的公民，不與社會脫節，其行動本身就是一個以政治的方式表達或引起人們思考的一種意識形態。在此可以北京為例，簡單回顧來自民間藝術力量聚集發生的過程：從上世紀90年代初期開始圓明園畫家村的雛形，到1992年圓明園畫家村被官方取締；從張洹、馬六明、榮榮、朱冥、蒼鑫等藝術家流落北京朝陽區的東村，到他們以身體為媒介，強調的是將社會現實的施虐轉化為受虐者的自虐，以此作為生存環境下痛楚的宣洩——張洹的《十二平方米》和他們集體創作實施的《為無名山增高一米》等作品，恰是他們當時生存艱難和抗爭的真實寫照。東村的命運是以馬六明、朱冥被抓，遭送原籍，張洹被迫逃離而告終的。再從90年代中期，隨著一批藝術家選擇聚居在北京通縣郊區的宋莊，建築自己的工作室和住宅。這一圍繞著北京都市城鄉結合部的邊緣藝術家居住群落的出現，並不斷地在世界各地的曝光，集中說明了他們在各大美術學院畢業後的以往中國人所必需的職業身份的轉化，擺脫了中國傳統的"編戶齊民"式的體制身份的限制，而成為職業藝術家的一種對個體生存狀態自由的嚮往、尋求與自為的方式。直至2002年，又有一些藝術家開始在北京城區內租用原國營798廠的廠房，在草場地、環鐵、酒廠等地作為工作室，在地理上形成了廣泛的"北京大山子藝術區"。這一從城郊邊界擴展到北京城區內的地域概念的線索，一方面說明了中國前衛藝術從"農村包圍城市"的滲透與延伸過程；另一方面也標誌著隨著中國改革開放的逐漸深化和文化全球化的蔓延，中國民間空間日漸擴大，使以邊緣藝術家為主體的群落，在一定的社會條件下按自己的願望去生存和從事藝術創作成為了可能。

作為藝術家的艾未未，他的創作與杜象、波伊斯、安迪·沃霍爾等是一脈相承的，但他更為偏執和極端。艾未未在《畫廊》雜誌的採訪中說："別人怎麼談我的作品，我不感興趣，說好說壞都不能影響到我。我甚至不關心人們從文化的角度去探討還是從其他的角度去探討。我不關心它是不是一個藝術品，是否有所謂的社會效益。""如果把畫張什麼畫，或搞個什麼活動都當回事的話，那就太不瞭解生活了。""所以，與其說我想向世界呈現什麼，不如說我想向世界不呈現什麼。""對我來說作品根本就不重要。"（見"1001個人的現代《童話》"，《畫廊》雜誌2007年第6期，第10頁）這是他對藝術的一種表白。也許藝術是他人生的一個意外，或者說是他天生反骨行為的一個藉口。你難以將他的藝術創作歸類，他總是天馬行空地沖入一個沒有料到的境地。他能給你無數的可能性，但就是不給你確切的答案。貫穿艾未未藝術創作的基本線索是他對傳統文化和經典藝術的挑戰、顛覆、篡改與戲仿。一般意義上的經典是文化傳承的主要內容和方式之一，它使我們形成了一個價值共同體，這個價值共同體也就是我們共同擁有的價值認同態度，以及我們對於經典的嚮往和期待，它幾乎成為我們主動的文化選擇。我們對那些經過時間檢驗的經典作品往往被其所具有的超越時代的藝術魅力吸引，所以繼承傳統也就成為藝術創作的一個必然邏輯。不過，反傳統在20世紀得到了空前的發展，以致于反傳統的傳統同樣是不可忽視的。當經典在後現代的文化語境中遇到前所未有的挑戰時，它不僅表現在人們對經典的輕視與漠視，還表現在經典被不斷地改造和顛覆。事實也是這樣，中外美術史上對經典的改造，一直就沒有間斷過，它們已經成為整個文化傳承的一部分。艾未未更是以解構、戲仿、篡改經典的話語方式為能事。他對經典作品的"整容"手術往往是通過拷貝、複製、移植、挪用、拼貼、戲仿等方式給予展開的。

艾未未玩過古董，尤其對古典傢俱的榫卯結構、玉器的打磨、陶罐陶瓷的燒制等情有獨鍾。按說他應該對那些經過時間檢視的古董，以及被其所具有的超越時代的藝術魅力吸引而心懷崇敬，但他卻反其道而行之。他不但把收藏的明式傢俱進行結構性的變形、篡改，還把古董彩陶、漢罐掛上建築刷牆的彩色塗料。更有甚者是他故意將一個漢代的綠釉罐直接摔到地上，"失手"而成粉碎狀。這一篡改、變形和破碎的過程，消泯了原作的功能屬性，也改變了具體媒介與材料的特徵。比較有趣兒的還有一件叫《鬼谷子》的作品，他戲仿燒制了96個元代青花瓷罐，一半是"鬼谷子"紋樣，一半是什麼都沒有。從不同角度觀看，鬼谷子時隱時現。顯然這是對這一瓷器在英國拍賣成天價的反諷，也是對原作的本色、材質、樣式的替換與調整，使作品呈現出原本與摹本並置的質感差異。確切地說他是通過個人與傳統經典之間的關係來展示他對傳統的不確定性和多重意義的思考與認知，並由此構成了原作經典意義距離感的消失。所謂距離感產生美的傳統美學觀，在他的這些具有後現代屬性的藝術作品中不再擁有價值和意義，意味著原創性、獨一無二性的終極價值的壽終正寢，從而原有的本真性與價值判斷也缺失了意義。從器物的打磨，榫卯的拼接中，體現歷史，反思現實，並通過器物的符號化象徵，寓意著中國在現代性歷史進程中潛在的，命運的糾結和歷史的歸宿，並對應和測度著現實的滄桑變異。從而在並置與兼錯的方式中構成了一種生命的質感，獲得一種視覺上的樸素而直接的力量。換句話說，艾未未沒有把他對歷史、現實的表達限制在一般性的表現上，他也不滿足於僅僅把具體的歷史、現實轉換為表像的視覺語言，而是把我們的歷史景觀與生存現實沉澱為實物的底色，把歷史著眼點對準了最為日常勞作的器物之上，記錄著歷史與現實本身的粗糙、艱辛和扭曲，表現出了一種來自自身狀態的切近和逼仄的視覺張力。據說，當他獲知中國南方一座百年寺廟將要被拆掉時，買下全部的大樑、柱子等木質材料，創作了《碎片》等一批裝置作品。《碎片》是他的工匠製作的工藝極其複雜的中國地圖，一百多塊來自廟宇的邊角料，被拼接在一起，並不相稱，碎片之間也沒什麼意義，但它很牢靠，又很荒謬地隱喻出了其中的脆弱。這種在經典內部處理經典，用殘留在經典中的能量破壞它們的控制力改變了以往經典作品力量的作用方向。滑稽地戲仿也是艾未未的拿手絕活。《泉燈》是戲仿前蘇聯藝術家Tatlin的《第三國際紀念塔》，而《十二生肖》戲仿的則是圓明園西洋建築海晏堂十二生肖的噴水雕塑。這些作品裏已不存在了歷史事件或消失的歷史年表，它們只是過去形象的模擬、移植，歷史意識被抹去的缺失使在場變得不完整與不確定，只是現在與過去的對話，而非往昔的真實掠影。我們可以看到的是一種中、外經典圖像的挪用和虛構、自我和他者、歷史的詩意和現實的困境混雜在一起——一種超文本拼貼、置換、

戲仿的效果。如果說艾未未的創作是使用了後現代主義的方法論，那麼，他這些戲仿與反諷的作品則是運用了更為直接有效的"處理"手段。他不僅是製造者，是作品中的"我"，還是一種他理解和判斷的社會現實的象徵與隱喻，這種多重的關係是相互交織和糾結為一體的，從而產生出一種新的視覺張力。這種張力的觀念來自於他對經典藝術作品所形成的認知方式和敘事規則的反叛與挑戰，是在"互為圖像"的關係上對原有創作意識和表述方式的顛覆與拆解，也是一種"新敘事"或"反敘事"嘗試。這種嘗試的目的一方面提供了一種多元的概念來重新認識歷史與經典，重新認識我們的現實社會；另一方面通過揭示已被接受的視覺模式的局限性，而對單一敘述的權威性提出挑戰，使這些耳熟能詳的作品所提供的標準變得短暫而不可靠，也在忍俊不禁的褻瀆、滑稽與荒誕、幽默中體會出犯忌的快感。當然，這些創作都不是進行普通意義上的臨摹與拷貝、整容與篡改，他是不受制於傳統審美確定的規則，或在沒有規則的前提下進行解構式地創作。從而使這些熟悉的圖像陌生化，以控制觀者的期待，讓觀者體味新模式和新視角所產生的驚喜，以及擺脫經典規則後的自由。使觀者在開始審視作品時就意識到，他將要閱讀的文本已不是傳統意義的美術史中的經典之作，而是經過整容後的"新"的視覺圖像。視覺文本已經深深地刻下了他們個人創作的烙印。因此，與其說他是在對經典的整容與篡改，不如說是在清理他過往的視覺記憶與經驗。從圖像到處理圖像，一件件通過主觀意識對外部世界的模仿而形成的藝術作品，不僅僅是對不同時期經典作品的審美趣味、樣式的顛覆與破碎，也是拼貼與建構性的一種嘗試。

拋開所謂藝術的批評，艾未未的極端另類人生，在抽象的意義上顯示了以個人的力量和方式抗拒社會所能達到的某種極致程度，即以個人的極端來渺視和挑戰社會和政治強權的極端，這就有點飛蛾撲火般的悲壯色彩了。艾未未生動的江湖事蹟和冒險人生——確實瘋狂得難有其匹。其原因不僅是他的這些作品，更在於他本人的"反骨"行為。自2006年6月伊始，艾未未在博客中寫文章抨擊廣州醫生鐘南山動用國家機器尋找他失竊的筆記本電腦，將秩序的毀壞直接投向時政領域；他為"楊佳襲警案"撰寫70余篇文章；

發起"5.12地震公民調查"等等。不僅使藝術小眾博客成為了他一個社會批判的陣地，也使他的觀念進入到比較大規模的行為，既顯示了公民意識，又自然而然成為他創作的延伸，這種延伸由於中國本土的語境而超越了西方行為藝術已有的先例。因為，在中國這是一個破碎的、無法彌合的裂痕，這是一個對峙著的兩個世界，它確實存在于我們的現實之中。作為無一例外的意識形態實踐，艾未未卻一定要做出他唯一的判斷與抉擇。因此，他的這種極端出格引起社會的關注、爭議也是必然的。對於他的作品、他的方式，江湖早有不同的看法，其中有對他嫉妒羨慕恨的，也有崇拜的五體投地的，尤其是年青一代的"粉絲"們。正如他的兩極性格導致了對他兩種截然相反的評價，抑或他的超脫與執著的矛盾就是他難以把握的雙重人格，也未可知。不過他最近的被監禁，當然地是專制政府對他"欲加之罪何患無辭"的迫害，所以他的憤世嫉俗又樹起了叛逆者和被迫害者的形象。如果只看他的作品而不及其他，那麼他為自己樹起的這種形象多少會打些折扣。只是他既有幸生存在一個動盪的時代，這註定了他的在劫難逃，而強權對他的懲罰相反地又在他形象上錦上添花。因此，傳奇般的人生因遭致監禁，現在又被"取保候審"，而變得越發撲朔迷離，引人入勝。顯然，他的"政治正確"和"特立獨行"覆蓋了官方認定的"政治不正確"。時間的距離不僅抹去了當下的利害關係，相反還引發了人們的寬容之心，並且使他的人生和作品獲得了非同尋常的讚譽。大概這也可算是一種"意外"吧。我們把他看成是一位自由、民主的鬥士，一個不管不顧聽從自己內心的天才，一個另立江湖的"老大"。他不按常理出牌的方式與他離經叛道的藝術表現也構成了他的兩極處境。他說"我是一個在分裂狀態中的人。對我來說，分裂是一個在生存中尋求可能的方式。"（見臺灣《ppaper》雜誌，108期，第38頁）這使得他天才的一面淋漓盡致地展現出來，而同時又再度成全了他叛逆性的自覺內容。按照這種理解的可能，對他的評介與判斷，除了藝術家、專家學者，還需要有公安局在場——他們也早就在場了。推而廣之，對於有著極端性表現的思想和行為，應當充分考慮其中在中國的現實依存，畢竟叛逆的另類在中國多事之秋的現實社會，可以作為一種完全意義上的價值評判標準。特

別是在那些所謂的"精英們"都在與官方同流合污，與商業機制隨波逐流的當下，他這種挑戰、揭露、質疑、批判的直接"反骨"行動，就顯得尤為難能可貴了。

# Ai Weiwei, Natural-Born Rebel

Feng Boyi

The first time I heard the name Ai Weiwei was during the first and second Stars Exhibitions of 1979 and 1980. At the time he was one of the exhibition's participating artists, not an active organizer or core member. Following the Stars Exhibitions, many participants relocated overseas one after another. In 1981, Ai Weiwei went to the United States as a student, one of the first batch of mainland Chinese artists to study abroad in the USA. From that point he dropped off the radar, until his return to Beijing in 1993. I met him for the first time because I took part in the *Black Cover Book* project, which he organized and edited along with Xu Bing and Zeng Xiaojun.

The saying "A painting mirrors its painter" seems to be common sense in evaluating most artists, but there are always things that are out of the ordinary in this world. When you first meet Ai Weiwei, it is hard to connect his art and his manner of behavior. On the surface, you can only see an unkempt "hooligan", sporting a prematurely protruding belly, with a slightly sideway walk. But he has always maintained the stance and attitude of an avant-garde artist. He is a rebel longing for freedom, unwilling to conform to the world. He struggles against political suppression and spiritual constraints to the utmost, radiating a certain unsettling aura. Whether personally or creatively, he has always maintained a calm, detached state, throwing his full being into his critical consciousness, crying out and experimenting with different possibilities for art at the same time, even radical, obsessive actions. His independent thinking and judgement, and his refusal to blindly trust or parrot others, in my view, reflect his wish to live a life filled with self-awareness. He is constantly posing questions for himself and the circumstances and situations involving himself and others, while also finding joys of life within the many abilities of people and the things that they can do.

In his book *Time and Place*, he wrote, "There can be no art, but there cannot be no life. When you live life to the fullest, everything is art." (*Time and Place*, Guangxi Normal University, 2010, p. 57) This is a self-discovery from self-observation. But his works show a completely different outlook: rigorous, finely crafted, imperious and pure yet filled with mischievous humor and transgressive thrill – not even remotely cynical or complacent. If we look back on the things he has done over the last two decades since he returned home, his Internet blogs and tweets, the opinion he has expressed in the media, his artworks and his exhibitions, we have a glimpse underneath that reckless exterior that he persistently hoists a heavy burden and a consciousness that both ruminates on history and reflects on reality. It permeates the dreams and pursuits of his generation and its absurd, twisted journey. The paintings are not like the person, for the person is Ai Weiwei, the "mischievous master" of Beijing.

An acute perception of contemporary culture and art will lead to changes in artistic perspective and methodology. And Ai Weiwei is an acutely perceptive person. You don't know what kind of idea he will suddenly pull out of his hat, or what action he will take. For example, he built his own studio in Caochangdi on the outskirts of Beijing, and inadvertently became a famous architect. Because of his intense and incisive opinions and concrete actions to address abuse and unfairness in society, he became a public intellectual. Privately, we

often say that Ai Weiwei is "five-fold" – actively playing multiple roles in both the Chinese and international art worlds as an artist, curator, architect, art promoter and public intellectual.

This brings to mind that generally when reviewing or interpreting an artist's works, move behind "artist's creations themselves", one starts with the artist's creations themselves, analyzing his artistic concept, style, forms, language, media and materials, extending from there to encompass the artist's personal history and personality, cultural background, relationship with tradition and practical affairs, and so on, thus assessing the so-called cultural significance and value of the art. This is a relatively old-fashioned mode of study. However, appraising the actions and art of Ai Weiwei in this manner is somewhat problematic. Ai Weiwei's rebellious and critical nature, his attitude and stance regarding art, his methods and creative nature, the help he provides to young, non-mainstream artists and his concern for the lower rungs of society have already transcended the scope of art itself. It is hard to judge his artworks' contemporaneity simply through linear thinking regarding his artworks. That is to say, the study and analysis of Ai Weiwei's art has expanded and logically progressed to include the overall state of his thoughts, opinion and ways of acting – his artworks are merely one link in the chain that must be considered. I do not think it is the most important aspect of his work, and we must not measure and critique the artist by standard convention. Ai Weiwei has consistently raised global concern. He has become the paragon of a public intellectual for this generation.

Ai Weiwei and I have collaborated on a number of occasions, the most significant being the

*Black Cover Book* and co-curating the exhibition *Fuck Off*. In 1993, Ai Weiwei's father became critically ill, and this was the reason he returned to China after living in New York for 12 years. The political atmosphere of Beijing was silent, bleak, and repressed after the Tiananmen Incident. The China/Avant-Garde exhibition held at the National Art Museum of China in 1989 could be described as bringing a sense of retrospection and closure to the '85 Art Movement, hinting that the spirit of '85 – characterized by a basic cultural orientation of enlightened, rational concern for society, and experimentation primarily in the language of painting – had come to an end. It seemed that Chinese avant-garde art was at a point of transition.

In early 1990, a crop of young non-mainstream artists, viewed by society as alternative, began to explore new modes of expression through a diversity of media. Their performance art and installations possessed a kind of simple emotive intensity and primitive spontaneity. Because the meaning of "avant-garde" lay in a critical orientation and experimentation with the undefined, such a pursuit endowed China's avant-garde artists with a certain lofty aura. Their state of existence, the unique viewpoints with which they observed the realities of society, and a mutual conflict with pre-established social perspectives and mores at an ideological level colored mainland avant-garde artists of that era with an "underground" hue. Their itinerant conditions led the media to characterize them as "vagrant artists." Their living circumstances made it impossible for them to participate in exhibitions or to have any form of dissemination or exchange. In a quandary as to how to proceed, they seemed to have lost orientation. But Ai Weiwei, who had just returned

from the United States, along with Xu Bing, who was in Beijing creating *Cultural Animal* at the time, and the artist Zeng Xiaojun based in New York, acutely sensed a certain mission or responsibility that the era presented. They began scheming together to organize, edit and publish *Black Cover Book*, containing scholarly information on China's modern art for internal circulation, with the stated aim: "To provide an opportunity for the publication, interpretation and exchange of experimentation in Chinese contemporary art. Through participation, exchange and exploration, to create an environment for Chinese contemporary art to exist, and to promote its development." (See "Editor's Statement," *Black Cover Book*, 1994, Chinese language, not publicly distributed.)

At the recommendation of Xu Bing, I became executive editor of *Black Cover Book*. This was also the beginning of my involvement in avant-garde art. *Black Cover Book* introduced a series of works by Hsieh Tehching, a Taiwanese performance artist based in the United States, for the first time in the form of an interview. We also published the works of over 20 artists, based on the concept of a "studio," and included comprehensive introductions and classic texts to the artistic concepts of Marcel Duchamp, Andy Warhol and Jeff Koons. The works of, Closing of the Art Gallery (Bi Guan), Notice (Gao Shi), and Recording (Lu Yin), also were released to the public in print form for the first time. Even today, this "illicit publication" is still influential in disseminating knowledge. For example, Hsieh Tehching has always had a direct influence on the mainland's performance art. This book could be the first publication of the installations and performance art of Zhang Huan, Ma Liuming,

Song Dong, Zhuang Hui, Huang Yan, the Big Tail Elephant Group of Guangzhou and other artists working outside the mainstream form of easel painting, who were all basically excluded from the "New Generation," "Political Pop" and "Playful Realism" in vogue at the time. The publication of this book was a validation and encouragement for young non-mainstream artists, and it powerfully bolstered the formation of their creative consciousness and self-confidence. *Black Cover Book* (1994), along with *White Cover Book* (1995) and *Gray Cover Book* (1997), for which Ai was editor-in-chief, served as print documentation of their early work, becoming the most influential underground publications of the mainland avant-garde art scene during the mid-1990s.

In 2000, we decided to collaborate once again. Arriving at Zeng Xiaojun's mansion to discuss this project, we sat down at a round table, and agreed to organize an exhibition called *Any Way You Do It Is Okay*. But the atmosphere and the feeling of working together on the *Black Cover Book* during the early '90s had already disappeared. "Any way you do it is okay?" I suppose "Not Doing It" is one kind of "way."

In 2000, I had just returned from Japan and was busy developing "art alliance" for the website Tom, when Ai Weiwei got in touch and asked me to help him curate the exhibition *Fuck Off*. The curatorial concept of this exhibition dovetailed perfectly with what I was doing at the time. Late last decade of the previous century was a period of transition for Chinese contemporary art. Contemporary folk art manifested a strong desire for self-expression. This was the background context that inspired *Fuck Off*. Another reason was that in the nineties when "Chinese avant-garde art" was active among international exhibitions, it introduced a number of issues worthy of consideration. China from the Far East seemed to depend on its role of 'the Other' to attract attention and to have the value and reason to exist. Having breached the gates of China, the dominant culture of Western art drove deep into the hinterland, gaining an unstoppable position of strength, and winning a considerable degree of identification and acceptance on Chinese soil. China had become a postmodern cultural production, a kind of codeword for difference from Western culture, and had become part of a large-scale system of production and consumption. Consequently, between East and West, Chinese contemporary art still existed within an observational paradigm of either "looking up to" or "looking down on," a state of being chosen. Even though Chinese contemporary art appeared often in the West, organizers and curators – due to ideological habits and prejudices – rarely attained a relationship of true communication and parity balancing similarity and disparity with the West. This left Chinese contemporary artists straining to deduce the psychology of Westerners in an attempt to craft and exhibit the so-called "image of contemporary Chinese art." This even amounted to "self-orientalism" flaunting the "visual spectacle" of the East, a self-mystification and self-demonization exploiting Chinese elements and symbols. While China's contemporary artists faced difficulties fully exhibiting their works in their own homeland, for reasons commonly known, it is nonetheless undeniable that the West's way of "choosing a mistress" was also a factor causing the symbols of "the contemporary art image of China" to mutate. If initially this was largely directed toward attacks originating from opposition to the system prevalent in China, then at the end of the nineties, the scope of this cultural opposition self-consciously expanded, directly referencing the international art establishment.

In November 2000, the fourth Shanghai Biennale curated by Hou Hanru and other intimated for the first time that a mainland official art institution has ambiguously authorized and accepted Chinese avant-garde art, inviting several mainland installation artists and exhibiting them side-by-side with the works of international avant-garde artists. Taking advantage of this opportunity, Ai Weiwei and I curated the collateral exhibition *Fuck Off* in November 2000 during the Shanghai Biennale. It became representative of the many collateral exhibitions taking place at that time. *Fuck Off* was an exhibition featuring 46 young artists whose works challenged the legitimacy of the power discourse and narrative of mainstream ideology. They all differed according to their own essential messages, unleashing criticism, conveying skeptical irony, expressing disdain for official realism, or denouncing commercial artistic success. Despite the difficulties of their marginal status, these artists were consistently increasing the incisiveness of their subject matter and the radicalism of their forms, expressed through dazzling intricacy or dumbfounding methods. Among those works that gained the most attention and sparked the greatest controversy were *Cannibalism* and *Skin Graft* by Zhu Yu, *Branded* and *Planting Grass* by Yang Zhichao, and *Conjoined* and *Human Oil* by Sun Yuan and Peng Yu – works expressing "an infatuation with injury." Our objective in curating this exhibition was to produce and affirm a self-oriented, independent form of Chinese

contemporary art, through the "uncooperative stance" of Chinese avant-garde art toward China's official art establishment and the power and vocabulary of the mainstream Western art system. The "uncooperative approach" (which is how the exhibition's Chinese title may be translated) that Ai Weiwei posited was an emphasis on "independent character and critical spirit possessed by the existence of art itself" in response to the state of art at the time and a strong, clear expression that "uncooperativeness with any power language system is eternal." (See Ai Weiwei and Feng Boyi, "About Fuck Off," Fuck Off, 2000, p. 8, Chinese language, not publicly distributed.)

In the article "The 2000 Shanghai Biennale: The Making of a 'Historical Event' in Contemporary Chinese Art," Wu Hong commented:

In an interview, Ai Weiwei refused to call the show a "satellite" or "peripheral" activity... To Ai and Feng, since their exhibition represented the "alternative" position in contemporary Chinese art, it played a critical role in challenging the dominant "power discourse" at this historical moment. From this position they interpreted the Biennale as posing a "threat of assimilation and vulgarization:" the inclusion of experimental artists in this official showcase could only destroy these artists' experimental spirit. Their refusal of this reformist official exhibition, therefore, also implied their rejection of a reformist historical narrative. (See Making History: Wu Hong on Contemporary Art, Timezone 8, 2009, p. 175.)

Indeed, this basic mode of thought was evident in his *Study of Perspective* photo series, which aptly manifested and demonstrated his refusal to curry favor with authority and his rejection of

artistic compromise.

According to sociological theory, human behavior is constrained by two types of systems, formal and informal. Informal systems refer to traditions and customs that form on their own over the course of societal and historical development without depending on the conscious imposition of power. Although culture is intangible, it, along with other informal systems, serves an important role in the establishment of a general system and the development of society. One might say that the rise of Chinese contemporary art was completely reliant on popular forces. The suppression and lag in cultural policies at official art institutions led to a boom of the Chinese contemporary art scene. Ai Weiwei was one of the founders, enactors and major promoters of this movement. By 2002, he has designed his own living space, studio and the "China Art Archive and Warehouse" in the Beijing suburb of Caochangdi. They combined the simplicity of traditional Beijing gray brick material with the minimalism and grand style of modern concrete construction. Today art centers and art studios of his design can be found all over Caochangdi. On the streets his architectural style has come to be known by the jocular expression "the Ai-style jailhouse." Moreover, he is constantly working to protect the rights and interests of the local artists and preserve the complete, orderly existence and development of such artist villages as Caochangdi. The movement Ai Weiwei led in 2010 to protect the rights of artists evicted from the Zhengyang Creative Art Zone demonstrates that he is first and foremost a citizen with a social conscience and has not broken his links with the community. Indeed, his actions can be described as the use of political means or

ideological expression to stir people's thinking.

In Beijing alone, we may take a simple look back on the process through which the artistic power arising from the people coalesced: In the early 1990s, the Yuan Ming Yuan artist colony came together in embryonic form, but was forcibly closed by officials in 1992. Artists such as Zhang Huan, Ma Liuming, Rong Rong, Zhu Ming and Cang Xin settled in the Chaoyang District of Beijing, in Dong Cun ("East Village"), where they used their own bodies as media, emphasizing the self-inflicted pain of social reality in which sadism is transformed into masochism, and thus venting the anguish of survival in their environment: Zhang Huan's *12 Square Meters* and their collective work *To Add One Meter to an Anonymous* Mountain aptly captured the hardships and struggles of their existence. The destiny of Dong Cun came to an end when Ma Liuming and Zhu Ming were arrested and sent back to their hometowns, and Zhang Huan was forced to flee. Then in the mid-1990s, a group of artists decided to set up Song Zhuang artists' village in Tongzhou District on the outskirts of Beijing, building their own studios and domiciles. The appearance of this non-mainstream artist community at the periphery of Beijing where urban and rural elements intersected, constantly made global appearances. It was a collective demonstration of how, after graduating from major art academies, they turned away from the obligation Chinese people felt in the past to attain professional status, shedding the traditionally restrictive identity of "properly registered citizens." The community served to express these professional artists' longing and quest for self-achieved means of attaining individual freedom. By 2002, another group of artists had begun to rent spaces in Beijing's

city center, in what was originally the state-run Factory No. 798, while others established studios in nearby complexes such as Caochangdi, Huantie and Jiuchang, forming the broadly spread-out "Dashanzi art district." This conceptual geographical border from the suburbs to the city center embodied the process by which China's avant-garde art began on the outskirts and reached inward, permeating urban spaces. It also signified that as China's policy of "reform and opening up" gradually took deeper roots and as cultural globalization extended its grasp, China's popular spaces were gradually expanding, allowing non-mainstream artists to form communities, and under certain social conditions, making it possible for them to live and engage in art according to their own wishes.

As an artist Ai Weiwei bears resemblance to Marcel Duchamp, Joseph Beuys and Andy Warhol, but he is more stubborn and extreme. In Gallery magazine, Ai Weiwei offered something of a confession regarding his art:

I'm not interested in what other people say about my work. Be it positive or negative, it has no influence on me. In fact, it's no concern of mine whether people discuss my work from a cultural perspective or from some other perspective. I don't care whether or not it's a work of art, or whether it has any so-called beneficial results for society... If you make a big deal of it when you paint a picture or organize some kind of event, then you really don't understand life... So rather than asking what I want to convey to the world, you might as well ask what I want to not convey to the world... To me, artworks are unimportant. (From the Chinese-language article "1001 Individual Modern Fairy Tales," Gallery magazine, 2007, no. 6, p. 10.)

Perhaps it was all an accident in his life, or perhaps it was an excuse for his naturally rebellious behavior, his art is hard to categorize. He is always soaring boldly into unanticipated terrain. He can give you countless possibilities, but he does not give you a definite answer. It is an attempt to challenge, subvert, revise and parody traditional culture and classic art that underpins and connects Ai Weiwei's art.

As it is generally understood, classicism is one of the main ways of passing on cultural heritage. It causes us to form a commonality of value. This commonality of value is a consensus and shared longing and expectation for the classics, almost constituting an active cultural choice. When we encounter classic works that have withstood the test of time, we are often seduced by the artistic magnetism of their ability to transcend a given era. Thus, passing on tradition has also become the necessary logic of art. Nevertheless, in the twentieth century, anti-traditionalism has developed tremendously, so the tradition of anti-traditionalism is also a fact that cannot be overlooked. As the classical encounters unprecedented challenge in the cultural context of postmodernism, it is expressed not only in people's disparagement and indifference, but also in a constant revision and subversion of classicism. In the history of art, both in China and around the world, the revision of what is deemed classic has always been uninterrupted, and has become part of the overall cultural heritage. Ai Weiwei's forte is deconstructing, imitating and tampering with the language and methods of classicism. He frequently achieves this "cosmetic surgery" of classic works through copying, reproduction, transplantation, appropriation, collage and parody.

Ai Weiwei has a history of playing with antiques. In particular, he is fond of the mortise-and-tenon structure of antique furniture, the polishing of jade and the firing of pottery. One would expect him to revere antiques that have stood the test of time and the artistry that transcends the era in which they were made, but in fact he is inclined towards the opposite direction. Not only did he structurally alter Ming-style furniture that he had collected, but he also covered antique pottery with colored wall paint. What is more, he intentionally "let go" of a glazed Han-dynasty urn, which was smashed into pieces on the floor. This process of tampering, alteration and fragmentation eliminates the functionality of the original piece and changes the characteristics of the specific medium and material. Even more interesting is a work called *Ghost Gu Coming Down the Mountain*, in which he fired 96 imitations of Yuan-dynasty blue-and-white porcelain jars, covering one half with the pattern from the original Yuan work, while leaving the other half blank. Viewed from different angles, *Ghost Gu* is alternately visible and invisible. Clearly, this work is a sardonic response to the record price the original fetched at a British auction, as well as a substitution and modification of the color, material and appearance of the original, manifesting a qualitative divergence between genuine and imitation when set side by side.

Put precisely, he uses the relationship between the individual and the classics of tradition to convey his own thoughts and understanding of the uncertainty and multiple meanings of tradition, thus erasing a sense of distance from

the classical significance of the original work. In these postmodern works of Ai Weiwei, the traditional aesthetic viewpoint that a "sense of distance" produces beauty has been stripped of its value and meaning, intimating that the absolute values of originality and uniqueness have met their end. Consequently, the original idea of genuineness and the original value judgments have also lost meaning. From polishing vessels to piecing together furniture parts, he manifests history, ruminates on reality, and through the symbolic nature of these objects alludes to the latent conflicts ongoing within China's modern history, to the entanglements of fate and the consequences of history. He also responds to and measures the vicissitudes and mutations of reality. Through this juxtaposition and overlapping, he has attained the quality of life, and gained a simple and direct visual power. In other words, Ai Weiwei does not limit his statements regarding history and reality to ordinary forms of expression, but dissatisfied with merely transforming concrete history and reality into a representational visual language, he also coalesces our historical landscape and the realities of life as the foundation color of physical objects, focusing the viewpoint of history on the most everyday utilitarian objects, documenting the coarseness, difficulty and distortion of history and reality themselves, to convey an apt and precise visual tension rising from his own condition.

When he heard that a century-old temple in southern China was about to be razed, Ai is said to have bought all the beams, pillars and other wooden materials, and used them to make *Fragments* and other installations. In *Fragments*, he led a group of skilled artisans in constructing a map of China of extremely complex workmanship. They pieced together over 100 pieces of joinery from the temple into a structure that was makeshift and irrational, yet sturdy while also absurdly alluding to its own fragility. This mode of internalizing the classical within a treatment of the classical, using the residual energy of classical objects to destroy their powers of control, shifts the direction toward which classic works of the past are employed.

Comical parody is Ai Weiwei's forte. *Fountain of Light* was a parody of Vladimir Tatlin's *Monument to the Third International*, while *Circle of Animals* mimicked the twelve zodiac sculptures of the fountain in the Western-style Haiyan Hall of Yuanming Gardens. In these works, the historical events or vanished historical chronologies no longer existed; they were only replications and transplantations of previous images. As historical consciousness had been erased, its absence made the installation site incomplete and uncertain – merely a dialogue between the present and the past, not a glimpse of past reality. What we can see is an appropriation and false construction of classic images from both China and the world at large, and a random mixing of self with others, and the lyricism of history with the predicaments of reality – yielding the effect of metatextual collage, displacement and satire. If one were to say that Ai Weiwei's works employ a postmodern methodology, then satire and irony utilize a more direct, effective method of "treatment." Ai is not only the maker, but also the "I" of the work, or a symbol and metaphor of his understanding and judgment of social realities. Such a multiplicity of relationships is mutually woven and entwined as one, thus generating a new form of visual tension. This tension arises from his way of recognizing classic artworks, and a rebellion against and challenge for narrative rules. It is a subversion and dismantling of pre-existing creative consciousness and methods of expression in terms of a relationship of "mutually referential images," or an attempt at a "new narrative" or an "anti-narrative." The goal of this attempt is to provide a conceptual diversity that may yield a fresh recognition of history and classicism, and a fresh recognition of real society. Moreover, revealing the restrictiveness of accepted visual models and presenting a challenge to the authoritarian nature of a singular narrative transforms the standards that these familiar works provide into something temporary and unreliable. It is all the more intriguing for the thrill of taboo one experiences amidst the droll irreverence and this right now are in the midst of creating the "classics" of this unclassical age.

None of these artworks have gone through copying, makeover or revision in the ordinary sense. Ai is not restrained by the rules of traditional aesthetics, or one might say, he engages in deconstructive creation under the precondition that there are no rules. This makes these familiar images unfamiliar. With the expectation of controlling the viewer, it allows the viewer to savor the surprise engendered by a new model, a new perspective, and the freedom that comes after shrugging off the yoke of classical regulation. As soon as the viewer begins observing the work, he would become aware that the text is not classical in the sense of traditional art history, but a "new" visual image that has undergone cosmetic surgery. The visual text has already left the deep imprint of its own individual artistic brand. Thus, his works are not so much a makeover and

revision of classicism, but rather a purging of past visual memories and experiences. From image to the treatment of image, each work of art formed from the mimicry of the exterior world by subjective consciousness is not merely a subversion and fragmentation of the aesthetic appeal and appearance of classic works from different eras, but also an assemblage and a constructive exploration.

Rejecting so-called art criticism, Ai Weiwei leads a radically alternative lifestyle, demonstrating at an abstract level the maximum degree of what can be achieved by resisting society through individual power and effort, disdaining and challenging the extremes of society and political power through individual radicalism. It is tragically heroic, like a moth plunging into a flame. Ai Weiwei lives a lively, itinerant, adventurous life – he is truly frenetic to a level rarely seen. The reason lies not only in his works, but also in his own "rebellious" behavior.

In June 2006 Ai Weiwei began posting articles on his blog lambasting Guangzhou physician Zhong Nanshan for mobilizing state resources to look for his lost laptop computer, directly attributing the breakdown of order on the current political regime. His publications have included over 70 articles on the case of accused police murderer Yang Jia, a survey on student casualties in the 2008 Sichuan earthquake, and many more. This not only turned his modest art blog into a battlefield upon which to criticize society, but also led him to engage in actions of a larger scale, revealing his civil consciousness and serving as a natural extension of his art. This extension has taken place because the context of China itself had transcended the preceding

examples of performance art from the West. In China this is a shattered, unmendable fissure, a clash between two opposing worlds. It exists within our reality. Without exception, these are practical enactments of ideology, but Ai Weiwei is guaranteed to act upon the one and only judgment and decision he has made. Therefore, it is inevitable that his radicalism attracts attention from the society and causes controversies.

The world has been full of different opinions for some time now regarding his work and his methods. Some people are filled with envy. Others prostrate themselves with admiration, especially his younger fans. Whether the polar extremes of his personality have led to diametrically opposite estimations of him, or whether he finds it difficult to master his own dual personality – paradoxically detached yet perseverant – is something we cannot know. Nevertheless, his recent detention is of course the persecution of an authoritarian government that acts according to the adage: "If you want to charge someone with a crime, there is no need to worry about having no pretext." So his indignation with the world has created an image of both rebel and victim of oppression. If you look only at his artworks and not his persona, then the image he has cultivated for himself will to a certain degree detract from his scorecard. Yet ultimately, he is leading a charmed life in a tumultuous era. This is the fate to which he is destined, and the punishment of the authorities has only backfired, adding greater luster to his image. Consequently, because he has gone through detention and is now "out on bail awaiting trial," his legendary life has become even more bewildering and absorbing. Clearly, his "political correctness" and "independence

of character" mask an officially recognized "political incorrectness." Distance in time has not only cancelled out the present stakeholder relationship, but has in fact stirred people's sympathies, and it has generated extraordinary acclaim for both his life and his works. I suppose this counts as an "accident."

We take him to be a champion of freedom and democracy, a genius who listens to his own inner voice without regard for the consequences, a leading man who blazes his own trail. His unusual methods and unorthodox art have also placed him in a polarized position. He once said, "I'm a person living in a schizophrenic state. For me, having a split personality is a way to seek out possibilities in life." (See ppaper magazine, Taiwan, no. 108, p. 38.) This allows his genius face to eloquently reveal itself, and further reinforces the production of his rebellious, self-conscious subject matter. According to this form of understanding, critiques and judgments of Ai Weiwei require the presence of not only artists and expert scholars, but also public security forces.

More broadly, a full consideration of radically expressed thought and behavior should take into account the practical interdependencies in play in China. After all, rebellious alternatives can serve as a standard for full value judgment in the China's ever-changing social realities. In particular, in the present day when the so-called "elites" all wallow in the same mire as officialdom and ride the same wave as the business establishment, his kind of "rebellious" action, presenting challenge, exposure, skepticism and criticism, is no mean achievement, and therefore all the more precious.

# 在美術館展出藝術作品顯得無趣

克里斯‧德爾康 / 倫敦泰德美術館館長

「我的信息是暫時的，不該成為永久條件。我的信息
跟風一樣會飛走；別的風會飛來。[1]」

## 一、艾未未在台北

我想不出來當下還有什麼地方比台北更適合展出艾未
未的作品。

2011 年 6 月 21 日，艾未未一遭到釋放，世界媒體立
即在現場發佈新聞、轉播和評論這則消息。只見艾未
未垂頭喪氣，筋疲力竭，勉強從一扇開了一點點的門
中走了出來，說了幾句話（「我什麼都不能說，這是
我唯一能說的。[2]」），搞不好這幾句話出自侯孝賢或
者蔡明亮的電影。

侯孝賢和蔡明亮以及其他台灣導演不斷描繪角色的疏
離感，以及他們想跟外界接觸的笨拙嘗試，而這些角
色最終都會找到某種有時看似怪異的個人心靈上的平
和。這些電影中的主人翁一直都面臨著諸如「如何找
到屬於自己的地方」？或「如何找到自己的身份？」
等存在有何意義、生命方向為何的問題。

只要一想到我最喜歡的台灣電影，比方說楊德昌的
《牯嶺街少年殺人事件》，我就會想起我第一次到台北
參觀的時候，當時有十幾名年輕的藝術系學生在雨中
騎著摩托車，一路跟著我和館方同事穿越濕答答的台
北，一邊喊道：「先生，看看我的代表作選輯！」他
們是否不自覺地就表現出一種不得其所的失落感呢？

## 二、艾未未穿著一件上面印有他名字的 T 恤

如今更甚於以往，艾未未，這個在真實生活中的主人
翁，他正面對著同樣的感受和疑問。然而，事實上，
在他遭到釋放後幾天，他便穿了一件上面印有自己名
字拉丁文拼寫 “Ai Weiwei” 的 T 恤，益發散播出戰
鬥訊息。

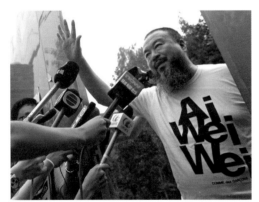

Ng Han Guan/AP Photos

自從艾未未於 2011 年 4 月 3 日在北京機場遭到拘
捕，在「艾未未在哪？」口號的呼籲下，國際社會
開始提出強烈抗議，如今艾未未則透過在國際媒體面
前穿著印有自己名字的 T 恤，公開表達他與國際社會
一體，共同發出強烈抗議之聲。歷經八十一天單獨監
禁後，艾未未再度強調在他自己的私領域和公領域的
「艾未未」之間的生產差異。誠如德國政治評論家馬
克‧賽門所言，儘管有關當局強迫艾未未個人保持沈
默，但 T 恤上的名字就跟商標似的，直指未來「艾未
未」會成為一個公有品牌。

正因如此，小道消息也隨之而來：「艾未未遭逮捕的
時候，是不是正打算去台灣籌備這次展覽？」而透過
這次在台北的展出——艾未未甚至沒辦法親自參與設
置——艾未未要求大家看見和聽見他的訴求。這次展
覽的氛圍如何？我們又該在什麼氛圍中來感受這次艾
未未的展出？

## 三、艾未未重塑十二生肖獸首

2011 年 5 月 11 日，我在倫敦十八世紀薩默塞特宮庭
院裡針對艾未未大型戲仿《十二生肖獸首銅雕塑》作
品發表演說。這一圈共十二尊青銅獸首曾是北京城外
夏日行宮圓明園的報時噴泉裝飾。就在我發表演說前
一個禮拜，紐約市長彭博在中央公園入口的大軍廣場
還幫它們的展出舉行過開幕典禮。

這十二尊獸首原本是於十八世紀中葉，在義大利傳
教士的監督下建造而成，但於 1860 年被英法聯軍破
壞。近年來中國官方與各界人士歷經多次嘗試，力圖
找出擁有者而加以收購。2009 年 2 月，在巴黎一場
女裝設計師依夫‧聖羅蘭藝術品收藏拍賣會中，兩尊
原始獸首引起各方莫大關注。原本大家都以為得標的
買家是來自中國大陸的私人富豪收藏家，豈料他只不
過是個地方買家，拍賣成交後甚至還取消交易。事後
大家才弄清楚事情原委，原來他為了抗議才參與投
標，某些人認為他有可能來自於中國官方支持與授

1. 艾未未在 2009 年 10 月於德國慕尼黑「藝術之家」與筆者之對話內容。
2. 艾未未在 2011 年 6 月 23 日釋放出來後首次對媒體之發言內容。

意。2009 年夏天，艾未未聽說這件事，就向我表示可以透過某件「有趣」的作品來加以彌補。我甚至相信當時他用了「好玩」一詞，搞不好艾未未當時用的是「淡」這個中文字？他為什麼會覺得做出這麼一件作品會「好玩」呢？不過，艾未未戲仿的十二生肖獸首，還真的充滿了有趣的參照，可是這件作品既非拙劣模仿，亦非諷刺挖苦，而且絕不憤世嫉俗，完全不帶一絲偶像破壞姿態──以上種種，它全包了。此外，艾未未十二生肖獸首的尺寸大到稍微有點「過火」，全然體現了 kitsch（庸俗作品）一詞的真諦。在西方藝術風格用語中，kitsch 指得是某樣跟原物相較之下，要不就太「小」要不就太「大」的東西。的確，這個動物圈，或許可稱之為動物屋，是一間充滿矛盾的屋子，就跟今日中國一個樣。我們知道，今日的中國大陸已經不只就當前社會和經濟秩序而言是一個矛盾的地方，即便在有關它自己的文化遺產上也照樣很矛盾。

中國人對他們的文化遺產、中國玩意兒和過去的老東西狂熱無比。 但同時，不管自己的文化藝品，古老或沒那麼古老，重要或沒那麼重要，某些中國人似乎對破壞和摧毀它們並不介意。中國人的態度如此矛盾，他們究竟有什麼盤算？什麼都沒。中國思想充滿信任：沒有悲劇，沒有形而上的空想。凡事別太理想化，人人都會有未來；中文裡「理想」這個詞兒不存在。然而事實則正相反，凡事看上去似乎呈現不平衡狀態。艾未未戲仿《十二生肖獸首》就是這種不平衡狀態的完美例證。何況，在中文的「淡」中，這些雕塑難道不正代表著某種「平淡」嗎？在專門研究中國哲學的法國教授弗朗索瓦・于連的《淡之頌，論中國思想與美學》這本書中，他就主張：「即使平凡似乎『沒滋沒味』，中國美學還是極其重視平凡，實際上，平凡比任一種獨特的味道更佔優勢，因為平凡對所有潛在的變異開放。」當「平凡」在中國美學中慢慢發展成為一種正面價值，「淡」的現象則體現了其變的本質。不過《十二生肖獸首》的確是極其「西方的雕塑」，它並不在於表達「無」，實則充滿了歷史暗示

與具體事件。感覺和思考──艾未未要我們兩樣都得做，有時候一樣比另一樣多做點。

## 四、艾未未比中國人還中國人

艾未未的藝術展示出：藝術實踐如何能夠探索所有潛在變異，甚至各式各樣的文化。就這個角度來說，艾未未比大多數的當代中國藝術家還更中國。而且他同時走在好幾條不同的路上。艾未未多重的「生命道路」，以及他的對抗性言語和行動，乍看之下有點古怪和令人不安，孰不知它們其實深深紮根於中國傳統哲學思想。中國有史以來，出現過好多個艾未未。

艾未未經常處於「這個與那個」之間：在學科之間，在舊與新之間，在原物與再製之間，在中國與西方之間。他就是透過這種角度來喚起中國傳統──古今皆然。或許這就是某些成都公安稱呼他「老師」，而不稱呼他「藝術家」的原因，跟我們在紀錄片《老媽蹄花》（2009）裡面所聽到的一樣。我真想知道打從艾未未獲釋後，中國公安是怎麼稱呼艾未未的。

"Police" 在希臘文中原本是「保護」之意，而不僅僅是「制定法規」或「保護法律」。再者，有句拉丁諺語也說道 "protego ergo sum"：「我會保護，所以我能治理」。一個國家沒辦法保護自己的公民，不論這些公民彼此之間有多麼不同，這個國家都沒法勝任治理。這樣的國家可能會有種種規定，但沒有法律；這是個沒有法律的國家。因此，像艾未未這種人，身在中國的他，他的公民狀況會是怎麼樣的呢？此時此刻，中國規定不准告知世人艾未未個人狀況如何，也不准透露他身為公民的狀況又如何。

艾未未曾經說過：「藝術有關生活。我們的生活整個就是政治。所以說我的藝術整個就是政治。[3]」

艾未未的確是個廣受好評的藝術家、有創意的設計

師、有影響力的建築師、具前瞻性的城市規劃專家、學養豐富的文化史學家、一等一的廚師，甚至還是個了不得的美髮師。但同時，他也是一位令人信服又愛爭論的作家，就跟最近出版的《艾未未的博客：寫作，採訪以及數位咆哮，2006-2009》一書中所陳述的一樣。艾未未知道怎麼向群眾發表演說，也知道透過社群和其他媒體手段來號召廣大觀眾。在這個繁榮的中國社會裡，每天都得應付令人不安的蜚短流長和冷言冷語，但他擅於把握機會適時發聲，表達出他自己以及他同胞的不滿。在遭到拘留和有條件釋放後，艾未未同樣遭到這個中國社會的說三道四，有人說他是個很強的行動家，卻是個很弱的藝術家，其他還有些別的說法。

艾未未曾經在曼哈頓東村住過一段時間，他早期在紐約的攝影作品以流亡、政治和暴亂為主題（可以回溯到 1983-1993 年），此外再加上他較為近期的作品，比方說 2010 年秋天在倫敦泰德現代美術館渦輪廳展出過的《葵花籽》，如今看來，益發令人感到意味深長。這些作品是真實生活的一塊塊拼圖，是藝術家所捕捉到的某些時刻，是一個藝術和生活不分的藝術家所捕捉到的自己這一生中的某些時刻。艾未未說：「種子增長。啁啾迴盪。人群最終會找到自己的路。[4]」的確，我們才剛開始了解艾未未的生活與藝術。

## 五、艾未未愛馬塞・杜象

艾未未聲稱對他影響最大的藝術家是法裔美籍的馬塞・杜象（1887-1968）和他的現成物概念，這種概念號稱只要藝術家決定讓某樣東西變成一件藝術品，任何東西都可以變成藝術品。可是杜象也認為反正藝術家製造出來的「藝術」已經夠多了，他又何必「開始」去創造一些大家所謂的藝術呢？就跟艾未未所指出的一樣：「杜象可以在瞬間成就經典，因此對他來說，藝術就是生活的一部分。[5]」

在艾未未早期於美國的照片中，我們可以看到許多今

---

3. 艾未未在許多場合說過，筆者第一次聽到的是在 2009 年 1 月。
4. 艾未未於其在倫敦泰德現代美術館展出〈葵花籽〉時所說的話。
5. 同註釋 2。

日中國藝壇重量級的人物：電影導演陳凱歌，詩人北島，作曲家譚盾，藝術家徐冰。紐約現代藝術館的艾未未自畫像甚至還更加發人深省（這幅畫就陳列在馬塞·杜象的作品旁邊），似乎他想呼應名詩人父親艾青的詩句，艾青寫道：「現代美術館／鋼的雕塑／電光的繪畫／構成奇麗的幻景／千百種的奇思怪想／都在這裡出現了／物慾世界的峰頂／有人進入天堂／有人進入地獄」（《紐約》，1980 年 11 月 17 日）。艾青交遊廣闊，他的朋友和許多藝術家不僅深深影響著艾未未，也成為他的資源。1964 年於北京出生的畫家邵帆，他是艾未未父母一位藝術界朋友的兒子，也是艾未未兒時鄰居。邵帆因「中國古典傢具的拆分和重組」而馳名國際，艾未未為此寫過一篇藝評，成為艾未未最早受到矚目的一篇評論。

不過，艾未未依然堅稱他所仿效的榜樣就是馬塞·杜象。他還在紐約的時候，就已經透過相當正式的引用，表達出他「追隨杜象」的欲望：艾未未將掛衣架彎成杜象的樣子，裡面部分填滿葵花籽。1986 年，艾未未提到：「要是誰走進紐約現代美術館而不會感到羞愧，那麼只有兩種可能，要不就是他感覺遲鈍，要不就是他道德淪喪。[6]」十年後，2006 年 5 月 23 日，一群收藏家和紐約現代美術館館方人員一併參觀他位於草地場的工作室，艾未未用監視攝影機把這一行人的參訪過程給錄了下來，變成很好玩的藝術事件。最後拍出五件錄像作品，每件都長五十分鐘，同步從五個不同角度展示那次參訪。短短數年後，同一款監視攝影機不間斷地紀錄著艾未未的所有活動和一舉一動——這次是由當地警方架設和控制。

## 六、艾未未是他自己的現成物

1993 年艾未未因父親生病從紐約回到北京。當時他就大膽聲明：「我是我自己的現成物。[7]」，透過把自己的名字當商標用，艾未未清楚表明了此一信念。艾未未開發出一種新元素——即「古老現成物」——並將這種變異引進杜象派策略，與羅勃·羅森伯格幾乎稱得上是返祖現象的集合作品，或是與米開朗基羅·

皮斯特萊托的「被取物」頗為雷同。為了創造新東西，艾未未回收、替代、操弄，有時甚至還毀壞傳統家具或古代船隻。他一邊抨擊把文化給揮霍光的這種行為，同時也對文化遺產甚至保存政策重新加以詮釋。艾未未說：「大家還是認得出它們來（把它們當成工藝品），所以大家還是很珍惜它們，因為它們從傳統古董博物館搬進當代藝術環境，而且出現在拍賣市場，要不就是成為收藏家的藏品。[8]」

艾未未透過一個名為「發課設計（fake design）」的公司團隊營運來實現他的想法，並以類似工廠大量生產的方式產出作品。「仿冒（fake）」一詞臭名滿天下，經常出現在中國和西方有關產業和商務的交涉中。同時，"fake" 這個詞的中文發音又跟 "fuck" 很像，而在艾未未某些藝術作品中，諸如早期的《透視學》，也出現過一些粗俗圖案。同樣地，"Sorry" 一詞的意義也有好幾種變化：當中國或世界其它地方的政府、公司行號或者財務單位，單純因為要補償某個悲劇或錯誤所造成的遺憾，而想努力道歉時，"sorry" 一詞經常代表「去你的（fuck off）」的意思。結果，2009 年艾未未在慕尼黑藝術之家首度舉行大型回顧展時，該展就是被稱為「非常遺憾（so sorry）」。

「發課設計」團隊由不同專家組成，其中包括了對古老傳統技藝十分嫻熟的傑出木匠。但是，艾未未經常都會有些外購計畫，比方看似相同其實每顆都不同的上億顆的葵花籽，是在景德鎮的作坊生產出來的。

在某些他的藝術作品中，艾未未玩弄或者「仿冒（fake）」當代西方藝術。同時，他也在不放棄中國文化本身傳統的情況下，利用中國文化及其容量將「外界」吸納進去。結果造成艾未未的作品在西方人眼中，有時看起來會平淡無奇。但正是這種平淡無奇，這種「沒滋沒味」，才吸引我們注意。根據弗朗索瓦·于連的說法：「平凡是種深入內心的疏離形式，唯有達到這種超脫狀態，一個人才能把自己從諸如『品味』等個人喜好中解放出來。」

運用大量材料和再製是艾未未創造作品的另一重要面相：深深紮根於中國思想、技術傳統和歷史文化的重複、複製與大量生產。再者，艾未未給人一種他更加熱衷於以這種方式來從事創作的感覺，因為他說過：「我現在比較不把力氣花在個人生產作品上面，因為跟別人一起執行的成果總意味著會有某種驚喜，創作時的集體智慧形式也會帶來驚喜。[9]」

## 七、艾未未和「次薄」

自 1993 年回國後，艾未未在北京實驗藝術舞台的發展上扮演著活躍角色。他跟同好及朋友創設了北京最早的非營利藝術空間，並開始出版書籍。《黑皮書》（1994）、《白皮書》（1995）和《灰皮書》（1997），讀起來就好像某種針對新激進藝術的宣言。這三部著作令人想起理查·漢米爾頓的「書的藝術」。漢米爾頓同時也是馬塞·杜象仰慕者、朋友和評論家，1960 年時，曾將著作《綠書》獻給杜象。

2000 年，艾未未在上海策劃極具爭議性的 "不合作方式" 藝術展，被視為是除了上海官方雙年展外的另一選擇。該展中文標題翻譯為「不合作方式」。開展幾天後，就被公安勒令關閉。同時，中國政府則開始安撫許多深受好評且財務充裕的中國藝術家，並致力於控制他們的活動，從而「軟化」他們的力量。策展和共同策展對艾未未來說是條重要途徑，讓他得以保持藝術地位獨立自主：2011 年，他跟彼德·費雪和烏里·希克共策劃了「山水」展，並於瑞士盧賽恩美術館展出；此外他還藉著 2011 年南韓光州設計雙年展之際，跟布蘭達·麥格克傑翠克一起策劃了「無名設計」展。這些展覽除了將艾未未涉獵之廣泛表露無遺外，也顯示出隨著時間往前推進，艾未未的主題也有所變化：從特別重視傳統和工藝，到改變設計定義。光州策展人甚至更將政治抗議組織視為是國際設計發展的新頁，至於盧賽恩，則將中國古代水墨畫用於裝飾展覽廳室牆面。

6. 艾未未替其在德國慕尼黑藝術之家的關於紐約現代美術館的錄像作品所寫的創作自述。

7. 同註釋 2。

8. 同註釋 2。

9. 同註釋 2。

我們再度可以在艾未未身上隱約看出杜象的藝術策略：在紐約的那幾年中，艾未未和朋友一直都以打零工度日，經過那幾年紐約的洗禮之後，他很快便想到「繼杜象之後，當一個藝術家更像是一種態度，是一種生活和工作的態度，以及一種感受事物的方式。想當一個藝術家，最重要的並非在於創造藝術作品。[10]」

不過，杜象的影子在艾未未的作品和想法裡面，遠比他自己所願意承認的來得多。「次薄」（"inframince" 或 "infratin"）是杜象派其中一個最出色的概念，按照杜象的說法「次薄」就是指：兩個相同東西之間的最細微差別。這一點在許多艾未未的作品中都很明顯，例如《彩色的陶罐》（2006~2008）還有《樹根》（2009）。這種「形象政治」，使得切爾多·梅雷斯或布里埃爾·奧羅斯科等許多非西方藝術家深深受到杜象吸引。他們的「形象策略」顯示出與艾未未的「形象手法」如同出一轍的趣味。在杜象之後，我們不可能明確定義「次薄」，只能舉出幾個例子。一般都將這種現象的特徵描繪成一種幾乎察覺不到的厚度，就跟薄薄的一層似的，但同時又是好幾層中的其中一層。在一張名為《養塵土》的照片中，曼雷把焦點放在杜象的《大玻璃》所累積的灰塵上。因此，曼雷在保持原物不動、未曾碰到原物的狀況下，透過在原作品上強加另外一層，從而改變了這件藝術作品的透視。「次薄」就是一種間距或距離，也許我們根本都察覺不到，但卻很容易就可以想像得出來。同樣的概念也適用於某些傢具，比方說《中國地圖》（2004），用「碎形」這個詞來加以形容似乎可行。「碎形」是數學家本華·曼德博在 1975 年所發明的新詞，意指某個物件的數學維數會大於其拓撲維數，所以說「碎形」就是指亂中有序的意思。

## 八、結語

2010 年 4 月 28 日到 5 月 1 日，北京中央美院美術館舉行「和而不同」展覽座談會，中國當代藝術界「大腕」與會探究中國實驗藝術的教學模式。經過跟藝術家和評論家數度交談後，有一點變得很清楚：與會人士坦然接受 4 月 3 日艾未未被捕一事，還用毛澤東的名言「殺雞儆猴」來描述這件事，艾未未被捕的例子不啻為對每個人發出清楚警訊。只有少數幾位年輕藝術家表達對中國藝術界的失望，展現出跟艾未未同仇敵愾的團結精神。有的人甚至指責艾未未簡直就是個闖禍精，他根本就對藝術喪失了興趣，卻因為他個人操弄政治的宣傳噱頭（「自私自利」），害得整個藝術社群陷入危機。在今日這個大家幾乎都對外國新聞報導消息靈通的時代，艾未未的消息卻幾乎遭到全面封鎖，不管是中國的或外國的新聞來源都不可靠，各界忙著編故事和造謠生事。雖然艾未未被捕茲事體大，然而在北京舉行「和而不同」座談會時，有一點是很清楚的：諸如「普世價值」等說法跟「和而不同」所帶有的意義大不相同。非常遺憾。

2011 年 4 月，艾未未被捕之時，中國電視委員會的長官正因太多電視連續劇會歹戲拖棚而開始感到憂心忡忡。他們還宣布：「製片和編劇以過於輕挑的態度去對待嚴肅的故事，令我們無法接受。」

2009 年 1 月，艾未未寫道：「我現在想把所有時間都花在搞政治上了。不過，要是他們不讓我這麼做，那可就難囉。所以我得想出好些點子，再不然就是以不同方式來進行藝術創作。在美術館展出藝術作品顯得無趣。」

茲在此感謝松加·強克斯、朱利安娜·羅茲、烏里·希克、娜汀妮·史坦克，當然還有艾未未。

本文中所陳述的意見為本文作者個人意見。2009 年秋，本文作者克里斯·德爾康在慕尼黑藝術之家策劃了艾未未的〈非常遺憾〉一展。因為 2011 年 8 月 12 日艾未未在成都被當地警方毆打頭部造成重傷，使得他一抵達慕尼黑，立即得進行神經外科手術。

---

10. 同註釋 2。

# Exhibiting Art in Museums isn't very interesting [1]

Chris Dercon / Director , Tate Modern Arts Museum , London

'My messages are temporary and shouldn't be a permanent condition. Like the wind they will pass. We will have another wind coming.' [2]

## 1. Ai Weiwei in Taipei

I cannot think of a more suitable place right now to show the work of Ai Weiwei than Taipei.

The internationally published, broadcasted and commented scene, where, immediately after his release on bail on 22 June 2011, the dreary, over-fatigued Ai Weiwei peered through a narrowly opened door and uttered a few words ("I cannot say anything but that I cannot say anything" [3] ) could well stem from a film by Hou Hsiao Hsien or Tsai Ming Liang.

Hou and Tsai, as well as other Taiwanese filmmakers, continuously chart the isolation of their characters and their fumbling attempts to connect, who finally find a sometimes very weird, personal kind of peace. These film heroes are always being confronted with existentialist, life bearing questions such as: 'how to find one's place?' or 'how to find one's identity?'

When thinking of my favourite Taiwanese films such as 'A Brighter Summer Day' by Edward Yang, I am reminded of my first visit to Taipei, when dozens of young art students on motor scooters followed my colleague curators and me through the rainy and damp city of Taipei, yelling: "Mister, have a look at my portfolio!" Were they - unknowingly - expressing a feeling of loss and displacement?

## 2. Ai Weiwei is wearing a T-shirt featuring his own name

Now more than ever, the real-life hero Ai Weiwei is being confronted with the same kind of feelings and questions. Yet, the fact that, a few days after his release , he wears a T-shirt that shows his own name 'Ai Weiwei' in Latin scripture seems to spread a more combative message as well.

By wearing his own T-shirt in front of the international press, Ai Weiwei openly expresses solidarity with the international outcry under the slogan 'Where is Ai Weiwei?', that, right from the beginning, had been surrounding his arrest at the Beijing airport on 3 April 2011. After 81 days of solitary confinement, Ai Weiwei once more stresses the productive difference between his own, private persona and the 'Ai Weiwei' of the public domain. As the German political commentator Mark Siemons states, the name on the T-shirt appears as logo pointing towards the future of the public brand 'Ai Weiwei', in spite of the silence imposed on the private persona Ai Weiwei.

As such, a circle has come around: wasn't Ai Weiwei on his way to Taiwan in order to prepare this exhibition, when he got arrested? By realizing this exhibition - even without the possibility of being physically involved in the installation - Ai Weiwei claims the right to be seen and heard. The exhibition in Taipei echoes and reinforces the production of meaning, triggered by the noted T-shirt Ai Weiwei wore on the morning after his conditional release. What is the condition of this exhibition and in which condition should we

---

1. From an e-mail exchange between Ai Weiwei and the author in January 2009.
2. From a conversation in October 2009 between Ai Weiwei and the author at Haus der Kunst in Munich, Germany.
3. Ai Weiwei's remark to the media on June 23, 2011, his first speech after release from detention.

perceive this presentation of works by Ai Weiwei?

### 3. Ai Weiwei recreates the Zodiac sculptures

On 11 May 2011, I got to speak in the 18th century courtyard of Somerset House in London on the occasion of the opening of Ai Weiwei's gigantic recreation of the so-called Zodiac sculptures. The circle of bronze animal heads once adorned the fountain clock of the old Summer Palace just outside Beijing. In New York, Mayor Bloomberg had opened them a week earlier at Grand Army Plaza, the gateway to Central Park.

The 12 original sculptures, created under the supervision of Italian Jesuits in the mid 18th century, were pillaged when the old Summer Palace was ransacked by French and British troops in 1860. In recent years many official and not so official attempts were made to buy the ones, which could be located, back from their owners. In February 2009, during the Paris auction of the art collection of the couturier Yves Saint Laurent, two of the original sculptures received great public attention. Everybody thought the highest bidder was a rich private collector from Mainland China, but it turned out that he was merely a humble regional auctioneer who backed out when the deal seemed to be done. Later it became clear that the bid was to be considered an act of protest, some say backed or instructed by Chinese officials. When Ai Weiwei heard of the story in the summer of 2009, he mentioned to me that it could make up for an 'interesting' piece. I believe he even used the word 'funny' or did Ai Weiwei use the Chinese word 'dan', meaning blandness? Why would he

consider it so 'funny' to make such a piece? The animal circle, recreated by Ai Weiwei, is indeed full of interesting references: yet, it is neither a parody, nor ironic, and certainly not cynical or an iconoclastic gesture. It is everything at the same time. Besides, the scale of Ai Weiwei's *Circle of Animals* is slightly 'off', embodying the very meaning of the word 'kitsch'. As a western idiom, kitsch is indicating that something is either too 'small' or too 'large' in comparison with its original. Indeed, this animal circle, or animal house, is a house full of contradictions, just like China today. We know by now that Mainland China is not only a contradictory place in terms of its current social and economical order, but also with regards to its own cultural heritage.

Chinese are crazy about their cultural heritage and Chinese things and objects of the past. At the same time though, some Chinese do not seem to mind ruining and destroying their cultural artefacts, ancient and not so ancient, important and not so important. What is the trade off between such contradictory attitudes? There isn't one. Chinese thinking is full of trust: no tragedy, no metaphysics. One reaches out to the future without worrying too much about an ideal. The term 'ideal' does not exist in Chinese. Quite to the contrary, there always seems to be an imbalance. The recreation of the Zodiac sculptures by Ai Weiwei is a perfect illustration of such an imbalance. And aren't these sculptures kind of 'bland', in Chinese 'dan'? In his book 'In Praise of Blandness' the French professor of Chinese philosophy, François Jullien, argues: "The plainness treasured in Chinese aesthetics, even though it seems to be suffused by an 'absence

of flavour', is in fact superior to any particular flavour, as it is open to all potential variations." While slowly developing into a positive quality in Chinese aesthetical and ethical traditions, the phenomenon of 'blandness' embodies a reality whose very essence is change. Yet it is true that that the 'zodiac sculptures' are very much a 'western sculpture' instead of expressing 'nothingness', the 'zodiac heads' are full of allusions to history and concrete events. Ai Weiwei invites us to do both: feeling and thinking and sometimes one more than the other.

### 4. Ai Weiwei is more Chinese than the Chinese

The art of Ai Weiwei demonstrates, how one artistic practice can explore all potential variations and even diverse cultures. In this sense, Ai Weiwei is more Chinese than most contemporary Chinese artists. And he is walking on different paths at the same time. Ai Weiwei's multiple 'walks of life' as well as his confrontational words and actions may seem erratic and disturbing at first. Yet, in fact they are deeply rooted in Chinese philosophical traditions. There were many Ai Weiwei's before in Chinese history.

Ai Weiwei is constantly nurturing 'in-betweenness': in between disciplines, in between the old and the new, in between the original and the reproduction, in between China and the West. In this sense he evokes Chinese traditions, both old and contemporary. Maybe that is the reason, why some Chinese police in Chengdu call him 'professor' rather than 'artist', as heard in the documentary *Disturbing the Peace, or in Chinese, Laoma Tihua* (2009). I wonder how

Chinese police are calling Ai Weiwei since his release.

'Police' is the original old Greek word for 'to protect', not just to 'write laws' or ' to protect the law'. Also, there is the Latin saying 'protego ergo sum': I do protect, so I am able to govern. When a state cannot protect its own citizens, no matter how different they may be from one another, it is incapable to govern. Such a state might have rules, but no laws. It is a lawless state. Thus, what is the status of citizens like Ai Weiwei in China? At the moment, the rules of China forbid telling the world Ai Weiwei's state or status as a citizen.

Ai Weiwei once said: "Art is about life. Our life is entirely political. Therefore all my art is political."[4]

Indeed, Ai Weiwei is a widely acclaimed artist, an innovative designer, an influential architect, a visionary urbanist, an educated cultural historian, a competitive cook, and even a great hairdresser. But at the same time, he is a compelling and disputatious writer, as expressed in the recent publication: Ai Weiwei's Blog: Writings, Interviews, Digital Rants, 2006-2009'. Ai Weiwei knows how to address and to rally a wide audience through means of social and other media. He is a manager of chance, voicing his own dissatisfaction, as well as that of his fellow countrymen at being confronted on a daily basis with the alarming glibness and harshness of a rampant Chinese society. After being taken into custody and released conditionally, Ai Weiwei is at mercy of the same society. Some call him a strong activist but a weak artist, some the other way around.

Ai Weiwei's early photographs of exilants, politics and riots in New York, dating back to 1983-1993, his sojourn in Manhattan's East Village, as well as his more recent works like 'Sunflower Seeds', on view at the Turbine Hall of Tate Modern in London in the autumn of 2010, now have an even stronger meaning. They are pieces of a life-sized puzzle or arrested moments in time and in the lifetime of an artist who cannot differentiate between his art and his life. Ai Weiwei: "Seeds grow. Tweets reverberate. The crowds will have its way, eventually."[5] Indeed, we are only just beginning to understand the life and the art of Ai Weiwei.

## 5. Ai Weiwei loves Marcel Duchamp

Ai Weiwei claims as his biggest influence the French American artist Marcel Duchamp (1887-1968) and his concept of the ready-made, which purports that anything can be turned into an object of art if the artist decides to do so. But Duchamp also believed that enough 'art' had been produced by artists, why he 'stopped' making art as we know it. As Ai Weiwei noted: "What Duchamp achieves is enlightenment in the moment, since for him art is a part of life."[6]

Many of today's important Chinese cultural figures can be seen in Ai Weiwei's early New York photographs: the film director Chen Kaige, the poet Bei Dao, the composer Tan Dun, the artist Xu Bing. Even more revealing are the self-portraits of Weiwei in the Museum of Modern Art next to objects by Marcel Duchamp, as if he wanted to greet his father, the famous poet Ai Qing, who wrote: 'in the museum of modern art/ steel sculptures/ electric canvasses/ create an uncanny mirage/ all kinds of eerie notions/ all embodied here/ the epitome of materialism/ some will enter the halls of heaven/ some will drop into the pits of hell' ('New York', 17 November 1980). Ai Qing and his extensive circle of friends and artists became a great influence and a resource for Ai Weiwei. The painter Shao Fan, born in Beijing in 1964, is the son of one his parent's artistic friends and Weiwei's childhood neighbour. Fan is internationally known for his 'reconstructive furniture', about which Ai Weiwei wrote one of his earliest known art critiques.

Still, Ai Weiwei firmly states, that if he had a role model, it was Marcel Duchamp. In New York, the desire 'to follow Duchamp' was expressed in rather formal citations: Ai Weiwei bent a cloth-hanger into the shape of Duchamp's profile, partially filled with sunflower seeds. In 1986, he noted: "If a person can walk into MoMA and not feel ashamed, it can only mean either that his senses are compromised or his morality is waning."[7] Ten years later, on May 23, 2006, Ai Weiwei turned the visit of a collector's group associated with the Museum of Modern Art in New York to his studio in Caochangdi into a playful art happening by recording it with surveillance cameras. The resulting five videos, each fifty minutes long, show the visit simultaneously from five different angles. Only a few years later, the same kind of surveillance cameras, this time installed and directed by the local police, would ceaselessly register all of Ai Weiwei's movements and actions.

4. Ai Weiwei mentioned this on many occasions, and the author heard it for the first time in January 2009.
5. From a conversation in October 2009 between Ai Weiwei and the author at Haus der Kunst in Munich, Germany.
6. Ai Weiwei's artist statement on his video work about New York's MoMA, for Haus der Kunst in Munich, Germany.

## 6. Ai Weiwei is his own ready made

When his father fell ill in 1993, Ai Weiwei returned to Beijing from New York. By then, he boldly stated: "I am my own ready made"[7], a belief he still clearly manifests through branding his name. By developing a new element, namely the 'ancient ready made', Weiwei introduces a variation to his Duchampian strategies, not unlike the almost atavistic assemblages of Robert Rauschenberg or the 'minus objects' of Michelangelo Pistoletto. In order to create something new, Ai Weiwei recycles, displaces, manipulates, and sometimes even destroys old traditional furniture or ancient vessels. Criticizing the sell-out of culture he at the same time redefines cultural heritage and even politics of preservation. Ai Weiwei: "People can still recognize them (as artefacts), and for that reason they also value them, because they move from the traditional antique museum into a contemporary art environment, and they appear in auctions or as some kind of collector's item."[8]

Ai Weiwei realizes his ideas from within a team operating under the trade name 'Fake Design' and producing works in a factory-like manner. 'Fake' is a notorious term, which often appears in negotiations about industry and commerce between China and the West. At the same time, 'fake' pronounced in Chinese pinyin resembles the English word 'fuck', a profanity featured in several of Ai Weiwei's art works like the earliest 'Study of Perspective'. Likewise, the expression 'Sorry' has undergone a change in meaning: when governments, companies or financial corporations in China as well as the rest of the world simply apologize in an effort to make up for tragedies or wrongdoings sorry more than often stands for 'fuck off'. Consequently, Ai Weiwei's first large retrospective in 2009 at the Haus der Kunst in Munich was entitled 'so sorry'.

The team of 'Fake Design' is composed of different specialists amongst them excellent carpenters, adept in ancient traditions. Still, often Ai Weiwei has to outsource projects like the production of ceramic and porcelain art works. The millions of sunflower seeds apparently identical but actually unique were produced at the workshop of Liu Weiwei in Jingdezhen.

In some of his art works, Ai Weiwei plays with or 'fakes' contemporary western art. At the same time, he deals with Chinese culture and its capacity to absorb the 'outside' without giving up its own traditions. As a result, Ai Weiwei's works sometimes look plain to western eyes. But it is exactly this plainness or blandness, the 'absence of flavour', which catches our attention. 'Blandness', according to François Jullien, is a form of interiorized distancing and upon achieving such a detachment one is able to liberate one self from individual preferences like 'taste'.

The sheer amount of material and reproductions embodies another important aspect of Ai Weiwei's work: repetition, copying and mass production are deeply rooted in Chinese thought, technical tradition and cultural history. Furthermore, Ai Weiwei had the impression that he became more enthused by working in such way, because, as he says: "I am putting less effort in personally producing the works, since the result of working with others executing the works always means there is a kind of surprise, as well as a form of collective wisdom at work."[9]

## 7. Ai Weiwei and the infrathin

Upon his return in 1993, Ai Weiwei took up an active role in shaping Beijing's experimental art scene. With colleagues and friends, he set up one of the first alternative art spaces in Beijing and began publishing. The 'Black Cover Book' (1994), the 'White Cover Book' (1995) and the 'Grey Cover Book' (1997) read like manifestos for a new radical art. They are reminiscent of Richard Hamilton's 'book art'. Hamilton also is an avid admirer, friend and commentator of Marcel Duchamp, which is why he dedicated his 'green book' to him in 1960.

In 2000, Ai Weiwei co-curated the controversial exhibition 'fuck off' in Shanghai, conceived as an alternative to the official Shanghai Biennial. In Chinese, the title was translated as 'Ways of In-cooperation'. After a few days the police closed down the exhibition. At the same time, the Chinese government started to appease the country's numerous, by then critically and financially successful, contemporary artists in an effort to control their activities and to 'soften' their power. Curating and co-curating exhibitions and projects seems an important way for Ai Weiwei to keep his independent artistic position: in 2011, he co-curated the exhibition 'Shanshui' with Peter Fischer and Uli Sigg, recently on view in the Kunstmuseum Luzern, Switzerland, as well as the section 'unnamed design' with Brendan McGetrick at the occasion of the Gwangju De-

---

7. From a conversation in October 2009 between Ai Weiwei and the author at Haus der Kunst in Munich, Germany.
8. From a conversation in October 2009 between Ai Weiwei and the author at Haus der Kunst in Munich, Germany.
9. From a conversation in October 2009 between Ai Weiwei and the author at Haus der Kunst in Munich, Germany.

sign Bienniale 2011 in Gwangju, South Korea. These exhibitions illustrate well the widely varied but timely themes of Ai Weiwei: from a reinforced interest in tradition and craft to the changing definition of design. In Gwangju the curators reckon even the organization of political protest as a new chapter in the development of international design while in Lucerne ancient Chinese ink drawings adorn the walls of the galleries.

Again, Marcel Duchamp's artistic strategies peer through: after the New York years, where Ai Weiwei and his friends kept themselves afloat with odd temporary jobs, he soon figured out that "after Duchamp, to be an artist is more like an attitude, it is a way of being and working and a way to perceive things. To be an artist, does not in the first place mean to produce works of art."[10]

Still, there is much more of Duchamp at work in Ai Weiwei's oeuvre and thinking than he likes to admit. One of the most remarkable Duchampian concepts is the 'inframince' or 'infratin', his term for the almost imperceptible difference between two seemingly identical items. It is clearly tangible in many of Weiwei's works, for instance in the 'Coloured Vases' (2006-2008) or 'Rooted Upon' (2009). This kind of 'image-politics' make Duchamp attractive to many non-western contemporary artists like Cildo Mereilles or Gabriel Orozco. Their 'image strategies' show interesting parallels to Ai Weiwei's 'image tactics'. Following Duchamp, 'inframince' or 'infrathin' cannot be clearly defined, one can only give examples. Generally, the phenomenon is characterized by an almost unnoticeable thickness, like a thin layering, and at the same time a separation of layers. In a photograph entitled 'dust breeding', Man Ray focused on the dust accumulated on Duchamp's 'large glass'. Thus, he changed the perspective of the art work by imposing another layer, while keeping the original untouched. 'Inframince' or 'infrathin' is an interval or a distance, which can barely be physically perceived but readily be imagined. The same goes for some of the furniture, like 'Map of China' (2004), where the term 'fractal' seems to be justifiable, which the mathematician Benoit Mandelbrot coined in 1975 to denote an object of which the mathematical dimension is greater than its topological dimension, thus meaning that an apparent disorder has an underlying order.

## 8. Epilogue

During the symposium 'harmonious differences', held at the CAFA Art Museum in Beijing from 28 April to 1 May 2010 the attending 'who is who' of Chinese contemporary art explored modes of teaching experimental art in China. In a number of conversations with artists and critics it became clear that amongst the participants was remarkable acceptance of Ai Weiwei's arrest on 3 April. Mao's adage 'kill a chicken, scare the monkey' was used to describe the tactic of stating an example on Weiwei and sending a clear signal to everyone else. Only a few younger artists expressed disappointment at the failure of the Chinese art world to show solidarity with Ai Weiwei's fate. Some even accused him of being a troublemaker, who had lost interest in art but who put the artist's community as a whole at risk with publicity seeking ('selfish') political stunts. While everyone was well informed by the foreign media coverage, there was an almost overall consensus that neither Chinese nor foreign news sources could be trusted and that all sides were engaged in spinning stories and rumours. Significantly, though, it was clear that at the symposium in Beijing, terms like 'universal values' don't bear the same meaning as 'harmonious differences'. So sorry.

In April 2011, at the time of Weiwei's arrest, the committee of Chinese TV directors became worried that too many TV series were toying with the idea of time travelling. They published the following: 'Producers and scriptwriters treat serious stories in a way too frivolous manner which we cannot support.'

In January 2009 Ai Weiwei wrote: "I want to spend all my time on politics now. However, if they stop me it will be difficult. So I need to come up with some ideas, or do art in a different way. Exhibiting art in museums isn't very interesting."

I want to thank: Sonja Junkers, Julienne Lorz, Uli Sigg, Nadine Stenke and of course Ai Weiwei.

The opinions expressed in this essay are the personal opinions of the author. In the autumn of 2009, Chris Dercon curated the exhibition 'So Sorry' of Ai Weiwei at the Haus der Kunst in Munich. Immediately after his arrival in Munich, Ai Weiwei had to undergo neurological surgery due to a severe head injury caused by local police in Chengdu on 12 August 2011.

---

10. From a conversation in October 2009 between Ai Weiwei and the author at Haus der Kunst in Munich, Germany.

# 童話機器，未來人民

陳泰松

不是去預設人民的存在並對他們講話，而是
去發明他們[1]。

德勒茲

## 自由之命

人民，被呼喚，但以什麼名義？

且不論是誰站在前面或高台上，對他們說了什麼又
如何說，有一個源初的場景是值得我們履勘再三
的；這不是什麼特定的地點，而是一個古希臘詞彙
archein，它出現於荷馬的史詩《伊里亞德》，原義
是：創始，像是走在前頭，走在眾人前面的帶頭行
動。archein 具有跨文化的人類學義涵，不為西方
文化所獨有，更是漢娜鄂蘭（Hannah Arendt）形
塑其政治哲學及其行動理論的基石。在其論說裏，
archein 跟自由有關，因為若沒有自由之身，人是無
法創始某事。漢娜鄂蘭以康德（Kant）的哲學語彙
"自發性"（Spontaneität）來闡發此字的自由內涵，
它意指：「每個人能引發一系列事件、打造新事的
能力」[2]。更精確地說，即使人的自由受到極權體制的
打壓，自發性遭到其制度性的扼殺，這個理念的重要
性不在於問你是否活於自由之中，而在於先行肯認自
己先天上就註定是自由的，具有創始、啓動某事的能
力，並勇於承擔行動的後果。自由，就是人給自己的
至上命令，借用柄谷行人對康德的詮釋，命令自己是
「作為一個自由的主體」[3]，或以沙特的存在主義語彙
來說，像是「處以自由的刑責」[4]。

## 個體維度

為何要談這？理由是：在中國當前資本經濟的後極權
社會裏，艾未未以其藝術創作無畏地為人們展示這種
可貴的行為與情操，且更走入社會實踐，帶出某種
未來性的文化政治願景，2007 年受邀參加第十二屆
德國卡塞爾文件展的《童話》便可被視為一個徵兆
（sign）。

在此作裏，艾未未變成一位組織人，以將近半年多繁
雜的前置作業，從網路徵求住在中國的志願者，挑
選其中 1001 位中國人全程免費到德國卡塞爾當地旅
遊、參觀文件展一個月，並訂下兩條規則：1. 人不離
開卡塞爾，都是來參加文件展的"作品"；2. 必須按
原計劃回國；除此之外，沒有制定行程，一切行動自
由，不須集會與公關應酬，艾未未在期間也沒有召集
他們進行講話，直到離開那天要求大家合影留念，如
此而已。顯然地，《童話》呈現某種集合概念，除了
人的部份，物件在規模上令人印象深刻，諸如擺在展
場各處的中式座椅，以及為這些旅客臨時搭建大型集
合式的個人床鋪——雖然允許自由外宿，但住宿空間
無疑成了作品結構之一。其實，這種概念普遍出現在
其諸多作品之中，盡管程度不一但都意有所指，例如
Whitewash（1993-2000）、《石斧》（1993-2000）、
《永久自行車》（2003）、《彩罐》（2006）、《葡萄》
（2011）以及最近展於英國泰德美術館輪機房大廳的
《葵花籽》（2010-2011）等作，不勝枚舉。

不過，《童話》更聚焦於人本身，是對人的動員與組
織工作。有意思的是，艾未未非常強調此作是針對個
體的「生存經驗與覺悟」，要凸顯的是「個人經驗、
個人身份與個人想像」[5]不可取代的存在價值，並以
其所謂 "1=1001" 的方程式來加以表示[6]。這是個體
與集體的等價式，在此當中，每個個體都是唯一的，
獨特的，是不可替代或無法代碼化的生命存在；他提
到《童話》是「為 1001 中的每一個人準備的，而不
是說 1001 個人在為這個作品準備」[7]。對此，我們何
嘗不可把 "1000" 解讀為集體的代表，而多出來的
"1" 則是指個體，指向集體中的每個人，包括艾未未
自己本人——正如他為他們拍照立像，同時也成就他
自身，使自己為人知曉。換句話，"1001" 意味著個
體的「唯一性」，是集體中一個無法被統整的個體，

1. Gille Deleuze，Cinéma, tome 2. L'Image-temps，Editions de Minuit 出版，1985，Paris，p.283。
2. 漢娜鄂蘭，《政治的承諾》（The Promise of Politics），蔡佩君 / 譯，左岸文化，2010 年，台北，頁 159。
3. 柄谷行人，《倫理 21》，林暉鈞 / 譯，心靈工坊，2011，台北，頁 84。
4. Jean-Paul Satre，《存在與虛無》（L'être et le néant），Ed Gallimard，1943，巴黎,p.598。參見陳宣良等譯，新知三聯書店，
   2007 年，北京。
5. 《此時此地－艾未未》（Time and Place　Ai Weiwei），廣西師範大學出版社，2010 年，頁 92。
6. 同（註5）。
7. 〈關於《童話》和做藝術—艾未未、鄒操訪談之一〉，仙人筆翻譯坊，網址：http://www.china-texttransfer.de/de/node/106。

《童話》(Fairytale)，2007
1001 個中國參觀者，德國第 12 屆卡塞爾文件展
1001 Chinese visitors, Documenta XII, Kassel, Germany

在象徵層上無法被收編、或將其耗盡與消化掉的多餘。

那麼，個體如此被強調，集體動員的理由何在？

## 集體診治

首先，絕非因中國人口眾多，而是若非集體／極權文化政治如惡靈籠罩著當代中國，艾未未是無須把人數做大，只要邀請少數或兩三個人就行了，且大可把人安排住在旅館，不必大費周章為他們搭建臨時住所，蓋出像是營房或疫區救護所，以規格化的床位集中管理，並供應大夥伙食。我想說的是，我們不應陷入某些西方藝評的刻板觀點，把《童話》簡化為資本奇觀、民族再現或中國崛起等諸多象徵的聯想[8]，因為這是一項細膩的心理操作（psychic operation），某種易地而處的聚眾治療，其"處方籤"正是：「各行其是」[9]的體悟。這是邀請從團體中走出自我的自我診療，也是從相信到承擔《童話》這件鮮事的個人之旅，總之是從集體的意識狀態中走脫，反身關注自我的旅程。艾未未說《童話》固然引導一個人去認識另一個人（卡塞爾文獻展），一種「保證見面的可能性」[10]，但他認為此作更具關鍵意義的內容是針對「每一個人而做的」[11]。當然，《童話》的參與者必然會侷限在包括藝術展演在內等諸多框架之中，但這樣並不表示不自由，反而是從決定加入那一刻就等於是自由的展現。就以康德（Kant）的基進倫理來說，自由首先就關係到做出決定而導致一個嶄新的事件系列，能負起「自己為因」的倫理責任[12]。換句話，不是從自然因果律（在此，任何人都是不自由的）來問人有沒有自由，而是在於先行把自己規定為一個「自由的主體」，並把這個規定當作是「至上命令」來加以承擔，義無反顧地負起自己決定事項、創始某事的後果。

追根究柢，《童話》是誘發主體、敞開自由契機的平台，或如艾未未所謂「提供一個架構和體系，生命、機器或動物」[13]。這些睿智與饒富詩意組合的概念項似乎不期然地暗合了德勒茲（Gilles Deleuze）的機器論。要知道，在德勒茲那裏，機器（machine）跟國家機制無涉。他不是在談國家為了控管社會、宰制人民而進行意識型態的生產與運作，因而不可以跟阿圖塞（Louis Althusser）所說的「國家機構」（state apparatus）[14]混為一談。那它又是指什麼呢？首先，機器在此首先是從藝術創作來開始進行理解的，尤其是指它的運作方式。德勒茲藉以要強調的是：意義不是預設的、被隱藏起來的內容，而是用法問題，因為它屬於生產性，是反邏各斯（anti-logos），一切得看作品如何運轉（marcher/work），猶如零件如何運作而定。據此，若想把作品意義視為真理，這個真理則是機器所生產出來的，是諸多真理中的一個，因而這機器是運作在我們身上的機器，而它生產的真理則是「萃取自我們的感知印象，是挖掘自我們的生命，並交付給作品」[15]。

## 零件與人

就在這裏，一個比《童話》讓人更易理解機器概念的是艾未未的《碎片》（2005）。這是零件與人的問題，"與"字在此有雙重含義，既是這兩者的締結，也是把零件交給人的給付。

8. 中國藝評家朱其也有如此觀點，參見 2007 年 04 月 30 日《廣州日報》〈對話艾未未:<童話>到底是一場什麼樣的遊戲？〉採訪文。
9. 「各行其是」是艾未未引述該屆卡塞爾文件展策展人 Noack Ruth 對《童話》的評語。見（註 7）。
10. 同（註 7）。
11. 同（註 7）。
12. 柄谷行人，《倫理 21》，頁 100。
13. 參見艾未未發表在 Youtube 網站的影片《童話》（上）－ 7，網址：http://www.youtube.com/watch?v=SMY1n8wiVjw&feature=related。
14. 通行的台譯是 "國家機器"，為了區分德勒茲的機器概念，在此改譯為 "國家機構"。
15. Proust et les signes, Gilles Deleuze, Presses Univeritaires de France 出版，1998，Paris，p.176。

正如艾未未對該作的描述，作品元素之一的木料是來自三、四座不同古廟被拆除後殘存的梁柱，在沒有特定的製作指示與預設的美學要求下邀請八位木匠把它們連接起來；他告訴我們，《碎片》不是他的創意，而是木匠在沒有他的干預下獨立工作半年的團體成果。外表看來，它像是一種隨興的、失去古典建築構件邏輯的東拼西湊，但實際上自有一套衍生的規則，屬於木匠們的臨機應變、經過彼此對話而形成的組裝。這是碎片的結構物，裝配著殘碎的歷史符碼，像是跳在歷史殘骸上的舞蹈。再者，在木匠的構思裏，《碎片》從高處往下看，便可得出梁柱所在的點所形成的中國地圖。不過，這個形象不能被單方解讀為完美的再現物，國族理念的邏各斯，反而應以立面（facade）來作整體觀照，也就是說，這殘骸之舞不僅形諸於建築殘片，也形諸它的歷史與倫理體系，甚至領土疆界，而艾未未在 2004 年的《中國地圖》也應如此作解：換句話，這是國族疆界／殭屍之物的諷喻。

即使《碎片》沒有真的動起來，沒有發出機械性 "喀喀" 的接榫摩擦聲，其型態本身便足以激發這層感受的想像了，至於零件與木匠在過程中的締結則是它的實質運作。《碎片》十足是一種機器，微型社會的抽象機器：人在其中是零件的操作者，反過來也成了零件狀態。先就零件來說，這是解構正統歷史敘事的碎片，有如 1995 年的《失手》，是藝術家本人對此的現身說法。當然，《失手》絕非失手，而是毫不手軟的放手，是碎片的宣示，並對以下兩者進行了交叉比對的挑釁：一是當代中國對歷史拜物化的情結，另是 60 年代文革時期毀文物的盲動。至於《碎片》，它反映了當前的中國文化狀態，但同時也點出它的未來可能性；也就是說，唯有坦然承擔這個廢墟，一切才有重獲新生的可能。《碎片》不復原，而是給人去實驗組合，給出互為主體的場域，人與零件在此構成一種換喻，也構成一種鑄合：如同每個木料的獨特性，《碎片》引導操作它的人也必須成就自身存在的獨特性，而木料元素的獨特連結，更給出一種寓意人際的重新

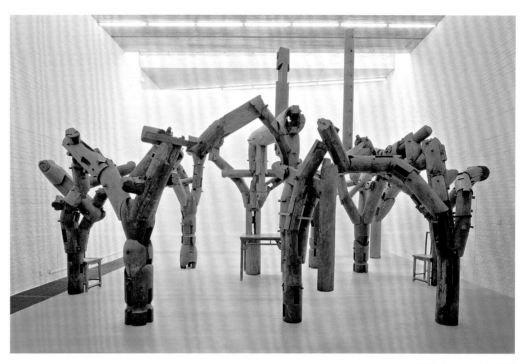

《碎片》(Fragments)，2005
拆解自清朝 (1644-1911) 寺廟的鐵力木、桌椅、部分樑柱
Ironwood tables, chairs, and some parts of beams dismantled
from a temple of Qing dynasty (1644-1911)

連結與社會的再發明。無疑地，這也是《失手》的弦外之音：一方面宣示自由，另一方面去承擔這個自由。

## 此 1 非一

在此意義上，《碎片》可說是一間讓人思考廢墟的工作坊，亦如《童話》之於診療所。那麼，著眼於兩者在邏輯上的呼應，有一個稱之為「此 1 非一」的命題可恰如其分地用來描述艾未未的藝術理念。
再次回到代表個體的 "1"。這是數字 1，是註定自由的個體，必須加以承擔的命數，也是艾未未所追求的理念：「個人極大的自由」——其中包括生存、個人

發展、資訊獲取與表達的權利等等[16]。這裏必須談他從 2008 年開始有計畫地推動的 "公民調查" 志願者活動，從關切維權人士遭受公安霸凌到官方掩蓋事件真相，並將錄像上網流通，獲得廣大迴響，如《花臉巴兒》(2008)、《一個孤僻的人》(2010)、《老媽蹄花》(2009) 以及《花好月圓》(2010) 等。這些屬於藝術行動者（artivist）[17] 的操作是試圖穿透國家機構「凝固體」的機器，以 2008 年的「川震」為例，艾未未以個人名義進行調查，在備受干擾與打壓的情況下公佈官方亟欲隱匿的龐大受難者身份，推出《花臉巴兒》的調查影片，並以裝置手法在 2009 年展於德國慕尼黑「藝術之家」(Haus der Kunst)。此作雖名為

16.〈艾未未談《花好月圓》〉，見《誰怕艾未未：影行者的到來》，徐明翰編，八旗文化，2011，台北，頁 62。

17.「藝術行動者」(artivist) 是個新詞，是行動者 (activist) 與藝術家 (artist) 兩種身份的結合，也是社會活動與藝術學科兩個概念的合一，或如〈艾未未談《花臉巴兒》〉該文所說的「社會活動家」，參見《誰怕艾未未：影行者的到來》，頁 36。

Remembering，但實為控訴官方為了政權「維穩」而藐視公民權的行徑，更值得注意的是訴諸個體名義的展牆標語；這是以學生書包排成的句子，一位百感交集的母親悼念其死去孩子的話：「她在這個世界上開心地生活過七年」。

Remembering 就是一部人民機器，諸眾的悼詞在此被轉寫為聲明，一種政治性的抵抗，因為它公開了中國官方亟欲隱匿的死者尊容，泯除其名所承載的社會身份與社群記憶；這是將人民給家政化（domesticated）與黨國化的生命治理，使其成了統治者的禁臠。於是，「此 1 非一」便是指：拒絕「一」的 "1"，拒絕姿態專橫的「一」。這是個體對極權、集體與大一統理念的抵制，抵制邏各斯的「一」，"定於一" 與 "以一為尊" 所代表的理型「一」，並可將這種抵制溯及體現中國帝制思想及其共構的政治哲學[18]。

據此，「此 1 非一」便帶有兩層寓意：一，抵抗極權國家的宰制諸眾，就《碎片》來看，它雖有結構，內涵卻是以碎片／零件／個體為論，是連結中的獨特個體，靈活機變的個體及其自由的聯繫，因而不是復原為「一」的復辟，邁向集體思維、國族象徵的重建：一座廟宇或宗廟之國族神器的所在。二，解除個體 "1" 在創始行動中有可能質變為「一」的獨夫、寡人或寡頭（oligarchy）[19]，我們可以把《碎片》、《童話》與《葵花籽》等作視為這種解除的美學表述。

## 匠人與諸眾

於是，我們不應把艾未未這個作者等價於那種「一」，或如某些網民因忌恨或因官方意識形態的反動操作而把它跟寡頭混為一談。簡單地講，政客統治，但藝術人表達，不統治，且事實上也跟統治無關——否則，那不是藝術人的本義。例如，《童話》不統治，《葵花籽》也是。

就以《葵花籽》為例，其錄像告訴我們，艾未未委託景德鎮鎮民在兩年期間以古法生產了一億多顆的葵花籽，創造該鎮自古以來肩負皇家陶瓷生產之外、宛若童話的一頁當代傳奇。對此，黃建宏最近對艾未未整體創作進行有趣的評論，文中援引桑內特（Richard Sennett）的「匠人精神」，提出「智識平權」與「匠人」[20]為切入點，值得再討論。黃先以西方現代藝術史為脈絡，指出藝術家與匠人在其中的認同斷裂，而艾未未在此是透過生產的再分配將它們重新揉合起來。黃說，《葵花籽》在於凸顯這種揉合在作品中的「本體論意義」，而作品的奇觀物質性便是這種意義的完成所在，解決了藝術家與匠人各執一端的「懸置性」。不過，這種揉合在黃眼中並沒有修得正果，因為艾未未固然沒有役使匠人，且還讓匠人進入作品意義的構成，「但他隨即又將匠人的作為弔詭地象徵化」，也就是說，匠人工藝遭到匿名化，形同失去個體性而異化為「資本數字」（一千六百名陶工），結果是充當空間裝置的美學修辭，喚起奇觀式的崇高感，結論是：我們看到了不斷擴張的藝術家個體與「公民之名」，而這兩者「順應消費市場的動力將『匠人』與其匠人之名越拉越遠」[21]。

依黃之見，《葵花籽》的量化操作帶來質變的弔詭，使匠人諸眾（multitude）的個體性被抽象化為匿名者。這項細微的觀察不無道理，觸及當今資本體制下藝術創作者——特別是文化行動的藝術人——在美學上的倫理賭注：贏得自我，還是成就他人，或兼而有之，社會成效之有無？只要有作者意識，這裏幾乎就沒有純粹的界定，或絲毫不帶有一點自我對文化資本的累積欲望。其實，問題的真正所在是遊戲規則如何制定，一種維根斯坦式的倫理構成；也就是說，除了至上命令的自由，倫理不是通識或先天規定的條例，而是施行性的（performatif），經過彼此協商與相互約定而產生，譬如說，我們應考察的是陶瓷匠在此計畫中有無作者權的要求，藝術家跟他們的契約為何，有何生產與社群關係，甚至彼此的情感臍帶等等。據

此，我們進入康德的自由理論的第二層：除了以至上命令的方式把自己視為自由的主體，我們「不只把他人視為手段，同時也要把他人當作目的來對待」[22]。同樣地，這個命題也應以維根斯坦的方式來加以延伸，也就是說，「把他人當作目的來對待」的倫理性不能單憑倫常、或自己對他人一廂情願的認定，而是基於雙方彼此的約定；如同遊戲規則的制定，這是雙方對所謂「目的」的開放討論以及種種發明。

艾未未始終強調《葵花籽》的諸眾在個體上的啟示[23]，為了掌握這個面向，藝術家／匠人的二元象徵結構是須要反覆剖析的。再者，藝術家與工匠的認同

《葵花籽》(Sunflower Seeds)，2010
陶瓷與釉料，一億顆
porcelain, paint, one hundred million sunflower seeds
英國倫敦泰特現代美術館，Tate Modern, London, UK

18. "定於一" 語出《孟子》〈梁惠王篇〉，或參見司馬遷《史記．秦始皇本紀》，「今皇帝並有天下，別黑白而定一尊」。
19. 寡頭是指少數統治，作為一種政府形態，其權力操控在少數人之手，或國家由少數人所統治，是少數人以私欲為目的之統治。
20. 黃建宏，〈Cos 星際大戰天行者的艾未未〉，見《誰怕艾未未：影行者的到來》，頁 142-143。
21. 同（註 20）。
22.《道德形而上學原理》，康得著，苗力田譯，上海人民出版社，1988，上海，頁 80-81。
23.〈艾未未與一億葵花籽〉，丁燕燕撰寫與訪問。在該文中，艾未未談到他喜愛的 Twitter，像是「汪洋大海中無數的意念和交流訊息，而這些全部來自個人」，並相信「一種由個人組成的巨大力量」，網址：http://thedreamhunter.blogspot.com/2011/01/blog-post.html

斷裂是起自西方文藝復興的署名姿勢，歷經 19、20 世紀之交現代藝術的技術變革。如林志明指出的，杜象（Marcel Duchamp）的「現成物」（readymade）給出藝術「智性化」的關鍵姿態：將「形式塑造」（mise en forme）轉變為藝術語言（langage artistique）」。這裏有一個看法，杜象固然聲稱要廢除製作（faire/make），想除去「藝術中所有工匠成份」，但實情是「把實行的邏輯帶回到製作的邏輯」當中，像是回溯歷史去「質疑希臘文明對『製作』（poiesis）與『實行』（praxis）的區別」[24]。依此看來，根據桑內特對「匠人」的擴大定義與當代版的基進化，杜象也可歷史性地被視為某種概念勞動的「匠人」，而艾未未本人亦何嘗不可。

或許，匠人的主體化才是《葵花籽》的旨趣所在。

這是主體化的分派，也是《葵花籽》機器所執行的分派，試圖誘導匠人諸眾在生活敘事上不可預期的主體化。這是多樣態的、在各種不同脈絡下的複元主體化；例如《童話》，曾有參與者在這段期間發生異國戀情、生活轉折、生命或感受的重大體悟，或其他為人不知的諸領域，而這一切有時比艾未未所擁有的作者身份還來得更有意義，更有價值；也就是說，主體化不一定以作者權為依歸，除非我們認定非得把任何感知操作都打上文化資本及其所有權的印記，一切非得歸結於這個體系的生產、流通與累積不可。事實上，商品生產關係的階級與政治性未必全然適用於某些有如團契（communion）的藝術場域，而主體化是否如黃語評此作「在資本主義架構中解放出複數的個體名字是一種最為根本的挑戰」則是在未定之天，得視案例的規則情況而定，反倒是個體之間的位階及其政治性可能才是其關鍵所在。

### 帶頭之議

當然，確如黃的顧慮，《葵花籽》亦如《童話》，給出一個數量龐大的強力象徵，大有凌駕個體之虞；但若不把它的紀錄片當成附件，我們當可理解艾未未正是藉由葵花籽的團體製作，構思著把人從集體走出個體的可行性，並由此預想個人的社會性——而《童話》藉助的是出遊。這不是孤絕的個體，而是自由的個體，由此要求形成自主性的社會[25]。於是，縱使象徵物的奇觀使這兩件作品在個體解放的訴求上顯得有些隱遁，但只要跟上艾未未訴諸直接行動的「公民調查」的腳步，我們便可豁然明瞭，或如他的自我陳述：

> 我的政治立場，如果有的話，是個人化的，
> 反權力的，反對由於某種利益而形成的價值
> 標準[26]。

不可諱言，艾未未是首要的個體，但是有條件的，是因藝術計劃的成案才得以存在，並得以召集他的諸眾個體。那麼，回到本文開頭的 archein，這裏出現一個關連它又有所差別的古希臘字 prattein，意指：尋求夥伴的協同實現，貫徹已經創始的事，是共同把事情做到終了的執行[27]——而這些人是投入「集會廣場」（agora）的平等者。就漢娜鄂蘭看來，archein 與 prattein 兩者的緊繫，締造了古希臘城邦政治的民主時刻，其衰敗則源自這兩者關係的斷裂，使 archein 變質為統治權與發號施令，prattein 則淪為臣民的勞役，承接命令的役使[28]。

這兩種概念可用來檢視艾未未藝術創作的美學政治性。首先，面對中國社會的禁聲犬儒，我們理應對艾未未勇於帶頭批判的行動給予毫無保留的支持與肯定。這是在黨國體制與資本主義交媾下，無懼於創始某事，並勇於承擔這個行動帶出一系列諸事件的後果，並由此反證了自己的自由，一種在康德哲學定義下的自由。不僅如此，艾未未的 archein 正體現了 prattein 的夥同理念，不用說他推動與身體力行的「公民調查」志願者活動，在《童話》裏，他便從一

種創建者變成從旁協助者，是投身於處理日常事務與服務工作的辦公室負責人[29]，或側身於觀察人事運作的諮詢者，如《碎片》等作。

不過，對於漢娜鄂蘭的論點，當代法國學者洪席耶（Jacques Rancière）的異議值得一提，他認為 archein 必然擺脫不了優越者治理或施力於低下者的邏輯假定[30]。難道洪席耶棄絕行動的率先起義？想必不是，而漢娜鄂蘭也理當不是站在精英、優勢社群的平等者所把持的治理那邊。其實，前者談的指揮或發號施令是變質的 archein，是跟 prattein 失去聯繫的 archein，不是漢娜鄂蘭所指的情況；但反過來說，她似乎沒有提出什麼機制能確保 archein 與 prattein 的必然聯繫，以致於不能排除有 "帶頭者拿走一切" 的獨占，因而洪席耶的論點應被反覆思量，他說：

> 人民（démos）只因領導（arkhè，archein
> 的動詞）邏輯的斷裂才存在，這是開端／
> 支　配（beginning/ruling）[commencement/
> commandement] 邏輯的斷裂。他們不該被視
> 為一個以相同開端與出身作為互認彼此的種
> 族，也不該被認為是人口的一部份，甚至是
> 部份的總加。人民是額外者，是自整體人口
> 中分離出來，並中止被合法化的宰制邏輯[31]。

或許，有一趟在政治理論上的論證須來回穿梭，去捕捉 arkhè 在諸眾迷霧中引領解放及其可能逆轉的弔詭時機。幸好，藝術不眈溺於 arkhè，除非它甘為政治所用，淪為政治宣傳的工具，而這正是艾未未身為《鳥巢》設計團隊的一員，拒絕參加 2008 年中國京奧開幕式的嚴正理由[32]。在他這邊，藝術是個動詞，是出入諸眾的迴旋流動，它將實行（praxis）納入到製作（poiesis）之中，更是在製作中體現人之 archein 的協同實現（prattein）。那麼，這人是誰？

### 發明人民

24. 林志明，〈藝術家／工匠區別與中西藝評旨趣〉（下），《當代》118 期，1996，台北，p.44-45。關於 praxis 的複雜語意，我暫且更譯為 "實行"。
25. 艾未未便如此說：「只有通過藝術的個人化才能完成它的真正的社會功能，這也是我傾向於杜象和安迪沃霍的一個原因」。參見〈關於《童話》和做藝術─艾未未、鄒操訪談之一〉。
26. 《此時此地─艾未未》，頁 95。
27. Hannah Arendt ,The Human Condition，p.189。
28. 同（註 26）。
29. 參見〈解析艾未未的《童話》：只為 1001 個 "卡塞爾經歷"〉，華商網，華商報，2007 年 7 月 20 日，網址：http://hsb.hsw.cn/2007-07/20/content_6432660.htm。
30. Jacques Rancière ,Aux bords du politique,Gallimard,1998,Paris,p.229。
31. Aux bords du politique，p.234。這裏的 "開端" 也是 "創始" 之義。
32. 參見艾未未發表於英國《衛報》（2008/8/7）的聲明，網址：http://www.guardian.co.uk/commentisfree/2008/aug/07/olympics2008.china。或參見《自由中國論壇》，
　　標題 | 告別專制：鳥巢設計師艾未未的宣言，網址：http://zyzg.us/viewthread.php?tid=185397&highlight。

再說一次，當然是指每個人，每個關切主體的人，包括艾未未本人在內，但不是要再現它，而是去發明它！

首先，這終究是要去面對人民的，但決計不是黨國招來的，被分配舉布條而來的群眾──他們被支配，是等著或將遭到被統治的人，像是 1949 年中國天安門廣場前被領導、立國者呼喊 "站起來" 的人，在此前後，以各種不同名義被叫喚、動員而來的人：總之，不是這些葵花子民，在計算分類下曾被榮光披身，但爾後不幸被羞辱踐踏者 [33]。誠如德勒茲說的，人民是要被發明出來的。試想「川震」的罹難者是從公領域被抹除於無名之中，她（他）們缺席，不在場，死了，且蒙受兩次，是從肉身之死到身份記號之死。發明，不是要我們去虛構，而是把自己當成一位「說情者」（intercessors/intercesseurs），為那些已不在的人民說情，手法是：一，採用「真實的、而不是虛構的人物」，二，將真實身份的他們「置入『虛構化』、『傳說化』與『神奇故事化』的狀態裏」[34]。例如 Remembering，這是帶著書包把「川震」的罹難者請到慕尼黑的「藝術之家」那裏講話（包括媽媽講的話），而私事與政治不再分屬各自的領域，並從展覽空間那裏向世人發出控訴的「集體聲明」（énoncés collectifs）。那為何要如此編造，虛構情事？最大的理由是：為了抵抗官方及其共謀者的再現治理，一種臣服於象徵宰制的政治性。

缺存的人民，不只在 Remembering 那裏，在艾未未的「公民調查」那裏還有的是，如被汙名者、被非法拘禁者、被官方消滅者、損害者與欺凌者等等，甚至連他自己本人也曾是 [35]，或此刻正是的進行式 [36]。這個「缺存」（manque/lack）是逝者、未現身者，無法現身者，同時也是尚未到來的未來者，而《童話》正是對這個未來者、甚至是未來人民的一種發明。但激進地講，到者──來到德個卡塞爾的人──還不是這個未來者，不是因為有所謂的真正來者遲滯

未來，而是到者本身始終空出未來者，投射著未來者的「缺存」。不過具體地講，對艾未未來說，這個未來人民就是公民。

這是一個戰場，其詭譎之處就在於兩條戰線在今日中國的彼此交纏，一是爭取公民社會的實現，另是抵抗可能迎面撲來的消費者型的公民社會 [37]。但無論如何，帶頭批判的動作總是要的，是非常必要之舉，就像路青的《撩裙子》（June 1994），《透視學》（1995-）的標示，或是艾未未在集眾裸體下演出的裸命，而最關鍵是騎著「草泥馬」去中指 / 中止黨國體制的專制政權。這是戮力於發課的文化事業，讓人想到薩德侯爵（Marquis de Sade）的 fuck 機器。關於這機器，特別引人側目的是他的著作《香閨哲學》（La Philosophie dans Boudoir），當中以夾頁般的宣傳小冊編入他這本春宮小說，標題是《法國人，你們仍須努力》，容我更動對象：同志們，大家仍須努力！

---

33. 金文 "民" 字是一把錐子刺進了眼睛而失去了瞳子的象形，是主人把奴隸的一隻眼給刺瞎，藉以支配並強迫他們勞動，所以在遠古時代，"民" 原本意指奴隸。有偶無獨，在荷馬的《伊里亞德》裏，故事裏的人告訴我們，人民唯一能做的就是：閉嘴，彎腰叩頭。參見 Jacques Rancière ,Aux bords du politique,p.228。

34. Gille Deleuze,Cinéma, tome 2. L'Image-temps,p.289。或參見黃建宏譯本《電影 II，時間－影像》，遠流文化出版社，2003 年，台北，頁 668。

35. 這是《老媽蹄花》的敘事，內容記錄維權人士譚作人揭露 2008 年四川「512」大地震中「豆腐渣校舍」而入獄，艾未未與調查志願者應前者辯護律師的邀請，在準備以證人身份出庭期間，在成都市下榻旅館遭到當地警方非法入侵與毆打，到德國後發現腦膜積血住院的過程。

36. 就是艾未未於今年 4 月 3 日在北京機場遭到公安逮捕，秘密拘禁，6 月 22 日獲准取保候審的迫害事件，並處於被官方禁止對外發言的狀態。

37. 桑內特（Richard Sennett）《新資本主義的文化》（The Culture of the New Capitalism），李繼宏 / 譯，上海譯文出版社，2006，上海，頁 123-140。

# Fairytale Machine, Future People

Chen Tai-Song

"Not that of addressing a people, which is presupposed already there, but of contributing to the invention of people."[1]

—Gilles Deleuze

## Destined to be Free

People are being summoned, but in the name of what?

Regardless of who is standing in front of the crowd or on a podium, regardless of what that person has to say or how he or she says it, there is that origin to which we should constantly return; it is not a specific location, rather, it is an ancient Greek term—Archein. It first appeared in Homer's epic poem, *Iliad*, and its original meaning is to begin and to lead, like walking in front of people and lead them in actions. The anthropological meaning of Archein is inter-cultural, and it is not something unique to the Western world. Furthermore, it is the foundation upon which Hannah Arendt developed her political philosophy and theory of action. In her arguments, Archein is closely related to freedom, because without freedom, men cannot begin anything. Arendt uses Immanuel Kant's philosophical term "Spontaneität"—by which she means the "ability to initiate a sequence, to forge a new chain"[2]—to illustrate this underlying meaning of freedom in Archein. More concisely speaking, even if people are deprived of freedom by totalitarianism, that is, they have limited degree of freedom in the system, the significance of the idea is that they should not ask if they live in a free society or not, they must first recognize that freedom is a birthright, and people are destined to be free. People have the ability to begin and to lead, and they also have the courage to be responsible for the results of their actions.

In other words, freedom has nothing to do with natural law of causation (no one is free under this law), but it is the ultimate command people give to themselves. According to Karatani Kojin's interpretation of Kant, one must obey the command to be "a free agent"[3], or, borrowing Jean-Paul Sartre's Existentialism, one is "sentenced to freedom"[4].

## Dimensions of Individual

Why are we talking about these? The reason is that Ai Weiwei fearlessly displays these valuable actions and ethics through his art creations in the post-totalitarian society and capitalist economy of modern China. Ai has even taken a step further and ventured into social practice, putting forth a cultural political vision with great perspective. When Ai was invited to documenta 12 in Kassel, Germany, his work "Fairytale" can be seen as a sign.

In this work, Ai Weiwei became an organizer. It took him over six months of preparation as he recruited volunteers throughout China via the Internet. He selected 1,001 Chinese to go to Kassel and visit Documenta 12 for a month. The trip was free of charge with only two rules: 1. These people were not allowed to leave the

---

1. Deleuze, Gilles. Cinéma, tome 2. L'Image-temps. Editions de Minu, 1985, Paris, p.283.
2. Arendt, Hannah. The Promise of Politics. Translated by Tsai, Pei-Jung. Sinobooks, 2010. Taipei, p.159.
3. Karatani, Koji. Ethics 21. Translated by Lin, Hui-Jung. PsyGarden Publishing ,2011. Taipei, p. 84.
4. Satre, Jean-Paul. L'être et le Néant. Ed Gallimard, 1943, Paris, p.598.

city of Kassel. They were all there for Documenta 12, and they were all part of his "work". 2. They must return to China as planned. There were no other travel plans; all the volunteers were free to do anything. They were not required to attend conferences or public events, and Ai Weiwei did not summon them up to give a speech during the period. Ai only asked all the volunteers to take a picture together on the day of departure. That was it. Obviously, "Fairytale" displays a certain assembly concept. In addition to the 1,001 people, the sizes of his actual works were also impressively large. The Chinese-style chairs that were placed throughout the exhibition venue, as well as the large temporary dorm with matresses put together ad hoc specifically for the 1,001 tourists. Although they were free to seek other accommodation, the dorm-like structure doubtlessly became a part of Ai's work. Actually, this concept is evident in a number of Ai's works. Although to different extents, the artist uses the same idea for various implications. Examples include "Whitewash" (1993-2000), "Still Life" (1993-2000), "Forever" (2003), "Colored Vases" (2006), "Grapes" (2011), as well as "Sunflower Seeds" (2010-11), which was recently displayed in the Turbine Hall at Tate Modern, UK.

However, "Fairytale" focused more on people. It was a mobilization and organization of people. Interestingly, Ai Weiwei emphasized that this work focuses on the "experience of life and awakening" of individuals, and highlights the irreplaceable value of the existences of "personal experience, personal identity and personal imagination"[5]. Ai used the formula

"1=1,001" to illustrate and represent this value[6]. It is an equation of individual to collective; every individual is a living existence that is unique and special, and they cannot be replaced or coded. Ai mentioned that "Fairytale" was "prepared for each and every one of the 1,001 people, instead of the 1,001 people preparing for this work."[7] Therefore, it doesn't hurt to interpret "1,000" as representing a group, and that extra "1" then, represents an individual—each and every individual in the group, including Ai Weiwei—just as Ai made a name for himself at the every same time he took pictures of the tourists. In other words, "1,001" represents the "uniqueness" of an individual, an individual that cannot be integrated into a group, and symbolizes that extra one who cannot be recruited, exhausted or digested.

Then, if so much emphasis is placed on an individual, what is the reason for mobilizing a group?

## Group Therapy

First, it is not because of the enormous population in China. If group/totalitarian cultural politics were not looming over contemporary China like a devil, Ai Weiwei had no need to recruit so many people, he simply needed to invite two or three. He could arrange for them to even stay in hotels, and save himself the hassle of building them a temporary dorm, something that resembled military camps or shelters at an epidemic zone. All the beds were subjected to centralized management, and meals were

provided to all the tourists. We should not be trapped in the stereotypes of certain Western art critics, and simplify "Fairytale" into symbolic associations such as capitalist spectacles, resurgence of an ethnic group, or the rise of China[8]. For, this is an intricate psychic operation, a group therapy through displacement. The "prescription" was to experience, explore and understand the idea of "to each their own"[9]. This is a self-therapy that invites individuals to step out of the group to find oneself; it is also a personal journey that derives from the faith in a unique event such as "Fairytale", through to becoming responsible for it. In short, it is a journey that a person embarks on to escape from the state of collective consciousness, and turn the attention back to oneself. Ai Weiwei said that although "Fairytale" leads a person to know another (or Documenta 12 in Kassel), and is a "possibility that guarantees encounters"[10], Ai believes that the most meaningful part is that it is "made for each individual"[11]. Of course, it was inevitable for participants of "Fairytale" to be subjected to many limitations including an art exhibition, but this did not mean they had no freedom. In fact, it was already a display of freedom from the moment they decided to join the show. Just as Kant's notion of radical freedom, it is an ethical operation with the underlying theme of "using oneself as the cause"[12].

After all, "Fairytale" is a platform that inspires all and opens up opportunities for freedom, or, just as Ai Weiwei puts it himself, "providing a framework and system, life, machine or

5. Ai, Weiwei. Time and Place—Ai Weiwei. Guangxi Teachers' University Press, 2010. P. 92.

6. See note 5.

7. <Regarding "Fairytale" and Art Creation - An Interview of Ai Weiwei by Zhou Cao>, China Text Transfer, http://www.china-texttransfer.de/de/node/106

8. Chinese art critic Zhu Qi has the same point of view, please refer to Guangzhou Daily: Dialogue with Ai Weiwei—What Kind of a Game is "Fairytale"?

9. "To each his own." Is cited by Ai Weiwei from Noack Ruth, the curator of Documenta 12, Kassel, Germany. Refer to note 7.

10. See note 7.

11. See note 7.

12. Karatani, Koji. Ethics 12. P. 100.

animals."[13] These wise and poetic combinations of concepts seem to coincidentally correspond to Gilles Deleuze's machine theory. For Deleuze, a machine has nothing to do with national mechanism. Deleuze is not referring to a country's production and operation of ideologies in order to control the society and manipulate the people. Therefore Deleuze's machine should not be confused with Louis Althusser's "state apparatus"[14]. What is it that Deleuze is referring to then? First, machine should be examined from the artistic creative process, especially the ways it operates. Deleuze emphasize that meanings are not predetermined and hidden; the issue of meaning lies in how they are used. Machine is productive and anti-logos, it all depends on how the artwork operates (marcher/works), just like how components operate in machinery. Thus, if the meaning of a piece of work is to be regarded as the truth, this very truth is produced by machine, and is but one of many truths. This machine is the one that operates on our body, and therefore the truth that it produces is "the extraction of our apperceiving impression; dug out from our lives and given to the work."[15]

## Components and People

Another concept of machine that is easier to understand than "Fairytale" is Ai Weiwei's "Fragments" (2005). It deals with the relationship between components and people. The meaning of this "and" is twofold: it is the link between the two, but also a relationship built on entrusting components to people.

Just as how Ai Weiwei describes the work, one of the work's main element, the wooden materials, came from the remaining beams of three or four demolished ancient temples. Without specific instructions or preset aesthetic requirements, eight carpenters were invited to assemble the beams. Ai told us, "Fragments" is not the fruit of his creativity, but it is the collective achievement of a group of carpenters after six months of work without any of his intervention. From the surface, it seems to be a random put-together that lacks any logic of classical architecture. Yet in reality, it has a set of rules in its development, as it is the result of the carpenters' improvisations and conversations with one another. It is a structure of fragments equipped with fragmented historical symbols, like a dance performed over the corpse of history. Moreover, according to the carpenters' design, if a person looks at "Fragments" from the top, he or she can make out a map of China from the connected points of the beams. However, this cannot be interpreted one-sidedly as a perfect representation, or the logos of national and ethnical ideology; its façade should be used for overall observation. That is, this dance of corpse does not just exist in the architectural fragments, but should also be projected to the systems of history and ethics, or even the territory. Therefore, Ai Weiwei's "Map of China" in 2004 should also be interpreted this way. In other words, it is the allegory of national territory/things that belong to the walking dead.

Although the fragments do not really dance and make the mechanical sound of "garr" at the joints, the work's appearance can ignite this kind of imagination. The connections between the components and the carpenters during the process are then the actual operation. "Fragments" is in all senses a machine, an abstract machine of the micro-society. People, in this machine, are operators of the components, and in return, they have become components as well. For components, they are the fragments that deconstruct the historical orthodoxy. For example, in "Dropping a Han Dynasty Urn" (1995), the artist demonstrates this idea himself. Of course, in "Dropping a Han Dynasty Urn", Ai did not have a slip of hands; he let go of the urn with determination. It was the declaration of the fragments, and a cross-referenced provocation to the following two things: one, the fetishization of history in contemporary China, and two, the blind destruction of relics during the Cultural Revolution in the 1960s. "Fragments" reflects the current cultural state in China, but compared to "Dropping a Han Dynasty Urn", it leans more towards admitting and assuming the responsibility of this ruin, and through which explores the possibilities of self-enlightenment and cultural resurrection.

"Fragments" is not a reconstruction, but an opportunity for people to experiment with assembly, to create a space where people and components are both the principal element. Components and people thus become a metonymy, and are casted together. Just like the uniqueness of each piece of wood, "Fragments" guide its operators to establish the uniqueness of their own existences; the unique links of

---

13. Please refer to Ai Weiwei's video "Fairytale, Part 1 - 7" on YouTube. http://www.youtube.com/watch?v=SMY1n8wiVjw&feature=related

14. Chinese translation by author differs to that of convention in Taiwan.

15. Deleuze, Gilles. Proust et les Signes. Presses Universitaires de France, 1998. Paris, p. 176.

pieces of wood also imply the reconnection between people and reinvention of society. Undoubtedly, this is also the underlying message of "Dropping a Han Dynasty Urn": on one hand, it declares freedom; on the other, it carries this freedom.

**This 1 is not One**

To an extent, "Fragments" serves as a workshop where people can contemplate ruins, just as "Fairytale" serves as a clinic. Then, focusing on the logical correspondence of the two, the title "This 1 is not One" can be promptly used to illustrate Ai Weiwei's idea of art.

Let's return to the "1" that represents an individual. This is the number 1, and it is the destiny that an individual must shoulder as he or she is destined to be free. This is also the belief pursued by Ai Weiwei: "maximum freedom of an individual"—which includes survival, personal development, access to information, rights to express oneself, and so on[16]. Here, it is necessary to talk about the "Citizens' Investigation" project that Ai systematically launched in 2008. From the suppression and torturing of human right activists by the public security officers, to the cover-up of truths by the government, Ai publishes and distributes documentaries online, attracting much attention; these films include "Box Your Ears" (2008), "One Recluse" (2010), "Disturbing the Peace" (2009) and "Hua Hao Yue Yuan" (2010). These operations of an "artivist"[17] are a machine that attempts to penetrate through the "solid" state apparatus. Using the

Sichuan Earthquake in 2008 as an example, Ai conducted an investigation and published the identities of the large number of student victims. As the government wanted to cover up the mass casualties of the disaster, Ai experienced government interventions and suppression. He published the investigative documentary, "Box Your Ears", and exhibited an installation at the Haus der Kunst in Munich, Germany in 2009. Though the work was named "Remembering", it was actually an accusation on the Chinese government, as it violated citizens' rights as an attempt to protect the regime. More attention should be paid to the slogan that appeared on the façade of the museum, as it took the accusation to a personal level; with backpacks of students, Ai spelled out in Chinese characters the words a grieving mother told him about her daughter who perished in the quake: "She lived happily for seven years in this world."

"Remembering" is a machine of people. The eulogies of the many victims are transformed into a declaration, a political resistance, for it publicizes the victims that the Chinese government tried so hard to hide, and to erase the social identity and collective memory borne by those names. This is the domesticated and party institutionalized life governance of people, making them mere properties of the rulers. Thus, "This 1 is not One" means: the "1" that resists "one", refusing the imperious "one". It is the boycotting of totalitarianism, collectivity, and the idea of unification. This "1" resists the "one" of logos and the "one" represented by "settled down by unification" and "to have one as the

ultimate priority". This resistance can be also applied to the embodiment of the Chinese imperial ideology and the co-structuring political philosophy[18].

Thus, the meaning of "This 1 is not One" is twofold: first, it means resisting a totalitarian state's manipulation of its people; in that sense, even though "Fragments" has a structure, but it focuses on the fragments/components/individuals, which are the unique individuals within the chain. These individuals are flexible and are freely connected. "Fragments" is not advocating for the restoration of "one", or reconstruction of a collective thinking, the symbol of one ethnic nation, a temple or ancestral shrine where national treasures are stored. Second, it also means the dismantlement of the possibility of an individual "1" in becoming a dictator, an autocrat or an oligarchy[19] as it leads the people in actions. We can regard "Fragments", "Fairytale" and "Sunflower Seeds" as the aesthetic narratives of this dismantlement.

**Craftsmen and the Multitude**

Therefore, we should not equate Ai Weiwei, as a creator and author, to that kind of "one", or talk about Ai as an oligarchy like a portion of netizens who comment out of jealousy, hatred, or the defensive mechanism of official ideology. Simply put, politicians rule, artists make themselves heard, but do not rule. In reality, artists want nothing to do with ruling; it is not their original intention. For example, "Fairytale"

---

16. "Ai Weiwei on 'Hua Hao Yue Yuan'" in "Who's Afraid of Ai Weiwei", compiled by Xu Ming-Han. Gusa Publishing, 2011. Taipei, p. 62.

17. Artivist is a new term. It is the combination of activist and artist. It also represents the combination of two concepts—social activities and art science. It may also be referring to "social activist" as mentioned in "Ai Weiwei on 'Hua Hao Yue Yuan'". Please refer to p. 36 of "Who's Afraid of Ai Weiwei".

18. "Settled down by Unification" is found in Mencius [1A:6]; it can also be found in the Records of the Grand Historian.

19. Oligarchy means a small group of people having control over a country. As a type of government, the power is in the hands of a selected few. These small group of people rule to fulfill their own desires.

does not rule, neither does "Sunflower Seeds".

Using "Sunflower Seeds" as an example, the documentary tells us that Ai commissioned the residents of Jingdezhen to make more than 100 million sunflower seeds over two years in accordance to traditional methods, writing a new fairytale-like chapter for the history of the town that has always been responsible for the porcelain production of imperial china. Huang Chien-hung has recently given interesting critiques on the overall creations of Ai Weiwei. In his critique, Huang makes reference to Richard Sennett's notion of "Craftsmanship", and proposes to use "intellectual equality" and "the idea of the "craftsman" as starting points of his analysis[20]. This is worth more discussion. Huang first points out the divergence of recognitions of artists and craftsmen in the history of Western contemporary arts, and Ai Weiwei has re-mingled the two through redistribution of production. Huang says that "Sunflower Seeds" highlights this mingling and its "ontological meaning" in the work, and the end result of this meaning is the spectacle and materiality of the work, which resolve the suspense of artists and craftsmen being on the two extremes of the scale. However, in Huang's opinion, this mingling has not yet achieved the ultimate result, for even though Ai has not given commands to the craftsmen, and has allowed them to enter the composition of the imagery of the work, "he soon turns their craftsmanship into strange symbolizations." In other words, the craftsmen and their works have become anonymized. It is as if the craftsmen have been stripped from their individuality and alienated into a "capitalist number" (1,600 craftsmen). The result is that they have simply become the aesthetic adjectives of the installation to suggest a spectacle-like sense of superiority. The conclusion is that we are seeing an ever-expanding individual in the artist, and "the name of citizens", and these two "follow the dynamics of consumers' market and pull 'craftsman' farther and farther away from its name."[21]

According to Huang, the quantitative manipulation of "Sunflower Seeds" results in the oddity of qualitative changes, and that the individualities of the multitude of craftsmen are turned abstract and anonymous. This fine observation does make some sense, and has something to do with art creators in the current capitalist system—especially those artists engaged in cultural activities—and their ethical bets placed in aesthetics. Are they aiming to win a self, to benefit others, or both, or hope to bring social effects, and so on? However, as long as there is author's consciousness, there will not be a clear division, or without a trace of accumulated desire for cultural assets of their own. In fact, the real problem here is how to establish the rules for the game, a kind of establishment of Wittgensteinian ethics. That is, in addition to the ultimate command of freedom, ethics are not common sense or natural guidelines; they are performative, and are produced through negotiation and mutual agreement. For example, we should investigate if any of the craftsmen demanded authorship during the project, what was the agreement between Ai and the craftsmen, what was the relationship between the production and the group, and even the emotional connections among them. Through this, we venture into the second level of Kant's notion of freedom: in addition to regard ourselves as free individuals through the ultimate command, we "use humanity, as much in your own person as in the person of every other, always at the same time as ends and never merely as means.[22]" Similarly, this topic should be expanded in a Wittgensteinian way, that is, the morality of "treating others as ends" should not be based merely on ethics or one-sided recognition, but should be on the foundation of mutual agreement, just like establishing rules for a game. This is an open discussion and all sorts of inventions by both sides for the so-called "ends".

Ai Weiwei has emphasized the inspiration to individuals by the multitudes of "Sunflower Seeds"[23], and in order to control this aspect, the symbolic bi-polar structure of artist/craftsman needs to be repeatedly analyzed. Furthermore, the divergence of the recognition of artist and craftsman is the result of a long process that began from the nomenclature during the Renaissance and continued through the technological revolution at the turn of the 20th century. As Lin Chi-ming pointed out, Marcel Duchamp's concept of "ready-made" has given rise to the key position of the "intellectualization" of art, which has turned "mise en forme" into "langage artistique". One observation of this, is that even though Duchamp claims to abolish the idea of "faire/make", and attempts to

20. Huang, Chien-Hung. "Cos Star Wars Skywalker Ai Weiwei", in "Who's Afraid of Ai Weiwei". p. 142-143.

21. See note 20.

22. Kant, Immanuel. The Metaphysics of Morals. Translated by Miao, Ding-Li. Shanghai People's Publishing House, 1988. Shanghai, p. 80-91.

23. "Ai Weiwei's 100 Million Sunflower Seeds", Interviewed and Written by Ding, Yan-Yan. Ai Weiwei mentioned in the interview that he likes Twitter, and it resembles "billions of ideas and messages in the great ocean, and they all come from individuals." Ai also believes that it is "a kind of great strength made up by individuals." http://thedreamhunter.blogspot.com/2011/01/blog-post.html

subtract "every element of craftsmanship in art", but the truth is that he "bring(s) practical logic back into the production logic", as if to look back into history and "suspect how Greek civilization differentiates 'poiesis' (produce) and 'praxis' (practice)."[24] Therefore, according to Sennett's expanded definition of "craftsman" and the modern radicalization, Duchamp can be historically regarded as a craftsman engaged in a kind of conceptual labor, and same thing can be said about Ai Weiwei.

Perhaps, the subjectification of the craftsmen is the main purpose of "Sunflower Seeds".

This is a branch of subjectification, and also the branch of subjectification that the machine of "Sunflower Seeds" operates in, attempting to induce the multitude of craftsmen to subjectify unexpectedly in the daily narratives. This is a diverse and compound subjectification within different contexts. For example, some participants of "Fairytale" experienced foreign relationship, faced dramatic changes in life, gained new perspectives in life and changed the way they look at things, or had some kind of experience unknown to others. All of these are more significant and valuable than the authorship itself. In other words, the end of subjectification is not authorship, unless we believe that all perceptive operations should be branded as cultural assets along with declaration of copyrights, and that everything must be categorized under the production, distribution and accumulation of this system. In fact, the classes and politics of commercial production may not be necessarily suitable to certain communions of art. It is also uncertain whether subjectification is, as critiqued by Huang, "the most basic challenge, as names of plural individuals are released under the framework of capitalism." Different cases will have different outcomes. However, the key may very likely lie in the classes of individuals, and the politics of these classes.

**Leadership Discussion**

Of course, just as Huang worried, "Sunflower Seeds", like "Fairytale", is highly symbolic in its scale. It seems that there is the risk of it dominating individuals. However, if the documentary is not regarded as the work's complement, we can understand that Ai Weiwei contemplates the possibility of having people stepping out as individuals from a group through the collective production of "Sunflower Seeds", and from this, he projects the sociality of an individual. As for "Fairytale", he achieved this through travelling.

This is not a lone individual, but a free one; through this, Ai asks for an autonomic society[25]. Although the symbolic spectacles have made these two works seemingly implicit regarding the appeal of liberation of individuals, but once we are caught up with Ai Weiwei's pace in "Citizens' Investigation", which does not involve direct actions as well, we will understand that maybe it is just like his self-narratives:

My political stance, if there is any, is individualized; it is anti-hegemony, and is against all value standards established for certain kinds of profits[26].

It is obvious that Ai Weiwei is the most important individual, but that identity comes with terms; it only exists with the art project, so that this individual can summon its multitude of individuals. Then, let's return to Archein mentioned at the beginning of this essay, there is another ancient Greek word—Prattein—that is related yet different. Prattein means to find companions to help complete a task that has begun and finish the task collaboratively[27]— these people are equal individuals that entered the "agora". In Hannah Arendt's opinion, the close link between Archein and Prattein gave rise to the democracy of the ancient Greek political system of city-states. The collapse of this democracy was the result of the faltering relationship between the two words. Archein turned into authority and commands, and Prattein turned into the duties of subjects, and their responsibility to obey orders.[28]

These two concepts are useful in evaluating the aesthetical politics in Ai Weiwei's artistic creations. First, with the Chinese society forbidding anyone from voicing out their thoughts, we must give unreserved support and recognition to Ai for his courage to lead the criticism. He is unafraid of taking initiatives at a time when party-institutionalization cross-pollinates with capitalism, and he bears the burden of the series of consequences. Through this action, he is able to prove his

24. Lin, Chi-Ming. The Difference between Artist/Craftsman and Some Art Critiques—Part 2, Contemporary Art, Vol. 118, 1996. Taipei, p. 44-45. Since the meaning of praxis is too complicated, here the writer uses the meaning of "practice".

25. Ai Weiwei said: "Only through individualization of at can it fulfill its other social functions, and this is why I prefer Duchamp and Andy Warhol." Please refer to <Regarding "Fairytale" and Art Creation—An Interview of Ai Weiwei by Zhou Cao>.

26. "Time and Place—Ai Weiwei", p. 95.

27. Arendt, Hannah. The Human Condition. p. 189.

28. See note 26.

own freedom—a freedom as defined by Kant. Moreover, Ai's Archein proves the concept of companionship in Prattein; leaving "Citizens' Investigation" that he advocates and conducts aside, in "Fairytale", he transformed from founder into helper, the office manager that engaged in daily affairs and services[29]; or, like in "Fragments" and other works, he became the consultant that stepped aside and observed how others operate.

Regarding Hannah Arendt's theory, contemporary French scholar Jacques Ranciere has voiced his disagreement. He believes that Archein cannot escape from the logical hypothesis that outstanding individuals will govern and command those less superior[30]. So is Jacques Ranciere advocating to abandon leadership in any actions? Presumably not. Yet, obviously Hannah Arendt is not siding with the governance of equal individuals among social elites and dominant group. Actually, the command and order referred to by the former are the transformed Archein. It is the Archein that has lost connection to Prattein; not the situation Arendt is talking about. On the other hand, she seems to have not proposed any mechanism to ensure a secure connection between Archein and Prattein, and thus unable to eliminate the possibility of exclusive rule of "the leader takes all". As a result, Ranciere's theory should also be examined repeatedly. Ranciere says:

The people (démos) exists only as a rupture

of the logic of arkhè, a rupture of the logic of beginning/ruling [commencement/commandment]. It should not be identified either with the race of those who recognize each other as having the same origin, the same birth, or with a part of a population or even the sum of its parts. 'People' [peuple] refers to the supplement that disconnects the population from itself, by suspending the various logics of legitimate domination[31].

Perhaps, it is necessary to go back and forth between the arguments in theories of politics in order to capture the strange moment during which arkhè can lead to liberation or reversal. Fortunately, art does not indulge in arkhè, unless it is willing to be used by politics, becoming a tool for political propaganda. This is also the righteous reason why Ai Weiwei, as a member of the design team of "Bird's Nest", refused to attend the opening ceremony of the 2008 Beijing Olympics[32]. For him, art is a verb, a dance among the multitude; it incorporates praxis into poiesis, and by poiesis, it embodies prattein through archein. Therefore, who is this person?

**Inventing démos**

démos, or people, is of course referring to every single person, every one that cares about the principal, including Ai Weiwei himself. However, it is not about discovering démos, but to invent démos.

First, this is something inevitable. However, party-institutionalization has no hand in this matter;

nor do those people who are assigned the protest banners—they are the ones who are being governed, or waiting to be governed—like the ones who were called to "stand up" by the leaders and founders of PRC at the Tiananmen Square in 1949; nor do those before or after 1949, who have been mobilized and summoned for various purposes. After all, not these subjects, who have worn the cape of glory under calculated categorization, and have since endured unfortunate humiliation[33]. True to Deleuze's words, people need to be invented. Imagine the earthquake victims in Sichuan, their names have been erased in the public eye into anonymity; they are absent, not there, dead, twice—they experience physical death and the death of their identities. Invention requires us not to fabricate, but rather we should regard ourselves as "intercessors/intercesseurs", to appeal for those who have departed. Our means include: one, use "real people that are not fictional"; two, take these authentic identities, and "place them in a state of 'fictional', 'legendary' and 'mythical'."[34] For instance, 'Remembering' is an invitation for the victims of the earthquake with their backpacks to speak up at the Haus der Kunst of Germany, (including the voice of the victims' mothers). Private matters and politics are no longer separated in different disciplines, and have become a "énoncés collectifs" (collective action) to the world, right at the exhibition space. Then what is the point to fabricate and fictionalize stories and events? The most important reason is: to resist the resurgence of the governance of officials and their accomplices, which is a

29. Please refer to "Analyzing Ai Weiwei's 'Fairytale': For 1001 Kassel Experiences", Chinese Business, July 20th, 2007. http://hsb.hsw.cn/2007-07/20/content_6432660.htm
30. Rancière, Jacques. Aux Bords du Politique. Gallimard, 1998. Paris, p. 229.
31. Aux Bords du Politique, p. 234. Here, the word "to begin" also means, "to start".
32. Refer to the announcement Ai Weiwei published on The Guardian in UK (Aug. 7th, 2008). http://www.guardian.co.uk/commentisfree/2008/aug/07/olympics2008.china or The Free China Forum, titled "Farewell to Authoritarian—The Announcement of Ai Weiwei, Designer of the Birds Nest". http://zyzg.us/viewthread.php?tid=185397&highlight
33. The character "民" (people) in the Chinese Bronze Inscriptions shows an awl poking into an eye. It illustrates how master blinds one of the servant's eyes in order to command them. Therefore, in ancient China, the character "民" (people) meant the blind servants. Coincidentally, in Homer's Iliad, the character in the story tells us that the only thing people can do is to shut up, and bow. Please refer to Jacques Ranciere's Aux Bords du Politique, p. 228.
34. Deleuze, Gilles. Cinéma, tome 2. L'Image-temps. Editions de Minu, 1985, aris, p.289.

kind of policalities symbolizing the surrender to dominance.

People of incomplete existence did not only manifest in "Remembering", but also in Ai Weiwei's "Citizens' Investigation" project. These people include the discredited, the illegally detained, the officially destroyed, and even impairers and persecutors. Maybe even Ai himself has once been one[35], or still is[36]. This lack/manque may be referring to those who've passed away, those who have not yet shown themselves, those who cannot be present, and, at the same time, those from the future who have yet to arrive. And "Fairytale" is an invention for these people of the future, or the future demos. But radically speaking, the comers— those who are there in Kassel, Germany—are not the people of the future. Not because the real comers have been delayed, but that those who have arrived leave blanks for the future comers, projecting the "lack" of future people. Tangibly speaking, to Ai Weiwei, these future people are the citizens.

This is a battlefield; the strange part is that two fronts intertwine in China today. One is the fight to realize a civil society; another is the resistance against a potential consumer society[37]. Nonetheless, a leader for criticism is in need; it is a necessity, just like the photo of Lu Qing lifting up her skirt (June 1994), the gesture of the "Study of Perspectives" series (1995-), the activities featuring a naked Ai Weiwei posing with other nude models, and the most significant one where Ai rides a grass mud horse to give the

middle finger to terminate the authoritarian regime of the party-institutionalization. It is cultural work devoted to FAKE, reminding people of the fuck machine by the Marquis de Sade in the 18th century. Regarding this machine, the most intriguing element is his publication *Philosophy in the Bedroom*; a propaganda pamphlet is compiled into the text of this pornographic novel titled "Yet Another Effort, Frenchmen", allow me to change a few words: Yet Another Effort, Comrades!

---

35. This is the narrative of "Disturbing the Peace". The documentary shows Human Rights activist Tan, Zuo-Ren being detained for exposing the "to-fu skin" buildings after the Sichuan earth quake in 2008. Ai Weiwei and volunteered investigators accepted the invitation of Tan's lawyer, and prepared to be witnesses at the court. They were attacked by local public securities of Chengdu City in their hotel room. Upon arriving in Germany, Ai had to be hospitalized for bruises in his meninges.

36. Ai Weiwei was detained at Beijing Airport on April 3rd, 2011. He was secretly detained, and was finally released on June 22nd. The officials have prohibited him from any public announcement.

37. Sennett, Richard. The Culture of the New Capitalism. Translated by Li Ji-Hung. Shanghai Translation Publishing House, 2006. Shanghai, p. 123-140.

# 善變的調侃

## —艾未未的直觀和生命衝突

劉永仁 / 北美館執行策展人

**前言**

今年（2011）初，台北市立美術館邀請艾未未來台洽談展覽，未料四月三日當艾未未於北京機場出關時，被中國政府無預警逮捕扣留，使得籌展過程一度陷入膠著狀態，至六月下旬，艾未未終於獲得釋放。在艾未未被扣押81日期間，本館仍和其工作人員聯繫展覽事務，並邀請於5月19日來台至本館討論預定展覽作品，初步有了實質的接觸，展品選件與空間規劃配置亦逐漸建立。然而，當艾未未幸免於牢獄之災後，重新檢視思考預定於北美館的展覽作品，於是艾未未與其團隊和本館努力展開了密集的策展聯繫工作。

艾未未（1957）生於北京，是中國當代觀念藝術家、建築設計師，為詩人艾青與高瑛之子。在中小學期間，曾在新疆居住十六年，之後返回北京就讀北京電影學院，並且曾在1979年就參加大陸中國美術館牆外舉辦的第一屆"星星畫展"應可視為早期藝術創作背景之濫觴。1981年，艾未未前往美國研習。他在羈旅十二年自由浪跡天涯的漫長時間，事實上已蘊涵養成創作的堅實態度。1993年艾未未返回中國定居北京之後，與獨立策展人馮博一等人合作編輯藝術刊物《黑皮書》（1994）、《白皮書》（1995）、《灰皮書》（1997），記錄中國當代藝壇的創作動向。九〇年代時期，艾未未的主要活動領域是藝術創作、書籍編輯，逐漸也開始策劃一些展覽，名隨即鵲起，也成為國際著名的藝術家。

艾未未的創作，從觀念、物件裝置到社會行動關懷，展現了多面向的藝術能量與開放的格局，其創作媒介包括攝影、雕塑、錄像等，使用的素材也很多樣化，從陶瓷、大理石、到腳踏車及古木器都有。艾未未的重要展出經歷包括：2000年上海雙年展期間策劃的富有爭議性的"不合作方式"展覽、德國第十二屆卡塞爾文件展以及英國倫敦泰德美術館的聯合利華系列、2010年第29屆聖保羅雙年展、2010威尼斯建築雙年展。2007年，艾未未以〈童話〉（Fairytale）作品，參展卡塞爾文件展，邀請1001個不同身份的人，親臨卡塞爾文件展現場，以為數眾多的一群隨機取樣人作為創作媒介，亦為作品內容，此作涉及生活、旅行與當代藝術環境之間的微妙關係，是針對文件展策劃極具包容性特色的藝術行為作品。

2010年十月，艾未未曾在英國倫敦「泰德現代美術館」（Tate Modern）渦輪大廳展示他的巨型裝置藝術作品〈葵花籽〉。這一億多顆的葵花籽，都是以手工在江西景德鎮製作的陶瓷品，展現"數大即是美"的藝術理念。值得注意的是，近年來，艾未未應邀至各國重要美術館與畫廊展出，同時也吸引了大量媒體報導，儼然成為當代中國最具新聞話題性和影響力的藝術家。

台北市立美術館策辦「艾未未‧缺席」（Ai Weiwei absent）個展，共計展出21件各時期的代表作品，創作年代自1983年到今年，精選傑作包括：1983-1993紐約與1993-2001北京時期的100幅攝影作品、〈失手〉、〈透視學〉、〈兩條腿在牆上的桌子〉、〈三條腿的桌子〉、〈十二生肖〉、〈彩罐〉、〈中國地圖〉、〈西瓜〉、〈葡萄〉、〈監視攝像頭〉、〈椅子〉、〈安全帽〉、〈如意〉以及錄像作品〈長安街〉與〈北京：二環〉、〈北京：三環〉，其中為北美館創作最新的作品〈永久自行車〉，以1000餘輛自行車構成裝置於10公尺高的空間展場，層層疊疊的迷陣猶如傳動的抽象造形，象徵中國社會的激烈變遷，這件將是艾未未以自行車為創作媒材的數量之最，屆時勢必形成眾所矚目的焦點。具有歷史糾葛情感的〈十二生肖〉青銅獸首作品，每件採用鑄銅和鎏金的奢華製作，巨大造形兼具質感與量感的氣勢，將會引起藝術界廣泛的討論，給予人衝擊力。

**諷世與挑釁權勢禁忌**

艾未未散發天生反骨的風格，善於逆向思考，他的個性具有兩極化的特質，若談話有趣，很可能惺惺相惜，反之則相當格格不入。他習慣性地顛覆所有既定的問題和規範，及至最後你會發現問題本身也變得荒謬，提問者可能會無力招架。艾未未的遊戲靈感與善變與調侃的態度息息相關，甚至藉由公共議題而巧妙地牽引出藝術問題之爭論，〈十二生肖〉作品即為明顯事例之一。

〈十二生肖〉（Circle of Animals）青銅獸首作品的靈感源於中國清朝皇家園林圓明園海晏堂噴水池前的十二生肖雕像。1860 年，英法聯軍火燒圓明園，獸首及其他大量文物都被掠奪並流散海外各地。獸首在歷經劫難之後，最終由一家中國企業耗費鉅資從西方買回。儘管幾乎所有的文物專家都認為該獸首價格物非所值，但是購買者充滿使命感的愛國行為，促使艾未未感興趣探索國寶獸首及其價值引發的各種問題。藝術家複製了圓明園十二獸首，旨在思考面對歷史文物的態度，並質問西方列強「掠奪」與「歸還」的嚴肅問題，同時省思諷刺、陳腐、傷痛、無知愚昧等多重含義。〈十二生肖〉獸首巨然矗立，以超出原獸首十倍左右的尺寸複製呈現，亦可視為重要的公共雕塑藝術。

〈透視學〉攝影作品，是縱透視的表現手法，將平面上離視者遠的物體置於離視者近的物體上面。圖像中的艾未未以其左手「比中指」朝向權力核心的建築物：天安門，空間的構圖與視覺形象鮮明；反威權以及強烈挑釁與嗤之以鼻的意味濃厚，他以調侃和戲弄的姿態指向蘊含政治、經濟、文化的權勢，顯現作者個人與外在權力之間的對峙狀態。

〈失手〉是一組三聯作的攝影作品，艾未未雙手端一個漢代古陶甕，以分解動作，呈現摔碎高古的漢代陶罐的過程。摔碎漢代陶罐的舉動，使觀者產生觸目驚心的內心衝擊，既是探尋視覺驚奇的可能性，亦可視為一種行為藝術。艾未未對於視覺意義、使用方法以

及觀看視角，提出了自身的立場，體現了藝術表現的極致，寓意於前衛、尖銳、隨機、分裂、以及源源不絕的創意能量。

## 生存感知與全方位攝影

八零年代至九零年代初，艾未未羈旅於紐約，在異國自由而廣闊的天地盡情遨遊，他總是抱持著放逐閒散的心情，觀察感受紐約的人事地物，並且以相機隨時拍下一些偶然遇見的事，漂泊的生活伴隨浪跡天涯的心情，往來去過的地方，熟悉的人，他的周圍的居住地、街道和城市，以鏡頭跨過每天放空的時間。艾未未的攝影捕捉了現實場景與真實的狀況，如人物、光線、距離、位置等；攝影鏡頭探討各式各樣的題材，拍攝者以其獨特品味的強烈趨使，針對物象概念進行一種新的辨識，追逐進取與掠奪圖像成為拍攝者的重要特質。攝影家認為，世界本來的面貌包括平庸的、神奇的，他們應該透過新的視覺創造出激起興趣的力量。艾未未在 "這漫長的路" 一文中述及『現代主義不需要面具和街頭，它是覺悟者的原始創作活動，是對生存的意義和真實處境的終極關懷，是對社會和權力的警惕、不妥協、不合作。覺悟來自於自我認識的過程，來自於對精神世界的渴望和追求，來自於永恆的懷疑和困惑。』(註一)

艾未未在論及攝影時的觀點：『當攝影技術和記錄的原始狀態脫離，它僅僅是一個由瞬間的狀態轉換為一個事實的可能。 活著僅僅是一個不爭的事實，而製作是與這個事實有真實關係的另一個事實，兩者都期待奇蹟發生：對意義的重新提問。攝影作為一個中介物將生活和感知活動推向陌生的掙扎之中。』(註二) 這是既務實又精神性的正向描述，從這裡的見解，可以得知艾未未思考攝影的本質並歷經實踐的操作過程。

本展精選艾未未的攝影作品 100 幅，分為紐約時期與北京時期兩大系列。紐約照片拍攝年代跨越 1983 年至 1993 年，這些黑白照片記錄了當年紐約東村的

詩歌朗誦會、在湯姆金斯公園廣場裸露的嬉皮、鎮暴警察、流浪漢、假髮節上男扮女裝的同性戀者。而更令人感興趣的是出現在鏡頭裏的年輕時期的詩人、畫家、作家、音樂家、演員、導演、觀念藝術家包括艾未未、王克平、艾丹、陳凱歌、顧長衛、譚盾、姜文、馮小剛、陳丹青、劉小東、北島、謝德慶、姚慶彰、舒婷等人，活動的地點從室內到室外公共場所，比如公園、餐廳、地鐵、洗衣店、街頭巷道、時代廣場以及現代美術館。

1993 年，艾未未自紐約返回中國，為了延續紐約的東村精神，在北京參與了一個實驗性的，類似紐約藝術家聚集東村的場所，稱為北京東村藝術社區。艾未未在這裏重新展開了其藝術旅程，並影響當時聚攏的藝術家，產生了令人驚嘆的激進行為藝術和繪畫、攝影以及裝置作品。例如：張洹、朱發東、蒼鑫與馬六明的行為藝術、毛栗子的繪畫、榮榮的黑白攝影、徐冰的觀念裝置藝術，藝評家栗憲庭也參與其中。北京東村的藝術家首次自主覺醒並關注反思藝術的生存狀態，他們在那裡盡情表達生命底層的冒險與掙扎，堪稱中國當代前衛藝術的大本營。

## 觀念衍生的機緣物體藝術

杜象對觀念藝術有著巨大影響，提出了現成物的概念，他的隨機選擇與精微詩意的表現手法一方面以揶揄戲謔的方式質疑傳統，同時以詩意的書寫賦予物件另類含義，以日常物件權充藝術載體形成衝突感，使得觀念藝術與現成物件彼此難以判別，顛覆傳統僵化的視覺概念，由此綻放驚世駭俗的獨特品味。觀念性創作旨趣在於激盪觀者的知性思維與藝術的反思。艾未未的藝術觀念來自於杜象，其來有自且有跡象可循，早在 1985 年艾未未的作品 Hanging Man 以現成鐵線衣架變造出杜象側面臉型，並用葵花籽部份填充其間，置放於有紋理的木板上，既存有對杜象的仰慕之情，而且隱含致敬之意味。25 年後，艾未未再度以葵花籽為創作媒材，以驚人的作品數量在倫敦

（註一）艾未未，《此時此地》"這漫長的路" 廣西師範大學出版社 2010
（註二）艾未未，《此時此地》"攝影" 廣西師範大學出版社 2010

「泰德現代美術館」大放異彩。

〈中國地圖〉以清代寺廟廢棄的鐵梨木為原料疊疊組合而成的巨型地圖。縱深切割的地形板塊清晰浮現中國遼闊的幅員，從藝術的角度剖析，艾未未的中國造形雕塑藉由內在的情感彰顯對於文化、歷史、政治、社會的總體批判。美國藝術家瓊斯將物件重新創作並賦予作品新的中立含義。〈中國地圖〉體現了典型的艾氏風格，亦即作品兼具社會與政治性的指涉，它總是充滿強烈而賦有形式意涵之張力。

〈可口可樂罐子〉是源自「普普藝術」挪用變造的表現手法，以大眾喜愛的可口可樂飲料的鮮麗商標，用英文書寫烙印於古陶甕上，可口可樂曾經是家喻戶曉的日常生活飲料和蔚為流行的標誌符號。去功能後的可口可樂符語賦予古陶甕新的美學倫理，探討歷史文物與現代流行品牌結合，在消費與被消費雙向之間，不斷地質疑“價值”的終極問題，進而提供藝術文化的可能性。

監視攝影器原是現代科技的產物，在現代的生活環境中，監視器拍攝的內容提供宵小犯案現場證據之用，是不可或缺的舉證工具。〈監視攝像頭〉作品是一具以大理石雕鑿的仿製監視器，象徵人們被監測無所遁形，在這個處處可能受到威脅的社會，監視器之無所不在，已經被視為日常生活的一部份。藝術家以其敏感的生活經歷與政治觀察回應他所感受到的隱藏在城市街頭的監視器，具有警示與嘲弄的本質。

如意是一種象徵吉祥的器物，通常用玉石、竹、牛骨等素材製成，造形呈現靈芝或雲朵形狀，柄微彎曲，供收藏賞玩。艾未未以陶瓷設計製作〈如意〉作品，形體流暢而色彩飽滿，特別在造形前端變換為人體器官的心肝肺形狀。在形制上，從傳統玉如意的鏤雕技法，冉提出新的視覺見解。在寓意上，象徵長生不老的靈芝伴隨祥瑞徵兆，由於增添人體熟悉的元素而更顯詭譎，甚至激發了難以言喻的品味。藝術家藉由傳

統技藝來重新詮釋其當代藝術的真實感知：吉祥與兇險，優雅與俗艷，流暢與矛盾等極端對立的狀態，挑戰觀者在視覺與心理上的雙重感受。

〈西瓜〉作品，以陶瓷製作的二十顆西瓜，是一件令人莞爾的作品。藝術家一貫調侃大眾飲食文化，並結合超現實表現手法，經由日常生活中的飲食經驗，將人們平常接觸的食物味覺，轉換成純粹的視覺物體，西瓜藉由精良製作成光鮮亮麗的形體，提供一種思考美味是否長存的想像空間。以大理石雕刻的〈安全帽〉，具有白晰光滑結實的質地，令人思及防護的安全問題。安全帽是現代人生活與工作的必須的保護用品，舉凡機車騎士、工廠作業員、賽車手等皆與安全帽的關係密不可分，而在藝術家受頭擊之創之後，這件雕刻卻令人思考是否是艾未未自身心靈的安全帽。〈彩罐〉組件作品的容貌介於古典與當代之間，披上鮮艷的色彩的古陶罐飽含賞心悅目的色澤；藝術家喜愛古文物蒐集古陶罐，以自動性技法用工業顏料澆淋於新石器時代的陶罐上，在現實感知與衡量價值觀的意義上，使觀者面對舊瓶新彩妝產生視覺上的衝突感。〈椅子〉與〈玩具車〉都是使用一塊完整的大理石雕塑而成。艾未未希望自己和作品之間保持一定的距離，和傳統藝匠合作，藉由手藝精湛的匠人以各種媒材（如大理石、陶瓷）雕塑器物，為材料添加新的身份，並致使藝術家的創意思維產生更多的可能。

## 建築於都市的理想實踐

艾未未的建築作品具有極簡主義的特質，清灰色的磚牆外觀，自然而無矯揉造作之習氣，精煉樸素展現磚本身的質素，在視覺上呈現出沉潛的氛圍。艾未未的創作遊走於藝術和建築之間，北京草場地的“藝術文件倉庫”畫廊便是他主導策劃、設計的成果。自1999年以來，他設計了自己的工作室和擔任藝術文件倉庫的藝術總監，後來也參與地產商、政府投資的景觀、建築設計專案，例如著名開發商潘石屹投資的SOHO現代城的景觀設計、長城腳下的公社景觀設計

以及2002年應他父親艾青故鄉――金華政府邀請設計艾青文化公園、金東義烏江大壩等專案。

2003年，艾未未成為赫爾佐格‧德穆隆（瑞士籍）建築事務所聘請的藝術總監參與中國國家體育場鳥巢的設計，這段時間艾未未接受了很多和建築、文化有關的媒體採訪，吸引了相當多的關注與討論。在2004-2005年期間，艾未未製作了〈長安街〉、〈北京：二環〉與〈北京：三環〉三部概念性的影片，藝術家特別選擇在冬天將北京清晰地展現在鏡頭前，以一種平淡隨機的手法進行記錄，探討建築與都市景觀的秩序紋理，隱含城市機能在社會政治和經濟發展相關的無窮課題。

## 心智造形與技藝結構量體

艾未未早期的藝術創作就開始運用古建築或古家具媒介，三腳攀牆立地的幾案、柱子穿心的方桌、二桌合體為一的物件，這些舊家具不斷地被拆解實驗，再重塑出具有獨特造形結構的視覺物體。〈葡萄〉作品以32張清朝板凳相互扣住串成如同葡萄的形體。造形是鮮活的多樣化，造形環繞彌漫著聯想之氛圍，透過艾未未的心智情感和夢想延伸與廣佈；可視為湧生意象之裂隙，導向一處不確定的領域，既非物理界限的領域，也非純粹思想的領域，而是藝術家直觀衍生的造形運動。

艾未未的大型裝置作品〈Through〉，是解構雕樑畫棟的建築意象。他拆解舊廟宇的素材重新組構為裝置作品，寺廟木梁歷經時間與空間的穿梭與刻痕，早已洗盡鉛華褪去火氣，無數根柱子穿插於方桌，被藝術家接嫁構成“人”形、“入”字，或多變的抽象造形，將本來橫縱有序的建築老構架，轉變成一個個丫杈枝的新姿態。原初規矩方正的結構蛻變成橫七豎八、斜牽橫倚，作者以豪邁壯大的心志入侵環境空間並與它產生對話的可能性。

〈兩條腿在牆上的桌子〉與〈三條腿的桌子〉頗有逆轉殘缺美的況味，將取自清朝桌子拆解的素材拼裝與嵌鑲成為似桌非桌的器形，它們都以牆面為支撐基點並形成物件與空間場所的有機關係。觀藝術家在選材方面的偏執與珍惜、睥睨與破壞之矛盾中，艾未未把原初造形結構強行錯位及轉變，形成另類的雕塑物件，這不僅顯示出艾氏獨特的品味風格，同時也反映出當代中國社會裡的某種現實詭譎之情境。

〈永久自行車〉裝置作品在某種意義上體現社會集體躍進的動能，在現代藝術史的進展過程中，「偶發」與「機緣」是突破藝術律則的重要觀念。1913 年杜象在其工作室將一具腳踏車輪倒置於圓凳上，便成為偶發機緣的作品。腳踏車原是普羅大眾的交通工具，既熟悉又親切，杜象卻將"可使用"的功能性從此物件抽離，而轉變成作品的載體內容。無獨有偶，艾未未以其個人的機敏與喜好，把使用現成物的觀念發揚光大，他選擇腳踏車，針對北美館最挑高的空間設計裝置巨作〈永久自行車〉，1200 輛腳踏車的數量與龐大的結構體是建構此作的最大挑戰，腳踏車的輪軸在層層疊疊交會間構成迷陣空間，觀者可從各個角度透視思索抽象造形的美感，感受蘊含其中的巨大能量與魅力。

# Mercurial Mockery
## Ai Weiwei and the Conflict between Intuition and Life

Liú Yung-Jen / Executive Curator, TFAM

### Introduction

At the beginning of this year (2011), Taipei Fine Arts Museum invited Ai Weiwei to come to Taiwan to discuss arrangements for this exhibition. On April 3, when Ai and his assistant were going through customs at the Beijing airport, he was unexpectedly taken away by Chinese public security officials, causing the exhibition preparation process to suddenly grind to a halt. Ai Weiwei was not released until late June. During the 81 days he was detained, TFAM remained in contact with personnel from his studio, hosting them in Taipei on May 19. Gradually, the selection of works and arrangement of the space were determined. After Ai Weiwei was released on bail, he re-examined the selection of works, and at this point the museum and the Ai Weiwei Studio commenced intense preparations for the exhibition.

Born in Beijing in 1957, artist and architect Ai Weiwei is the son of the poet Ai Qing. In his youth, he lived in Xinjiang for 16 years, returning to Beijing to attend the Beijing Film Academy. In 1979 he took part in the Stars Exhibition. In 1981 Ai moved to the United States. During the 12 years he roamed there freely and cultivated a solid mindset of creativity. In 1993 he returned to China, settling in Beijing. The publications *Black Cover Book* (1994), *White Cover Book* (1995) and *Gray Cover Book* (1997), which Ai edited in collaboration with independent curator Feng Boyi, documented the creative trajectory of contemporary Chinese art. During the 1990s, Ai's principal sphere of activity was artistic creations and book-editing, and gradually he began to curate some exhibitions.

Ai Weiwei's creations, from conceptual art and installations to socially oriented actions, manifest multifaceted artistic energy and a wide-ranging scope of concern. He created through media such as photography, sculpture, and video. He has also used a wide range of materials from ceramics, marble, to bicycles and antique wooden implements. Ai Weiwei's works have been exhibited at major events, including the controversial exhibition *Fuck Off,* which he curated parallel to the 2000 Shanghai Biennale; the Documenta 12 in Kassel, Germany; the Unilever Series at the Tate Modern in London; the 29th Bienal de São Paulo in 2010; and the 2010 Venice Biennale of Architecture. At the 2007 Documenta, Ai Weiwei presented *Fairytale*, in which he invited 1001 people to appear at the exhibition venue in Kassel, making their presence both the medium and content of his work. Exploring the subtle relationship among lifestyles, travel and the contemporary art environment, this was a work of performance art addressing Documenta's extremely tolerant curatorial approach.

In October 2010, Ai Weiwei presented the large-scale installation *Sunflower Seeds* in Tate Modern's Turbine Hall. Over 100 million ceramic sunflower seeds were handcrafted in the Jingdezhen, Jiangxi, expressing the artistic idea of "beauty in numbers." In recent years, Ai Weiwei has presented exhibitions at major art museums and galleries, attracting heavy media coverage. He has become one of the most newsworthy and influential artists in present-day China.

### Ai Weiwei at Taipei Fine Arts Museum

The solo exhibition *Ai Weiwei absent* at Taipei Fine Arts Museum presents 21 works from various periods of the artist's life, from 1983 to today,

including: 100 photos from his years in New York and in Beijing; *Dropping a Han Dynasty Urn; Study of Perspective; Table with Two Legs on the Wall; Table with Three Legs; Through; Circle of Animals; Colored Vases; Map of China; Watermelon; Grapes; Surveillance Camera; Coca Cola Vase; Helmet; Chair; Ruyi; Toy Car; Chang'an Boulevard; Beijing: The Second Ring* and *Beijing: The Third Ring.*

Ai's most recent work, created specifically for TFAM, *Forever Bicycles*. This installation piece is made up of more than 1,000 bicycles and will be shown in a display area that is 10m high. Its layered labyrinthine space creates what appears to be a moving abstract shape that symbolizes the way in which the social environment in China is changing. This is also the most bicycles Ai Weiwei has ever used in a single work to date and is certain to become a focus of attention during the exhibition. Also on display will be *Circle of Animals/Zodiac Heads*, huge bronze animal heads infused with historical dispute and sentiment. These large shapes are imbued with such a sense of both texture and volume that they have an immediate impact on the viewer and are certain to generate much discussion in the art community.

## Ridiculing and Provoking the Forbidden Halls of Power

Ai Weiwei radiates a naturally rebellious style, and is adept at thinking against the grain. His personality is remarkably polarized. He is drawn toward those who have something interesting to say, but at odds with those who do not. He habitually subverts all pre-determined questions and norms, to the point that one discovers the question itself to have become absurd, and the person asking the question may become overwhelmed by his counter-reaction and himself become the object of criticism. Ai's inspired playfulness is closely related to his mercurial, jesting attitude. By addressing public issues he is able to ingeniously incite debate on artistic questions. His *Circle of Animals* is one prominent example.

The twelve bronze sculptures that make up *Circle of Animals* were inspired by the twelve sculptures seated at the fountain in front of Haiyan Hall in the Qing-dynasty imperial Yuanming Gardens. In 1860, allied British and French forces razed the Yuanming Gardens, looting the zodiac heads along with many other cultural objects, which were eventually dispersed throughout many lands. After much turmoil, a Chinese company bought back some of the bronze heads at great expense. Almost all experts on cultural artifacts considered them to be worth far less than the price paid, but the buyer had acted on a sense of patriotic mission. To Ai Weiwei these national treasures suggested a host of questions to explore – the difference between authenticity and replication, and the meaning of value. The artist reproduced the 12 animal heads, pondering about attitudes toward historical artifacts and calling into question the somber issues of "plundering" and "repatriation", while also musing upon satire, triteness, grief and ignorance. Each of the animal heads in this work was produced at a scale approximately ten times larger than the originals.

The photographic work *Study of Perspective* makes use of perspective, a method of expressing distance on a two-dimensional surface by placing a remote object next to an object close at hand. In this picture Ai Weiwei directs his middle finger at a building standing at the core of power: Tiananmen, the "Gate of Heavenly Peace." With vivid spatial composition and visual image, and a strong air of anti-authoritarian provocation and contempt, the artist points mockingly and mischievously at an architectural symbol of centralized force, revealing his awareness of human rights and resistance to power, in a state of opposition between the meek and the mighty.

*Dropping a Han Dynasty Urn* is a photographic triptych recording the process of Ai Weiwei holding an antique urn in his hands, dropping it, and letting it shatter on the floor. Smashing the urn generates an alarming assault on the mind of the viewer. It is an exploration of the possibilities of visual surprise, and can be seen as a form of performance art. Ai Weiwei presents a personal stance regarding visual meaning, method of use and angle of observation, embody the pinnacle of artistic expression: a cutting-edge, sharp, random, divisive and highly creative energy that delivers extreme sensation to the viewer.

## Perception of Existence and Multidirectional Photography

From the 1980s to the early 1990s, Ai Weiwei lived in New York City, roaming with abandon in a

free, vast, foreign land. He always maintained an attitude of leisure, observing and experiencing the people, sights and sounds of the Big Apple, capturing with his camera what he happened upon by chance. With a vagabond disposition, he passed the idle hours of each day, camera in hand, filming the places he went, the people he met, the neighborhoods, streets and cities around him. Ai Weiwei's photos captured real scenes and realistic situations – people, light, distances, places. His lenses explored all manner of subjects. Strongly driven by his unique sense of taste, he achieved a new form of recognition of physical phenomena and concepts. Assertively pursuing and seizing images became the photographer's hallmark. Photographers believe the world's innate appearance includes both the mundane and the marvelous, and that they should create a force that stirs interest, determined by a new sense of vision. In the article "The Longest Road," Ai Weiwei stated, Modernism has no need for various masks or titles: it is the primal creation of the enlightened, it is the ultimate consideration of the meaning of existence and the plight of reality, it is keeping tabs on society and power, it does not compromise, it does not cooperate. Enlightenment is attained through a process of self-recognition, attained through a teeming thirst for and pursuit of an inner world, attained through interminable doubts and puzzlement." [1]

On photography, Ai Weiwei wrote: "Once photography has broken away from its original function as technique or means for documentation, it is merely a fleeting state of existence that has been transformed into one possible reality. It is this transformation that makes photography a kind of movement and gives it its distinctive significance: it is merely one type of existence. Life is merely an undisputable fact, and the production of an alternate reality is another kind of truth that shares no genuine relationship to reality. Both are waiting for something miraculous to occur - the reexamination of reality. As an intermediary, photography is a medium endlessly pushing life and perceived actions toward this unfamiliar conflict." [2] This description is both pragmatic and spiritual. The passage bespeaks how Ai Weiwei's understanding of the basic nature of photography arose from the actual process of taking pictures.

Among other works, this exhibition presents 100 photographs by Ai Weiwei, divided into two main series: those taken during his years in New York, and those taken in Beijing. The New York series, black-and-white photos from 1983 to 1993, documents East Village poetry readings, nude hippies in Tompkins Square Park, riot police, homeless people and drag queens. Equally compelling are the images of poets, painters, writers, musicians, actors, directors and conceptual artists in their younger days, including Ai Weiwei, Wang Keping, Ai Dan, Chen Kaige, Gu Changwei, Tan Dun, Jiang Wen, Feng Xiaogang, Chen Danqing, Liu Xiaodong, Bei Dao, Tsieh Tehching, C.J. Yao and Shu Ting. What they all share in common is a raw, mystified look in their eyes. The settings range from private homes to public places: parks, restaurants, subways, laundromats, alleys, Times Square, the Museum of Modern Art.

In 1993 Ai returned to China from New York. In order to continue the spirit of the East Village, he became a part of an experimental venue in Beijing, similar to the ones where artists would gather in New York, calling it Dongcun, which means "East Village" in Chinese. Here, Ai started a new chapter in his artistic journey. The artists that gathered there at the time produced a startling array of radical performance art, paintings, photos and installations. Examples include the performance art of Zhang Huan, Zhu Fadong, Cang Xin and Ma Liuming, the paintings of Mao Lizi, the black-and-white photos of Rong Rong, and the conceptual installations of Xu Bing. The art critic Li Xianting also joined their ranks. The Beijing Dongcun art movement was the first self-awakened movement to ruminate on the state of art in China. There, grassroots artists expressed their risks and struggles. It was one of the major nerve centers of contemporary Chinese avant-garde art.

**Conceptually Derived Serendipitous Object Art**

The conceptual art and readymades of Marcel Duchamp, his random selection and subtle, lyrical mode of expression, cast doubt on the meaning of traditional classical works in a derisive, jocular manner, while also endowing objects with alternative meanings through poetic rendering. Using everyday objects as stopgap artistic vehicles to form a sense of conflict, he made conceptual art mutually indistinguishable from readymade goods. Subverting traditional, ossified visual concepts, he let loose a uniquely shocking sense of taste. The objective of con-

1. Ai Weiwei, "The Longest Road," Ai Weiwei' s Blog: Writings, Interviews, and Digital Rants, 2006-2009, The MIT Press, 2011
2. Ai Weiwei, "Photography," Ai Weiwei' s Blog: Writings, Interviews, and Digital Rants, 2006-2009, The MIT Press, 2011

ceptual creation is to puncture the viewer's cognition, initiating a state of shock in which to reconsider the artistic values of the past, negating art as we know it. Ai Weiwei gained his artistic perspective largely from Duchamp. As early as 1985, Ai produced Hanging Man in which he bent a readymade metal coat hanger into the shape of Duchamp's profile, and filled part of it with sunflower seeds, placing it on a wood-grained floor panel. Expressing admiration for Duchamp, and also implicit homage, the work brims with cleverness. A quarter century later, Ai unveiled his brilliant installation of 100 million sunflower seeds at Tate Modern, demonstrating an astonishingly potent physicality.

In *Map of China* Ai assembled wood into the shape of Chinese territory, conveying political and geographical concepts. This work is a large-scale map composed of multiple layers of ironwood from a derelict Qing-dynasty temple. Slices of paneling cut vertically in geographical shape clearly reveal the vast terrain of China. Dissected from an artistic perspective, Ai Weiwei's sculpture in the shape of China is an emotional manifestation of his critical orientation toward culture, history, politics and society. While the American artist Jasper Johns's re-creations of objects endowed his works with neutrality – the entrancing, exquisite surfaces of Johns's oil paintings served the existence of the surface, not a national flag – in contrast, Ai's *Map of China* possesses both social and political significations and is filled with formal meaning and powerful tension.

*Coca Cola Vase* appropriates pop art's expres-sive technique of altered form, printing the vivid English logo of the popular mass-market product Coca-Cola on an antique ceramic vase. Coca-Cola is a commonplace beverage, its logo a popular symbol. After removing its function, the emblem of Coca-Cola endows the old vase with a new aesthetic interpretation. In exploring the integration of historical artifacts and pop brands, the constant interplay between consuming and being consumed, questions are raised about the definition of value, thus producing new possibilities for artistic and cultural expression.

Surveillance cameras are modern technological products. Not only does the footage they capture serve as on-site evidence of burglaries, they are also an essential tool for producing evidence in the age of scientific investigations. The work *Surveillance Camera* is sculpted from marble, symbolizing that no matter where we go, no one can escape constant monitoring. In this society where everyone may be threatened anywhere, the omnipresence of surveillance cameras prevents social disorder, and has come to be seen as a normal part of life. With his incisive observation of life experiences and politics, the artist responds to the controlling, contemptuous nature of the urban surveillance camera.

The ruyi is a decoration symbolizing good fortune. Collected and admired as an objet d'art, it is usually made of jade, bamboo or cow bone and fashioned in the shape of the medicinal mushroom lingzhi, or clouds, with a streamlined handle. Ai Weiwei's ceramic artwork *Ruyi*, with its curvilinear handle and dense colors, is particularly noteworthy for its cloud-head shaped in form of internal organs – perhaps a heart, liver or lung. The lingzhi, an auspicious symbol of longevity, becomes metaphorically incongruent when juxtaposed with familiar human anatomical elements, stimulating an ineffable and upsetting sense of paradox. The artist employs traditional techniques to reinterpret its real perception: a dualistic sensation that challenges the viewer visually and psychologically with a state of extreme opposition – propitiousness and peril, grace and vulgarity, fluidity and contradiction.

*Watermelon* is a humorous artwork comprised of 20 ceramic watermelons. The artist pokes fun at mass culinary culture, using surrealist methods of expression to comment on the everyday experience of eating, by transforming foods usually encountered through the sense of taste into purely visual objects. Through the transformation from edibility to a non-utilitarian function, enticing food items undergo a qualitative alteration. Produced with sophistication, the watermelons become gleaming, pretty objects, providing room to imagine whether delicious taste can last forever. The white, glossy, solid quality of the marble sculpture *Helmet* incites consideration of the issues of protection and safety. The helmet is a piece of protective gear commonly found in modern life and work, intimately familiar to motorcycle riders, factory workers and race car drivers. Since the artist himself was injured by a blow to the head, this sculpture suggests the possibility that it might be a safety helmet for Ai Weiwei's own body and soul. *Colored Vases* is

a visual spectacle part classical, part contemporary. Simple, unadorned antique vases are covered with bright paint. The uniformly shaped vases with their attractive colors suddenly become so dazzling as to be unfamiliar. The artist loves antique artifacts and collects old vases. Using a mechanized technique, he has poured industrial paint over Neolithic urns, causing a sense of conflict between the ancient vessels and their new cosmetic makeover, which challenges the viewer's perceptions and values. *Chair* and *Toy Car* were both crafted from single pieces of marble. Ai Weiwei attempts to maintain a certain distance between himself and his art by collaborating with traditional artisans, using their refined skills to produce sculptures in a variety of materials, such as marble and ceramics. The artist endows his materials with new identities through creative ideas, allowing for a greater range of possible outcomes.

**Idealistic Enactment of Architecture in the City**

Ai Weiwei's architectural works is minimalist. His use of gray brick walls appears natural and unpretentious – pure, simple expressions of the nature of the bricks themselves, exuding a visual aura of profound strength. Ai Weiwei's creations hover somewhere between art and architecture. He began to dabble in the latter field in 1999, designing his own studio as well as China Art Archives & Warehouse where he serves as artistic director. Eventually, he also took part in a series of both privately and publicly invested landscape and architectural design projects. These included landscape design for well-known real estate developer Pan Shiyi's project SOHO, and

for Commune By The Great Wall. And in 2002, Jinhua, his father's hometown in Zhejiang Province, commissioned him to design the Ai Qing Memorial Cultural Park and the Yiwu River Dam in the city's Jindong district.

In 2003, he served as an artistic consultant to the Swiss architecture firm Herzog & de Meuron, assisting in the design of the Beijing National Stadium (the "Bird's Nest"). During this period Ai Weiwei accepted many media interviews on the subjects of architecture and culture and was the focus of considerable attention and discussion. From 2004 to 2005 he made three conceptual films – *Chang'an Boulevard; Beijing: The Second Ring; and Beijing: The Third Ring*. The artist deliberately chose to present Beijing in the winter, recording in a prosaic, random manner and exploring the order and texture of the city's buildings and landscape, thereby implying a host of topics related to the city's role in the development of society, politics and the economy.

**Mental Formations and the Artistry of Structure and Volume**

From his early artistic creations, Ai Weiwei began employing old buildings and old furniture as media. He constantly dismantled old furniture and experimented with their parts, reassembling them as visual objects with unique shapes and structures – three-legged tables, a table with a pillar piercing through its center, two tables merged into one. In *Grapes*, Ai joined together 32 Qing-era stools like a cluster of grapes. The shape is fresh and surprising, surrounding and permeating the space with an atmosphere of

associations extended and proclaimed through Ai's cognition, emotion and imagination. From his mental imagery, we are led to a domain of uncertainty. The domain has no physical nor mental boundary. This is the artist's intuitive mental action upon form.

Ai Weiwei's large-scale installation *Through* deconstructs the image of an ornate building. He disassembled and reassembled the material from an old temple. After countless years of rubbing and scarring, its wooden beams had long ago been stripped of cosmetic decorations and drained of vitality. Numerous pillars pierced through tables, joined together in A-frame formations and altered into abstract shapes, transforming what was originally the orderly structure of an old building into a new arrangement of slanting branches. A systematic structure of right angles metamorphoses into a lopsided jumble. The artist boldly invades the space and engages in a dialogue of possibilities.

*Table with Two Legs on the Wall* and *Table with Three Legs* have the flavor of inversion and fragmentation. The works are composed of dismantled parts of Qing tables, pieced together into objects that appear to be tables and at the same time, not. They both use walls as points of support, forming an organic relationship between the objects and the spaces they inhabit. Regarding his materials, the artist reveals a contradictory bearing of appreciation and esteem, disdain and destruction, forcibly malpositioning and transforming the original form and structure to create an alternative object. This not only

demonstrates Ai Weiwei's unique taste and style, but also reflects a certain bizarre state within the reality of contemporary Chinese society.

The installation *Forever Bicycles* manifests the motive force of collective progress. Throughout the process of modern art history "accident" and "luck" are major concepts involved in breaking the rules of art. In 1913, Duchamp mounted a bicycle wheel upside down on a stool in his studio, and it serendipitously became a work of art. The bicycle was originally a tool of mass transportation, both familiar and intimate. Disconnecting this object from its utility transformed it into a vehicle for art. Similarly, with his own personal wit and preferences, Ai Weiwei enhances and glorifies the concept of utilitarian readymades. Addressing the loftiest space at Taipei Fine Arts Museum, he designed the installation *Forever Bicycles*, an enormous structure composed of 1,200 bicycles. The construction of this piece was a daunting challenge. Superimposed layer upon layer, the bicycle axles form a labyrinthine space. The viewer can ponder the beauty of abstract forms from any number of angles and perspectives and feel the mighty energy and charisma radiating from it.

十二生肖
**Circle of Animals**

青銅
Bronze
尺寸不等 · 2010 variable dimensions
余德耀基金會 · Courtesy of the Yuz Foundation, Jakarta

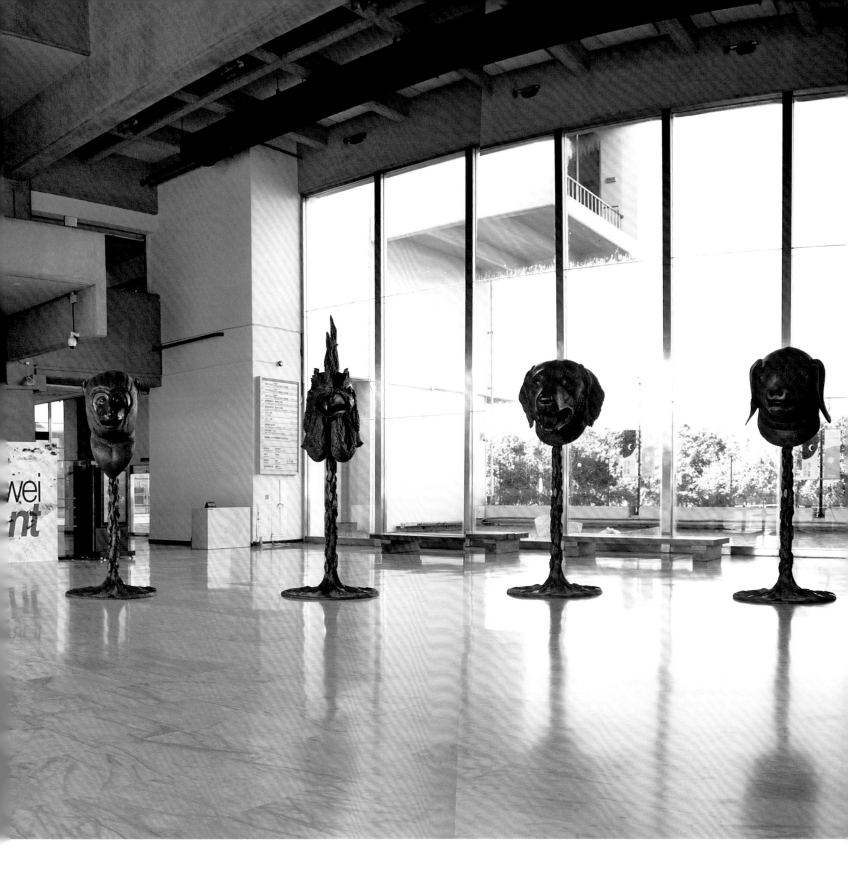

## 十二生肖局部
## Detail of Circle of Animals

Ⅰ.鼠 Rat · 163×130×293 cm · 415kg
Ⅱ.牛 Ox · 157×152×322 cm · 465kg
Ⅲ.虎 Tiger · 155×130×310 cm · 456kg

Ⅰ

# 十二生肖局部
## Detail of Circle of Animals

IV . 兔 Rabbit · 150×130×325 cm · 435kg
V . 龍 Dragon · 190×158×355 cm · 650kg
VI . 蛇 Snake · 150×130×299 cm · 454kg

IV

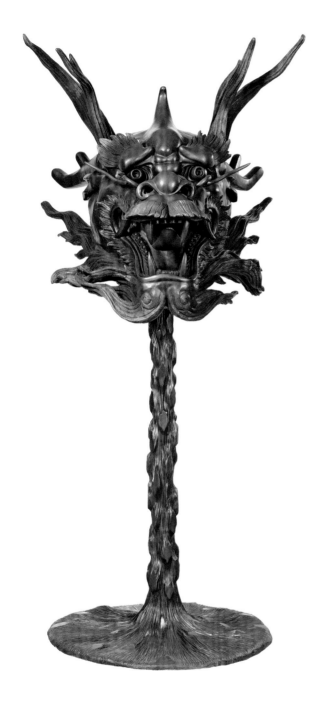

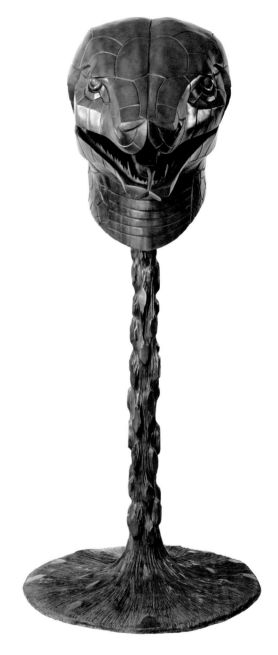

V

VI

十二生肖局部
**Detail of Circle of Animals**

Ⅶ . 馬 Horse · 147×130×302 cm · 450kg
Ⅷ . 羊 Lamb · 156×154×310 cm · 480kg
Ⅸ . 猴 Monkey · 130×130×300 cm · 382kg

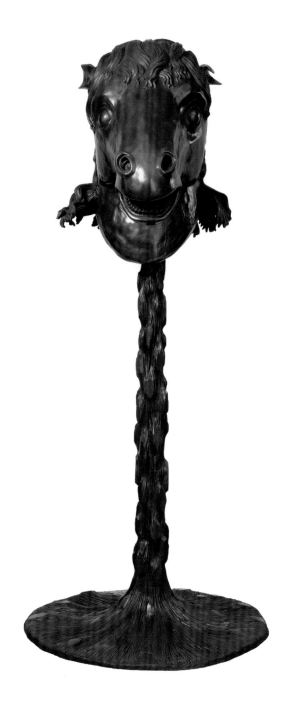

VII

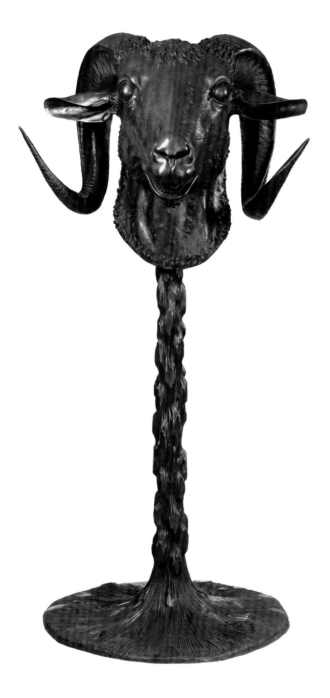

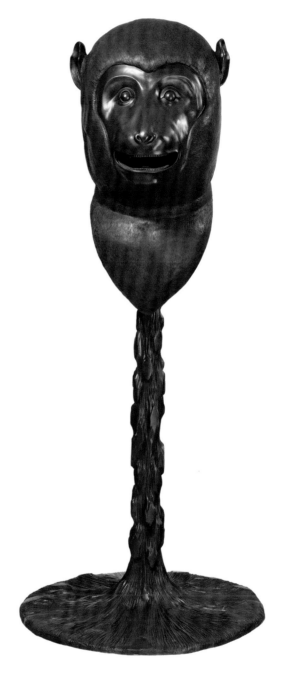

VIII

IX

十二生肖局部
**Detail of Circle of Animals**

Ⅹ．雞 Rooster · 150×130×380 cm · 495kg
Ⅺ．狗 Dog · 165×130×130 cm · 502kg
Ⅻ．豬 Pig · 175×130×312 cm · 462kg

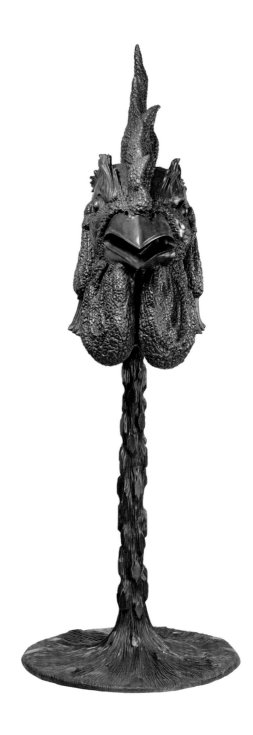

X

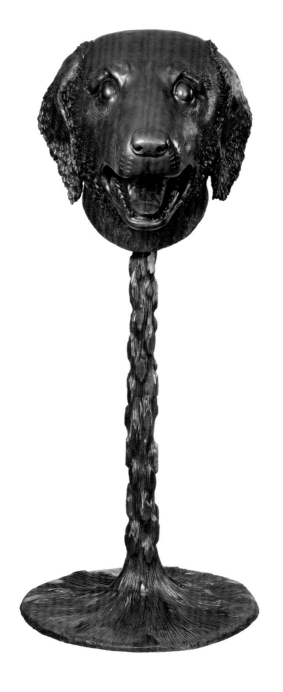

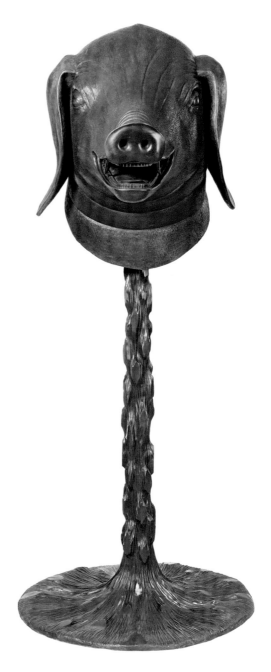

XI                                                                                                          XII

透視學
**Study of Perspective**

天安門 · Tiananmen Square
黑白印刷
b/w print
90×127 cm · 1995

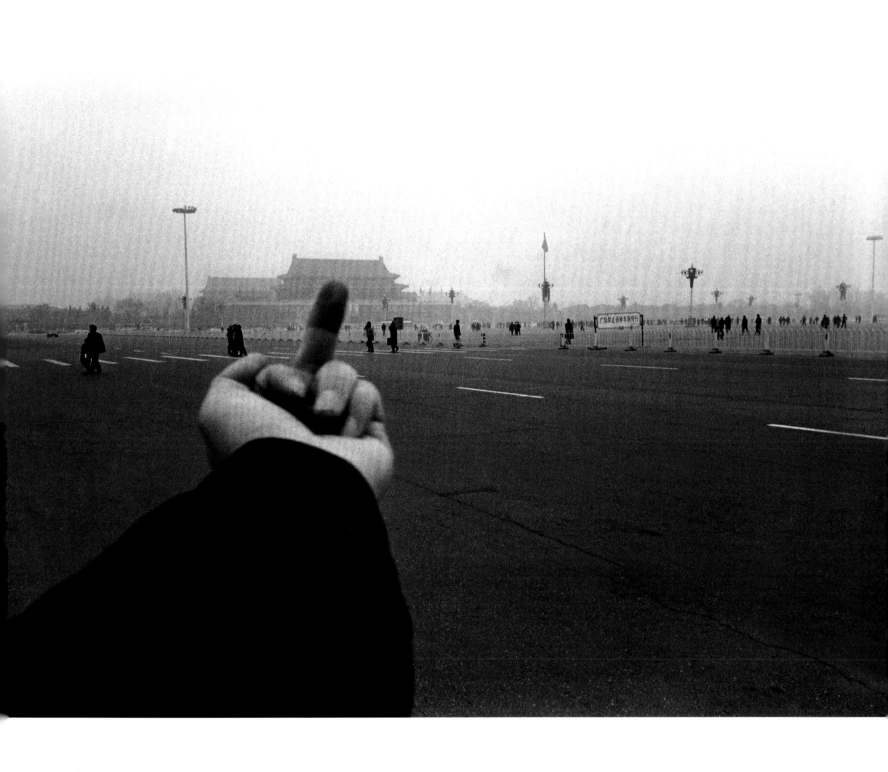

失手
**Dropping a Han Dynasty Urn**

三連聯 黑白印刷 · 200×190 cm×3 幅
3 b/w prints · each 200×190 cm
1995

三連聯 黑白印刷 · 200×190 cm×3 幅

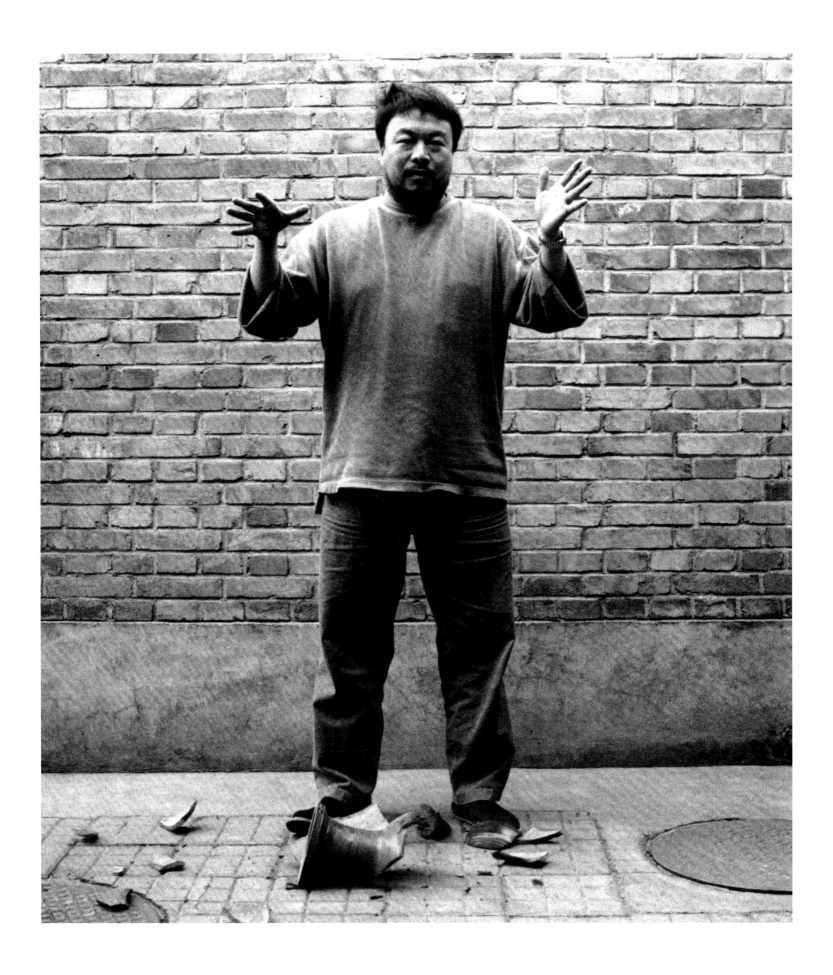

# 紐約 1983~1993
# New York 1983~1993

1. 衣架人和葵花籽
   Hanging Man with Sunflower Seeds
   1983

1

自拍
Self-portrait
1983

I . 在下東城區
Lower East Side
1985

II . 舒婷
Shu Ting
1986

I

II

I. 郭衛、胡詠言、周臨 · 東三街公寓
Guo Wei, Hu Yongyan, Zhou Lin /
East 3rd Street Apartment
1986

II. 王穎和譚盾 · 東三街公寓
Wang Ying & Tan Dun / East 3rd Street Apartment
1986

I

II

I. 周臨和卡瑪的禮物
   Zhou Lin and Carma's gift
   1986

II. 陳凱歌．金字塔俱樂部
    Chen Kaige, Pyramid Club
    1986

I

II

Ⅰ. 譚盾
Tan Dun
1986

Ⅱ. 胡詠言
Hu Yongyan
1986

Ⅰ

Ⅱ

I. 胡詠言、徐惟聆．在格林威治村街頭表演
Hu Yongyan, Xu Weiling,
Street Performance in Greenwich Village
1986

II. 徐惟聆和胡詠言
Xu Weiling & Hu Yongyan
1986

I

II

I. 周臨和貓 · 三藩市
Zhou Lin and cat, San Francisco
1986

II. 自拍
Self-Portrait
1986

I

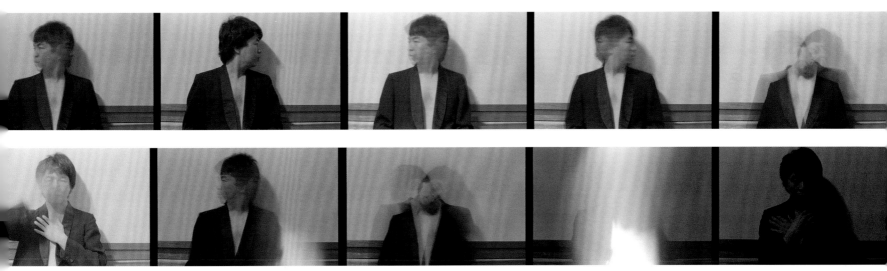

II

I. 艾丹、行人
Ai Dan, Pedestrian
1987

II. 地鐵站口
Subway Entrance
1987

III. 艾丹和艾未未‧自助洗衣店
Ai Dan & Ai Weiwei‧Laundromat
1987

IV. 大都會歌劇院後臺‧八街地鐵站
Backstage at the Met‧8th Street Subway Station
1987

I

II

III

IV

I. 艾丹
   Ai Dan
   1987

II. 鏡子
    Mirror
    1987

I

II

Ⅰ. 世貿中心的地下商場
   Basement of the World Trade Center
   1987

Ⅱ. 在杜尚作品前‧紐約現代美術館
   In front of Duchamp's work‧
   Museum of Modern Art
   1987

Ⅲ. 在紐約現代美術館
   At the Museum of Modern Art
   1987

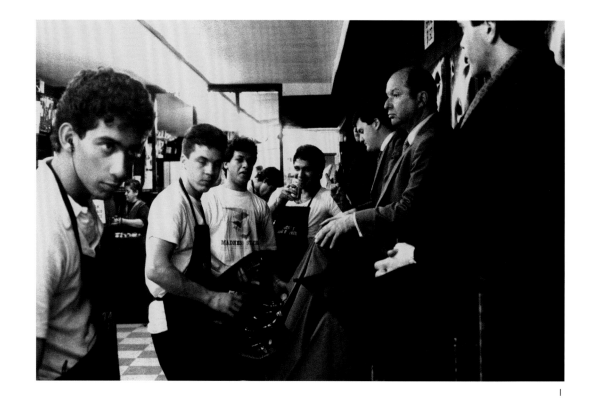

Ⅰ

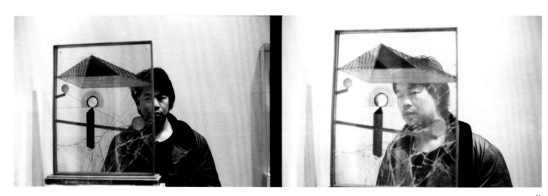

Ⅱ

Ⅲ

Ⅰ. 工會廣場地鐵站
Union Square Subway Station
1987

Ⅱ. 譚盾·在地鐵口
Tan Dun · Subway
1987

Ⅰ

Ⅱ

I. 大都會歌劇院的《圖蘭多》彩排
Dress Rehearsal for Turnadot
at the Metropolitan Opera
1987

II. 來自臺灣的學電影的學生
A Film Student from Taiwan
1987

I

II

I. 在時代廣場街頭畫肖像
Portrait Artist in Times Square
1987

II. 自拍
Self-Portrait
1987

I

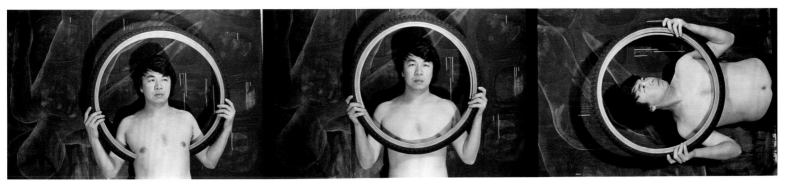

II

I. 東三街衛生間
East 3rd Street Bathroom
1987

II. 東村兩位著名的無家可歸者
East Village's Two Most Famous Homeless People
1987

I

II

Ⅰ. 王克平和艾未未
Wang Keping & Ai Weiwei
1987

Ⅱ. 姚慶章
Yao Qingzhang
1988

Ⅰ

Ⅱ

I. 謝德慶・蘇荷
Hsieh Tehching in Soho
1988

II. 公園抗議活動中的員警
Police at a Park Protest
1988

I

II

Ⅰ. 流血的抗議者·湯普金斯廣場公園暴亂
Bleeding Protestor·Tompkins Square Park Riots
1988

Ⅱ. 艾倫·金斯伯格在電話上
Allen Ginsberg on the phone
1988

Ⅲ. 東村的逮捕
East Village Arrest
1988

Ⅳ. 一家猶太人
A Jewish Family
1988

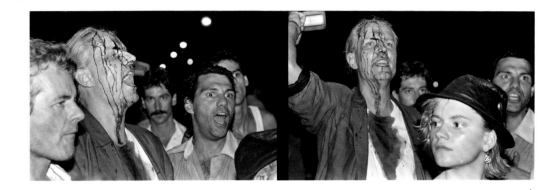

Ⅰ

Ⅱ

Ⅲ

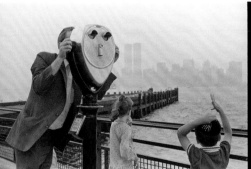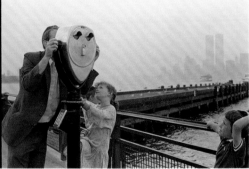

Ⅳ

I. 華盛頓廣場公的抗議活動
   Washington Square Park Protest
   1988

II. 炮臺公園
    Battery Park
    1988

I

II

Ⅰ. 塔瓦納 · 布勞雷抗議活動
Tawana Brawley Protest
1988

Ⅱ. 在下東城區的餐館中
Lower East Side Restaurant
1988

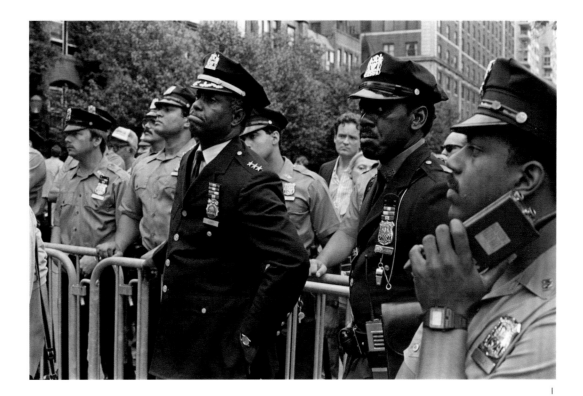

Ⅰ

Ⅱ

Ⅰ. 顧長衛‧勿街的中國新年
Gu Changwei‧Chinese New Year on Mott Street
1989

Ⅱ. 勿街的中國新年
Chinese New Year on Mott Street
1989

Ⅰ

Ⅱ

I. 羅伯特 · 弗蘭克和艾倫 · 金斯伯格
Robert Frank & Allen Ginsberg
1989

II. 帶側影的肖像
Portrait with Profile
1989

III. 倒下
Fallen
1990

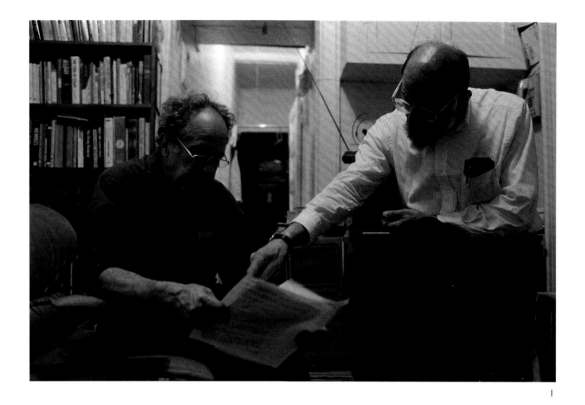

I

II

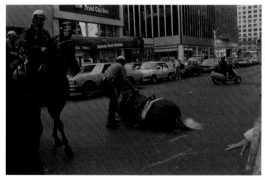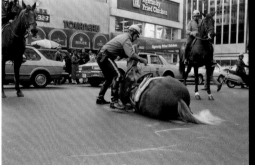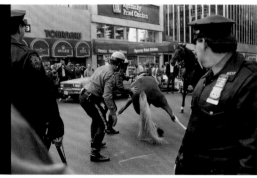

III

Ⅰ. 在鮑厄裡街換崗的員警們
Police Changing Shifts‧Bowery
1989

Ⅱ. 比爾‧克林頓競選的最後時刻‧紐約
Bill Clinton at his last campaign stop in New York
1992

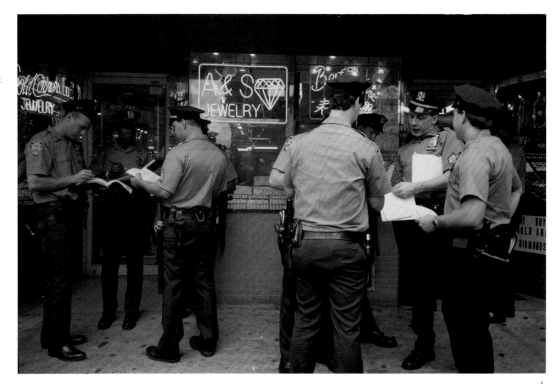

Ⅰ

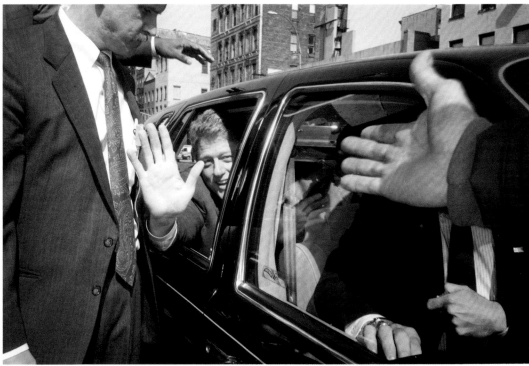

Ⅱ

Ⅰ

Ⅱ

Ⅲ

Ⅳ

I. 馮小剛
Feng Xiaogang
1993

II. 馮小剛在一輛租來的計程車上 ‧ 時代廣場
Feng Xiaogang on top of a rented taxi
Times Square
1993

I

II

Ⅰ. 馬曉晴、姜文
Ma Xiaoqing, Jiang Wen
1993

Ⅱ. 劉小東和喻紅在陳丹青位於四十二街的畫室中
Liu Xiaodong & Yu Hong at Chen Danqing's 42nd Street Studio
1993

Ⅰ

Ⅱ

## 北京 1993-2001
## Beijing 1993-2001

Ⅰ. 東四十三條四合院
Dongsishisantiao Courtyard
1994

Ⅱ. 路青、白宜洛、莊輝等人·河南洛陽
Lu Qing, Bai Yiluo, Zhuang Hui and others
Luoyang, Henan
1994

Ⅲ. 老三
Lao San
1998

Ⅰ

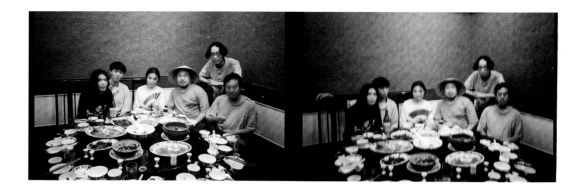

Ⅱ

Ⅲ

I. 人像：莊輝、蒼鑫、馬六明（由上至下）
  Portraits: Zhuang Hui, Cang Xin, Ma Liuming
  (from up to down)
  1994

II. 人像：路青、艾未未、莊輝（由上至下）
  Portraits: Ai Weiwei, Lu Qing, Zhuang Hui
  (from up to down)
  1994

I

II

Ⅰ. 張洹、路青、榮榮、艾未未（由左至右）・東四十三條四合院
Zhang Huan, Lu Qing, Rong Rong, Ai Weiwei (from left to right) · Dongsishisantiao Courtyard
1994

Ⅱ. 余心樵、艾丹、左小祖咒（由左至右）・東四十三條四合院
Yu Xinqiao, Ai Dan, Zuoxiao Zuzhou (from left to right) · Dongsishisantiao Courtyard
1999

Ⅲ.〈傾斜的桌子〉
Slanted Table
1997

Ⅰ

Ⅱ

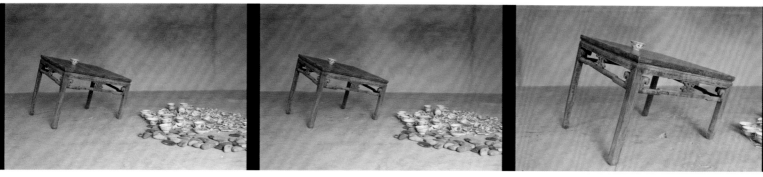

Ⅲ

Ⅰ. 路青‧攝於工作室
Lu Qing‧Studio shots
1997

Ⅱ. 自拍
Self-portrait
1996

Ⅰ

Ⅱ

I. 張洹作品〈65KG〉細節
   Details of 65KG by Zhang Huan
   1994

II. 張洹的行為藝術作品〈65KG〉
   Performance piece by Zhang Huan, 65KG
   1994

I

II

I. 毛栗子、魏京生、徐冰（由左至右）‧東四十三條
Mao Lizi, Wei Jingsheng, Xu Bing
(from left to right)
Dongsishisantiao
1993

II. 在東村最後的照片
Last photo in the East Village
1994

III. 在東村最後的晚餐
Last dinner in East Village
1994

IV. 在東四十三條家裡
At home in Dongsishisantiao
1994

I

II

III

IV

I

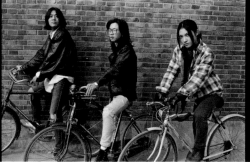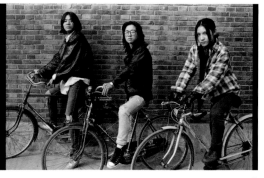

II

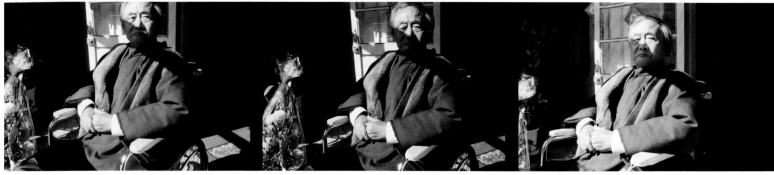

III

I . 安裝 Whitewash
Installing Whitewash
2000

II . 製作 Whitewash
Making of Whitewash
2000

III. 清洗新石器時代的石頭
Washing Neolithic rocks
2001

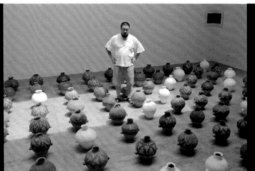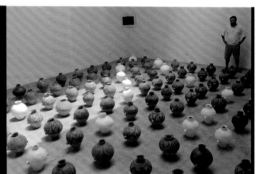

I

II

III

I. 張洹〈12m2〉
Zhang Huan, 12m2
1994

II. 自拍像・草場地工作室
Self-portrait・Caochangdi studio
2001

I

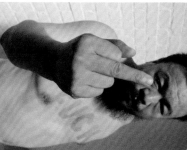

II

I . 張洹〈65KG〉
  Zhang Huan, 65KG
  1994

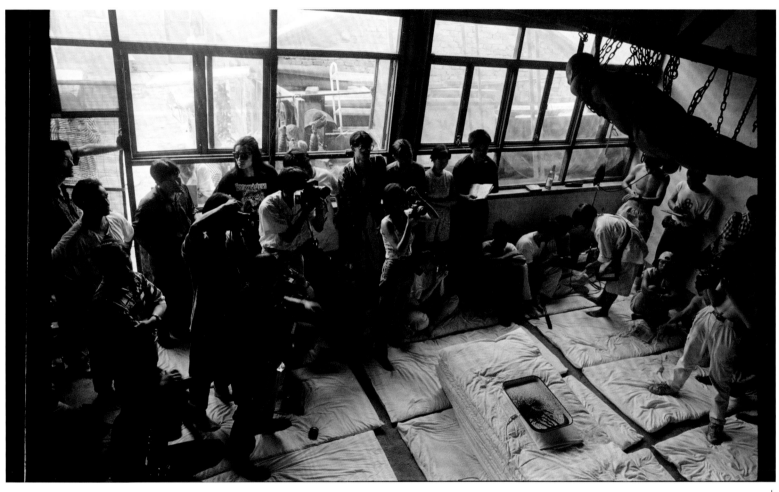

I

**長安街**
**Chang'an Boulevard**

錄像
Video
10" 13' · 2004

长安街·北京　　　2004
Chang' an Boulevard·Beijing　2004

北京：二環
**Beijing: The Second Ring**

錄像
Video
1" 6' · 2005

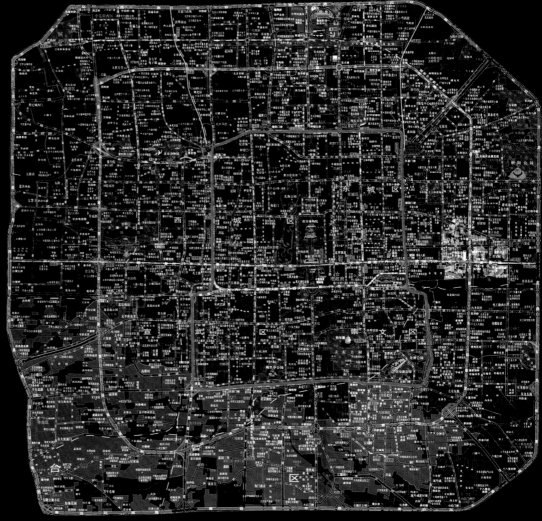

北京 · 二环立交桥    2005
The Second Ring · Beijing  2005

**北京：三環**
**Beijing: The Third Ring**

錄像
Video
1" 50' · 2005

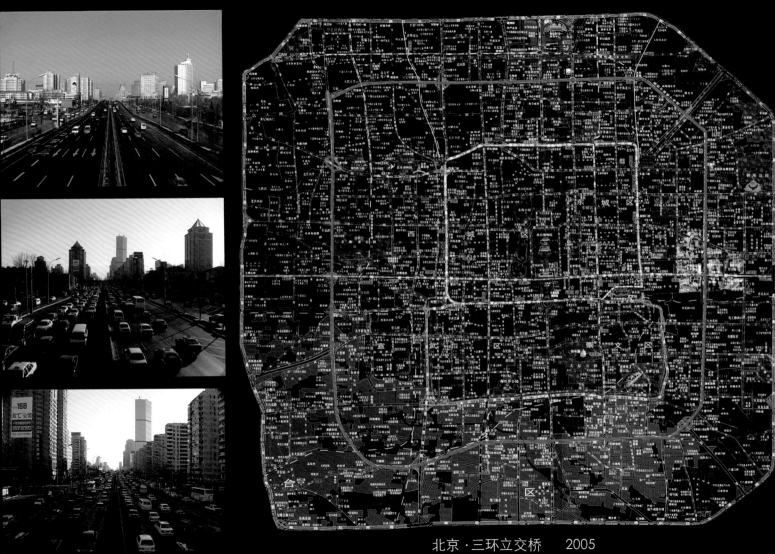

北京・三环立交桥　　2005

中國地圖
**Map of China**

清朝廟宇的鐵力木（1644~1911）
Tieli wood from dismantled temples of the Qing Dynasty（1644~1911）
150×150×50 cm · 2004

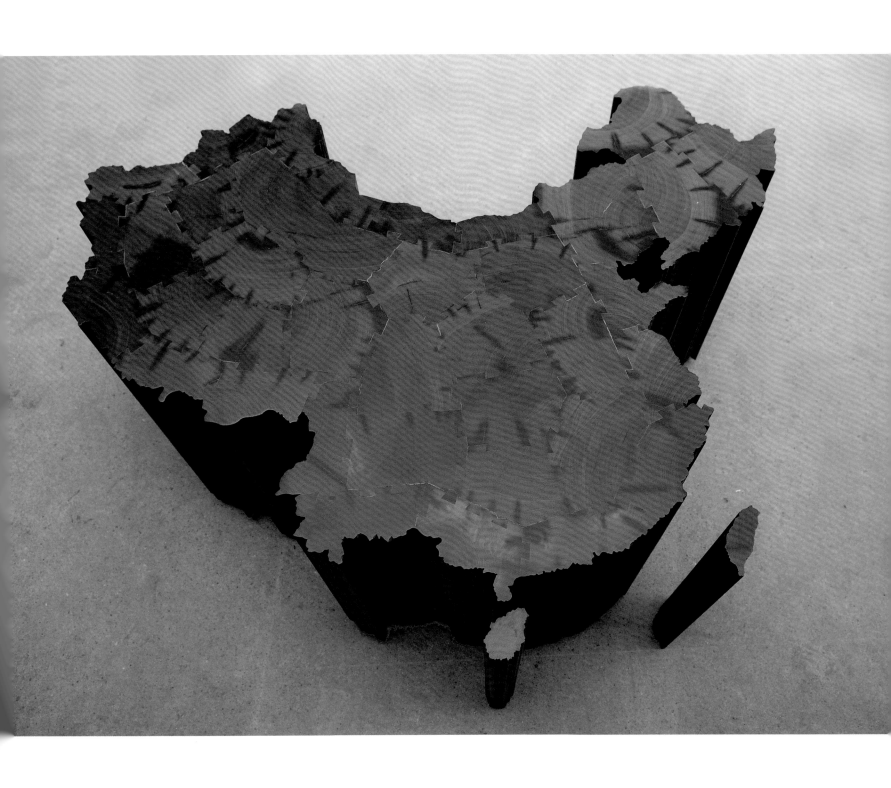

**可口可樂罐子**
**Coca Cola Vase**

漢朝陶罐（202BC-220AD）、工業用顏料
Han Dynasty vases (202 BC-220 AD) and industrial paint
35×35×26 cm · 2010

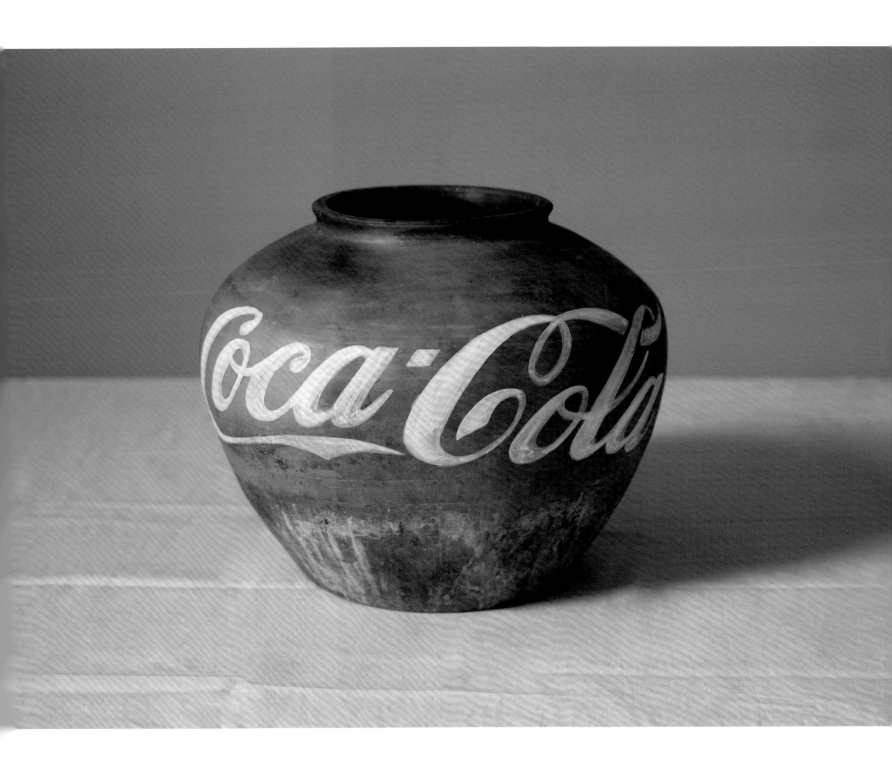

**監視攝像頭**
**Surveillance Camera**

大理石
Marble
40×40×20 cm · 2010

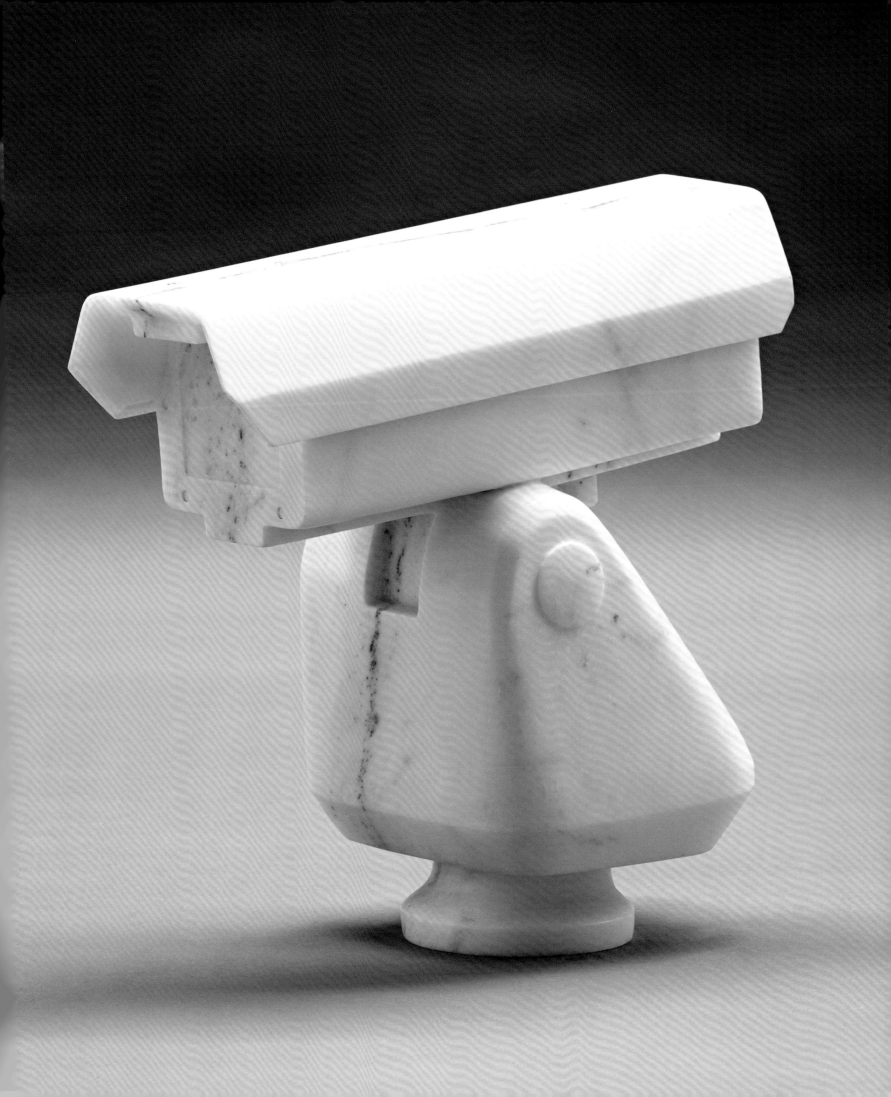

**如意**
**Ruyi**

瓷
Porcelain
81×28×20 cm · 2006

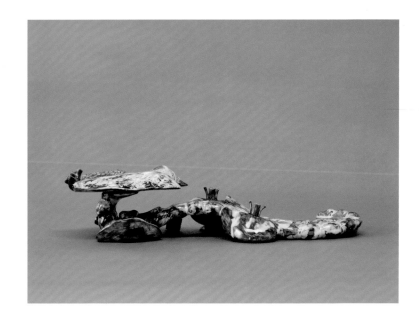

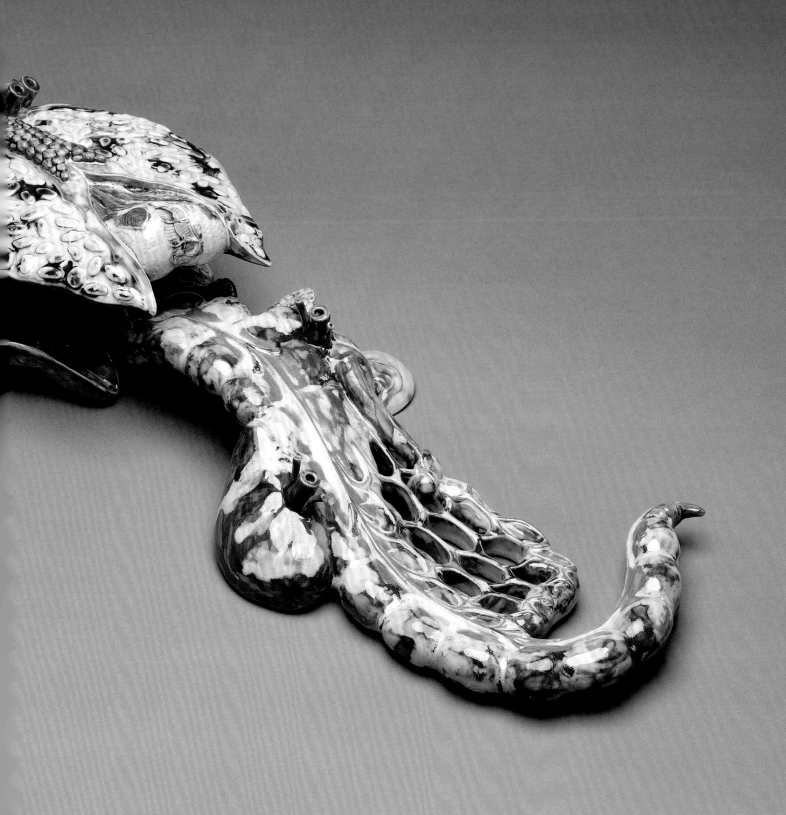

西瓜
**Watermelon**

瓷
Porcelain
Ø 38 cm each, 每個 Ø 38cm

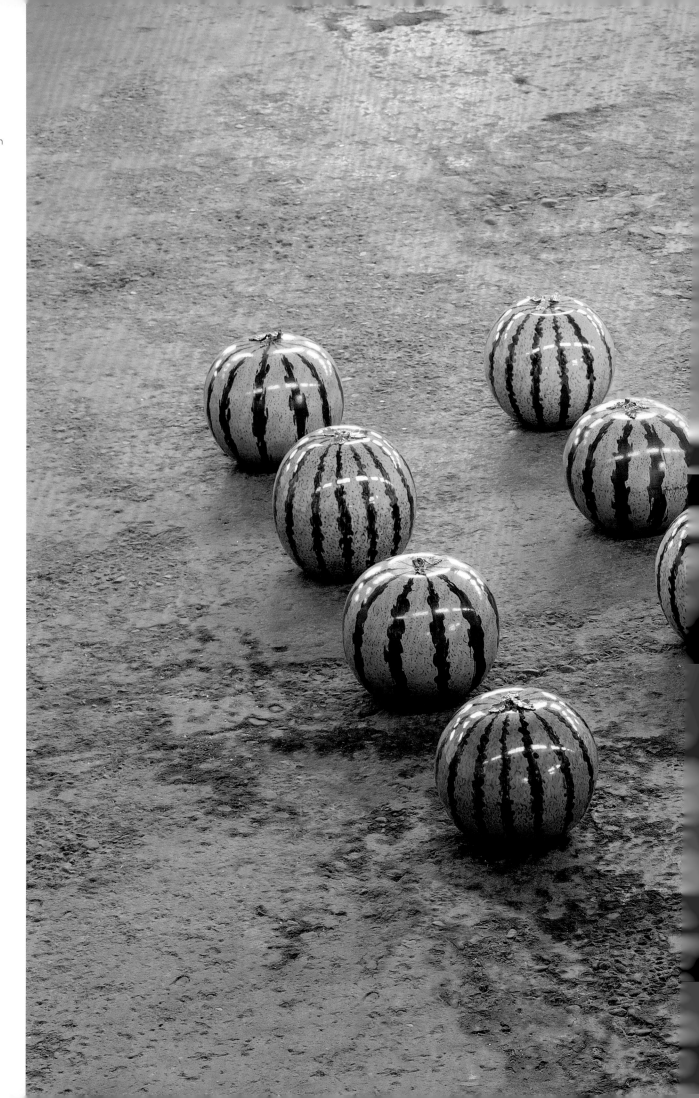

**安全帽**
**Helmet**

大理石
Marble
30×25×15 cm · 2010

# 彩罐
## Colored Vases

新石器時代陶罐（5000~3000 BC）、工業用顏料
Neolithic vases (5000~3000 BC) and industrial paint
尺寸不等．2010
Dimensions variable, 2010

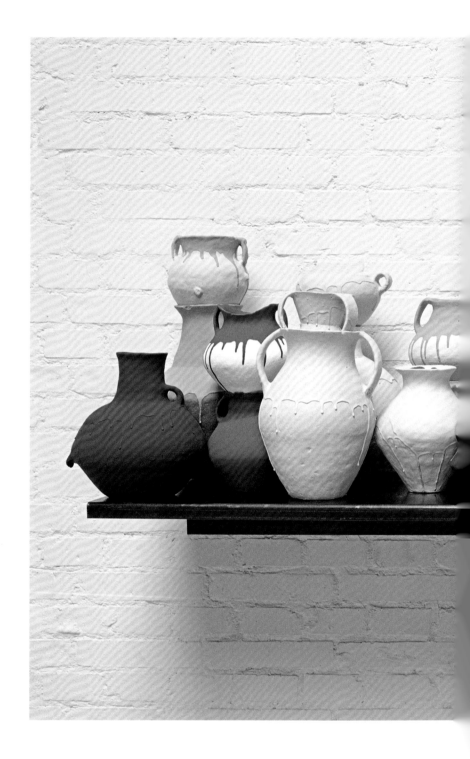

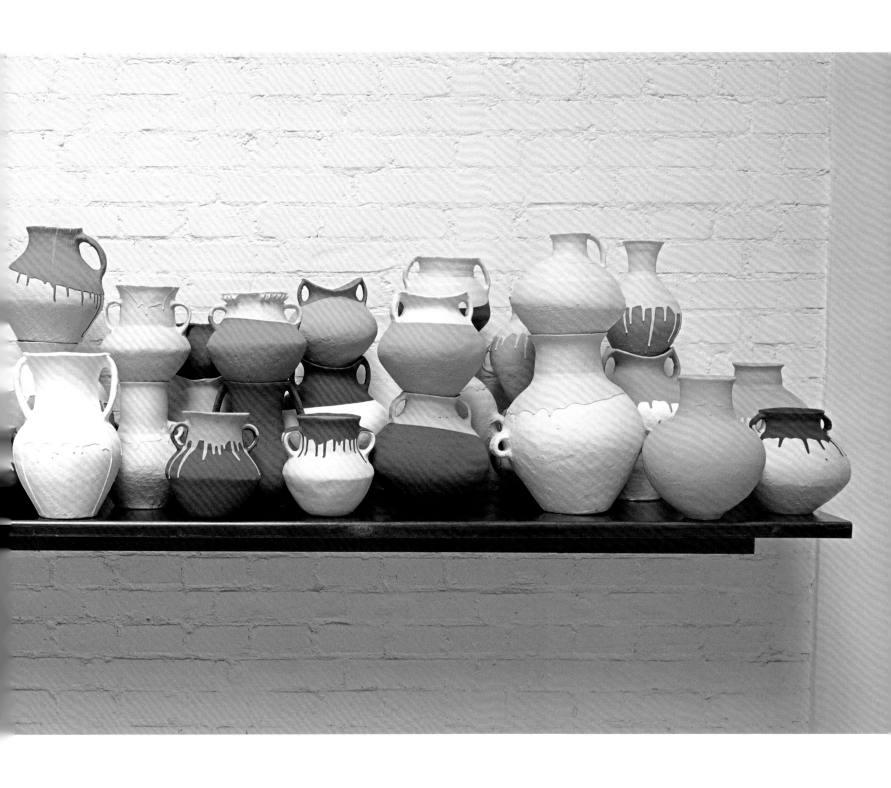

## 椅子
## Chair

大理石
Marble
120×56×46 cm · 2008

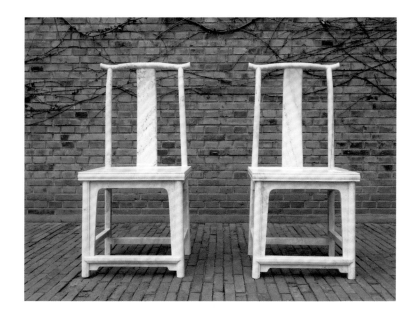

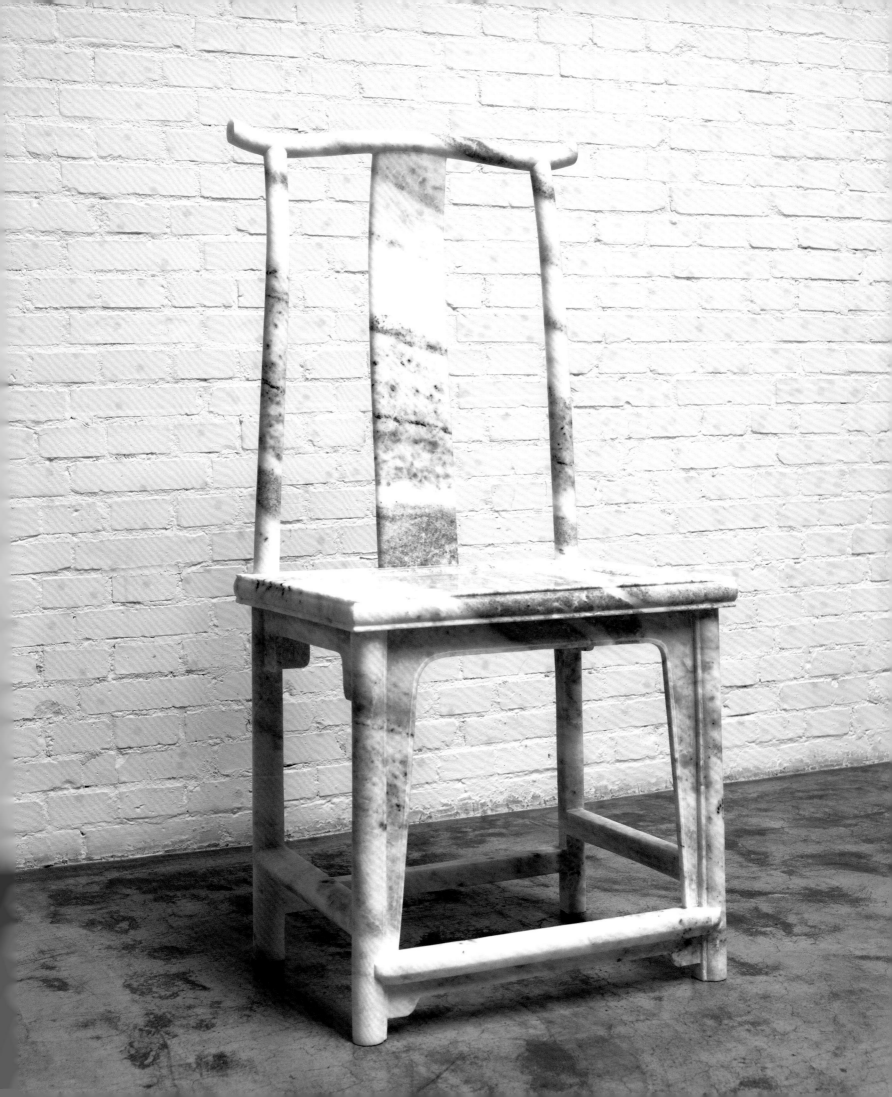

## 玩具車
## Toy Car

大理石
Marble
70×34×42 cm · 2010

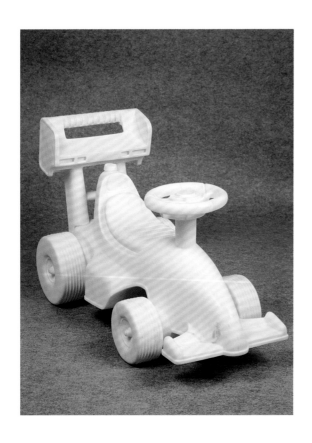

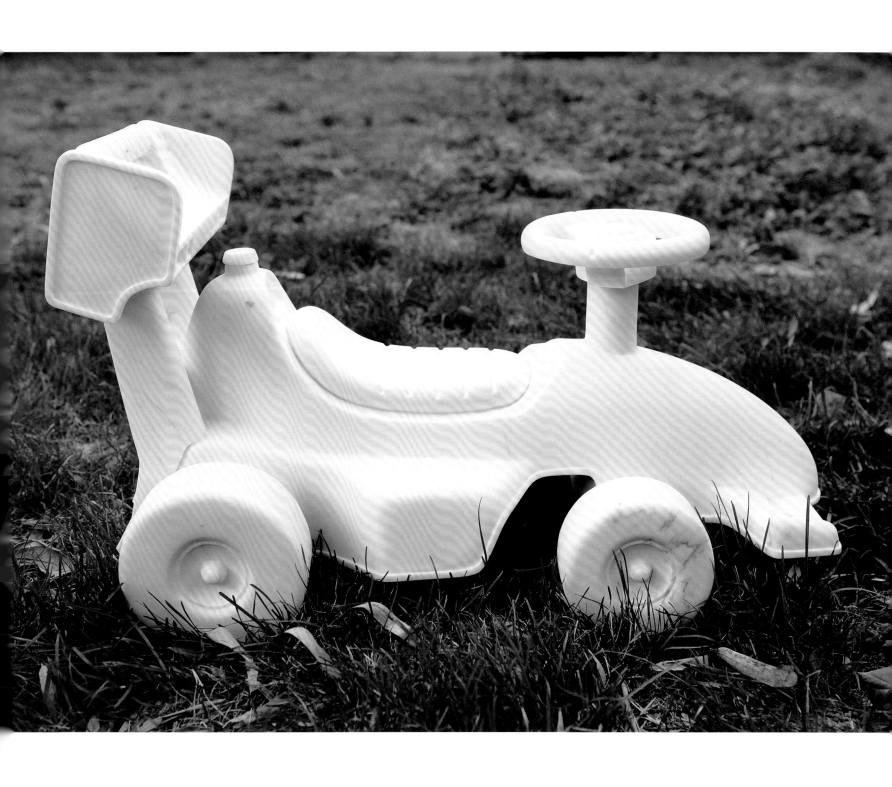

**葡萄**
**Grapes**

清朝板凳（1644~1911）
32 stools from the Qing Dynasty（1644~1911）
167×174×140 cm · 2010

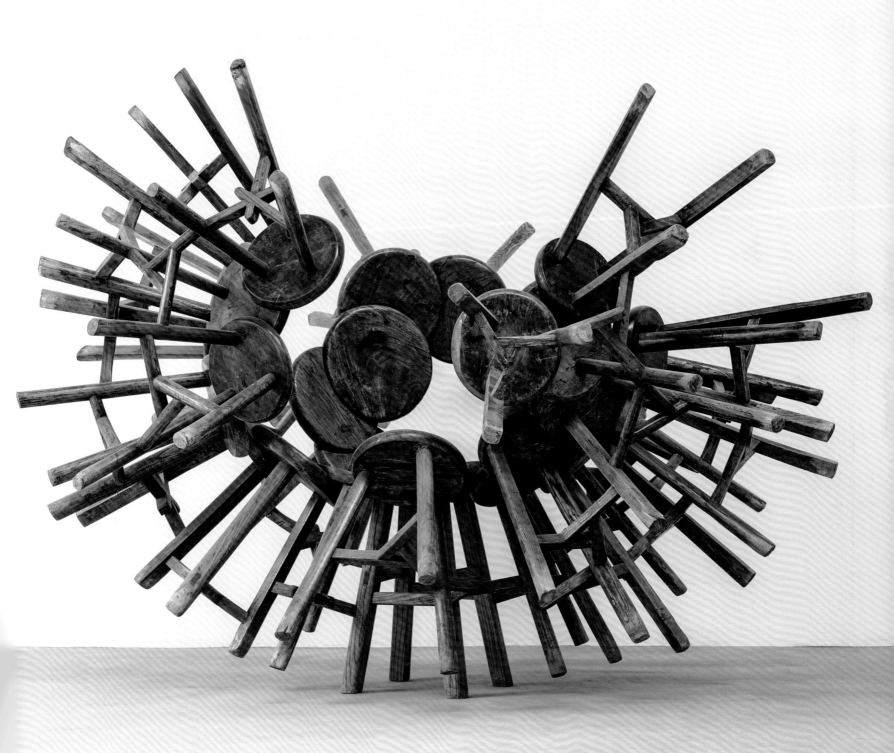

## Through

清朝廟宇的鐵力木桌子、樑柱（1644~1911）
Tables, parts of beams and pillars made of Tieli wood from dismantled temples of Qing Dynasty（1644~1911）
850×1380×550 cm · 2007-2008

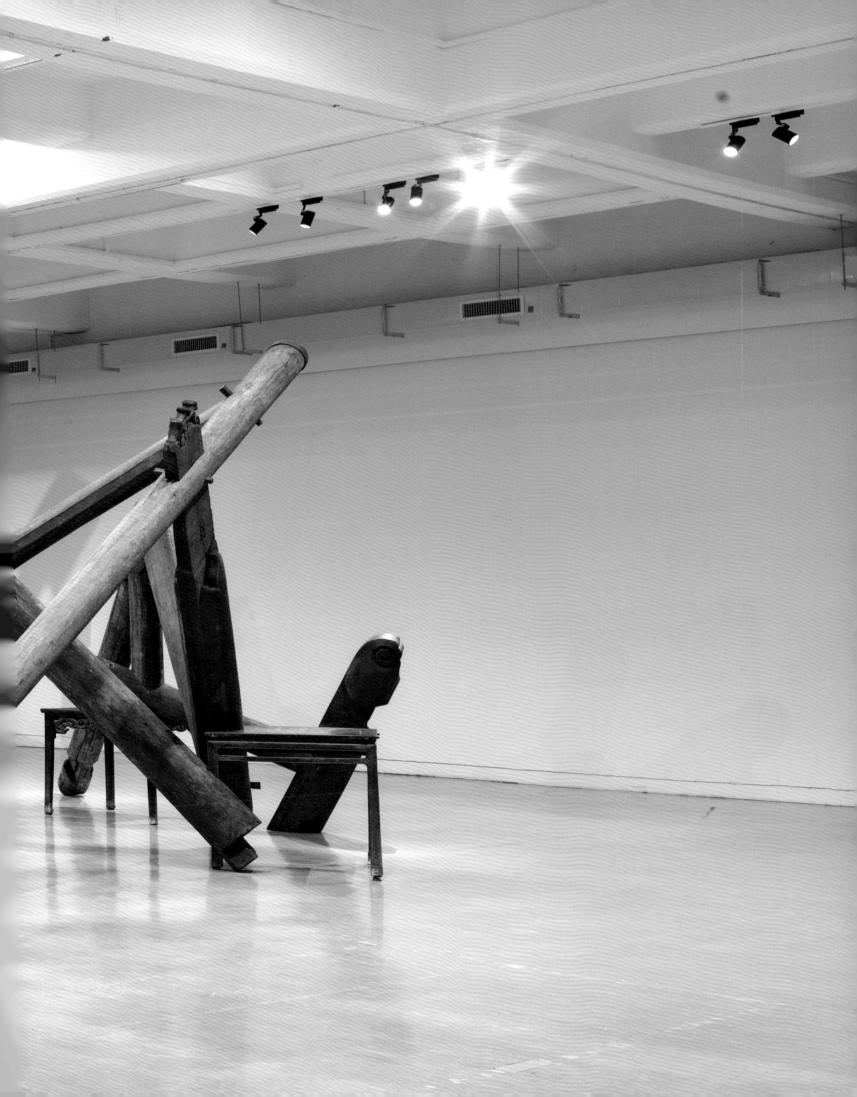

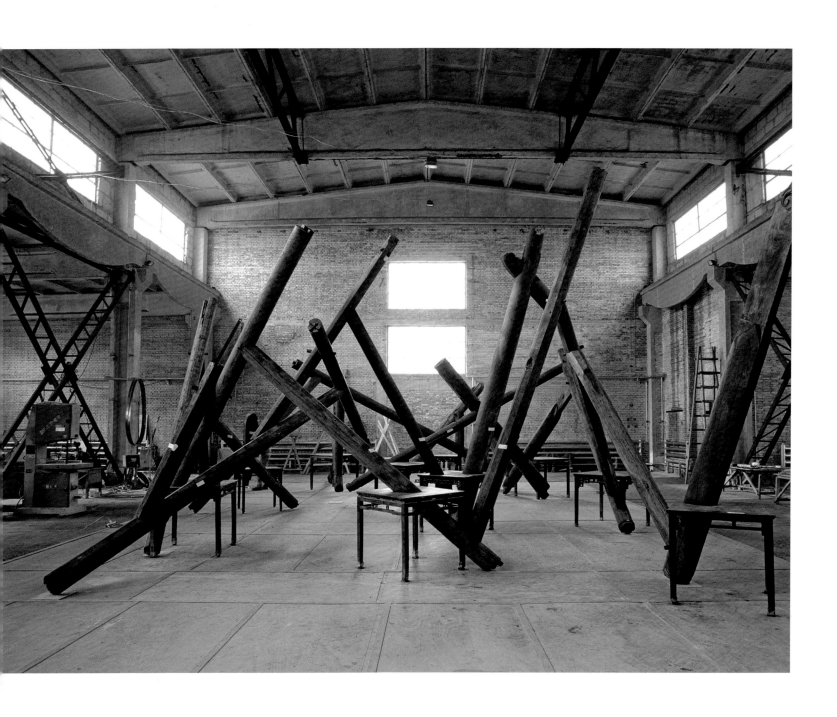

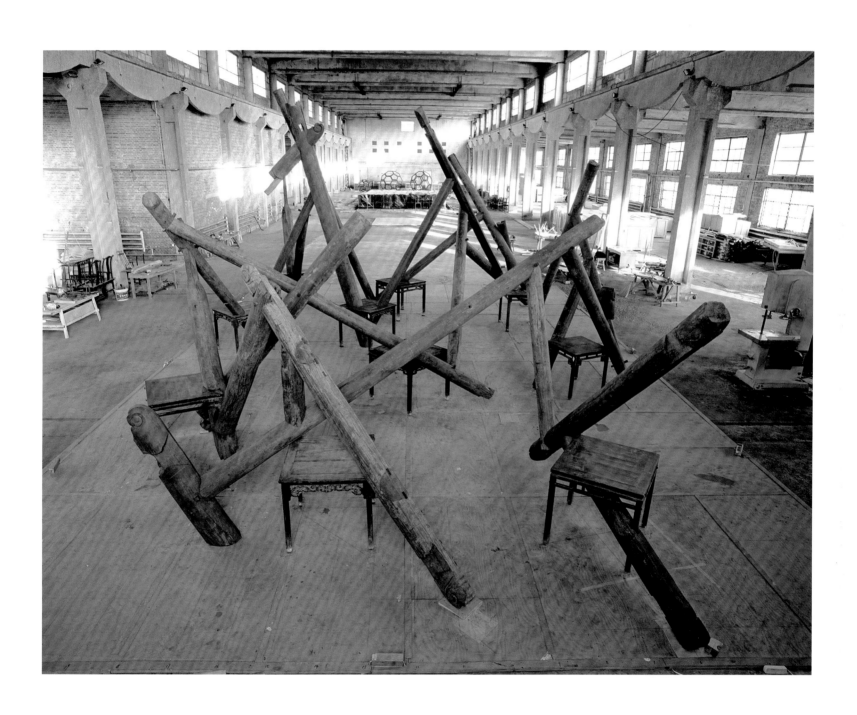

**兩條腿在牆上的桌子**
**Table with Two Legs on the Wall**

清朝桌子（1644~1911）
Table from the Qing Dynasty（1644~1911）
98×120×124 cm · 2010

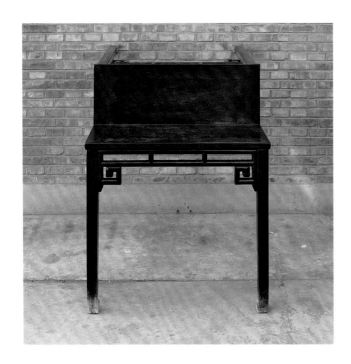

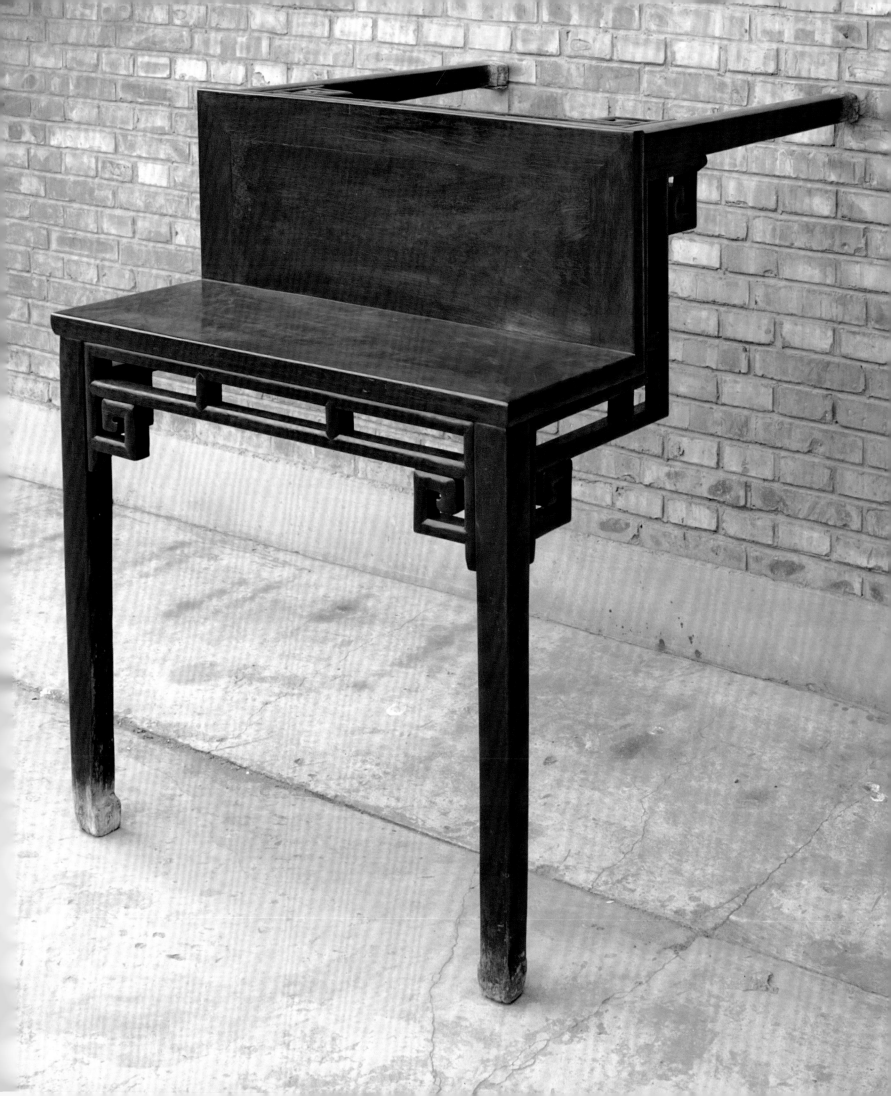

三條腿的桌子
**Table with Three Legs**

清朝桌子（1644~1911）
Table from the Qing Dynasty（1644~1911）
164×193×116 cm · 2010

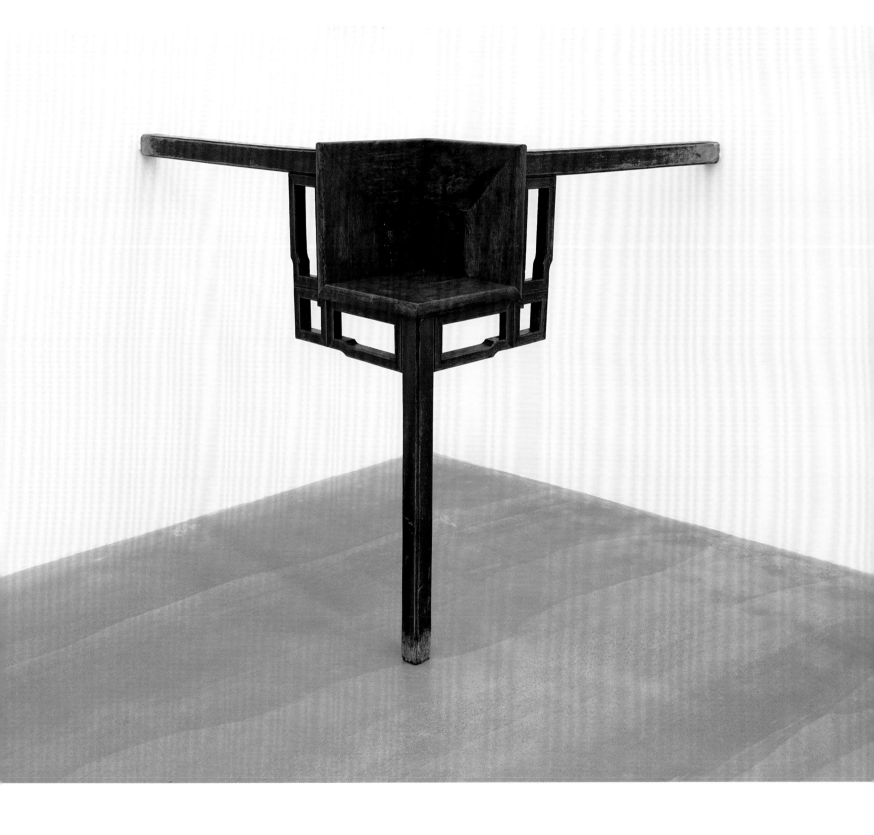

永久自行車
**Forever Bicycles**

1,200 輛腳踏車
1,200 bicycles
262.8×95.7 m · 2011

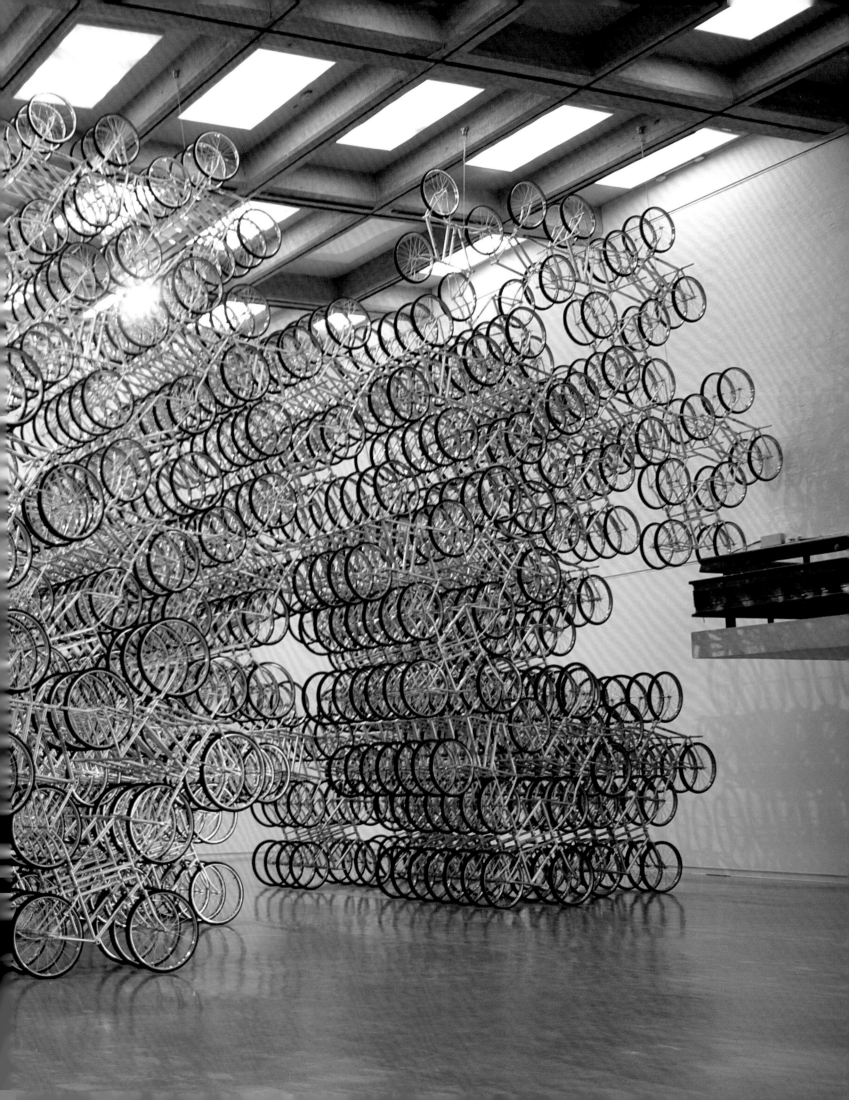

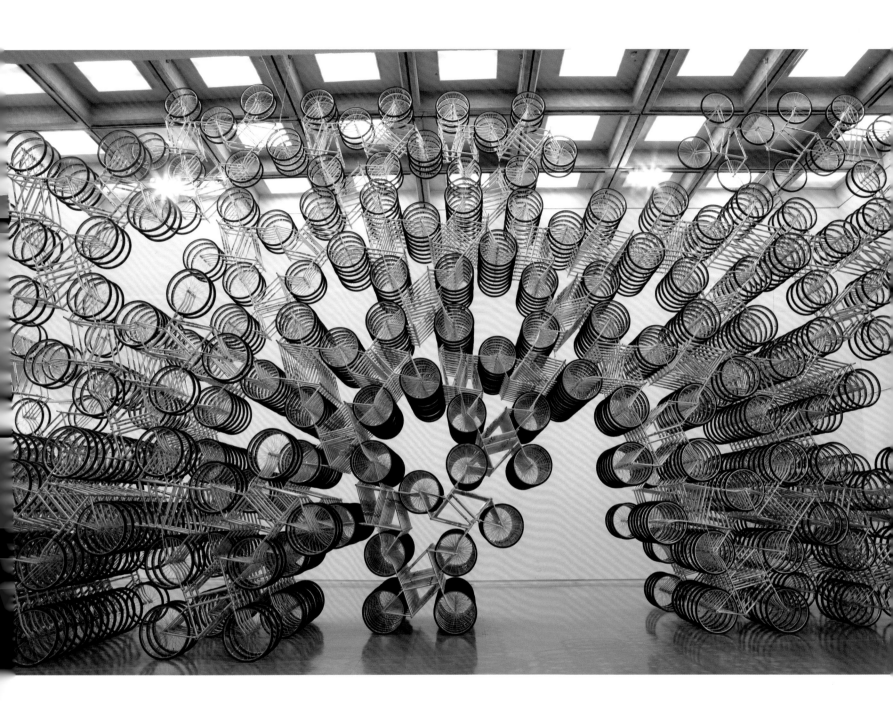

# 艾未未簡歷

1957       生於北京
                現生活和居住於中國北京

**大事輯錄**

2013       發表第一張音樂專輯《神曲》
                參與威尼斯雙年展
2012       自我監視項目 WeiWeiCam 在發表以後 46 小時遭中國官方勒令關閉
                十天內於網上籌集近 9 百萬人民幣以作發課公司稅案保證金
2011       被取保候審，禁止離開北京一年
                在北京首都國際機場被拘留並被秘密失踪 81 天
                一月十一日，上海工作室在沒有預告情況下被當地政府拆除
2010       為防止其參加紀念上海工作室面臨被拆聚會，艾未未被警方軟禁其北京家中兩天
                出版博客選輯
2009       四川警方阻撓艾未未為譚作人出庭作證，深夜拘留並毆打艾未未，艾未未因此受傷
                並因腦溢血需於德國接受緊急手術
                博客因發表公民調查資料及死難學生名單被官方關閉
2008       啟動《公民調查》項目，收集四川地震死難學生資料並調查震災豆腐渣工程
                策劃《鄂爾多斯 100》建築項目
2007       參與第 12 屆德國卡塞爾文件展並發表《童話》項目
2006       在世界經濟論壇發表演說
2005       受新浪邀請開始博客寫作
2003 – 2008   與赫佐格、特梅隆建築事務所合作設計北京國家體育場
2002       策劃金華建築藝術公園
2000       與馮博一合作策劃《不合作方式》展覽
1999       建造並遷至草場地工作室
1994 – 1997   出版《黑皮書》（1994）、《白皮書》（1995）、《灰皮書》（1997）
1993       返回並定居於北京
1981 - 1993   在美國生活，大部分時間在紐約
1978       就讀北京電影學院
                參與 "星星畫會"
1958 - 1976   隨家庭被流放至東北，後至新疆
1957       生於中國北京

**獎項與殊榮**

2013　《藝術評論》雜誌最具影響力百大人物第 9 位
2012　哈維爾創意異見人士大獎
　　　英國皇家建築師協會榮譽院士
　　　《藝術評論》雜誌最具影響力百大人物第 3 位
2011　《時代周刊》年度人物第 3 位
　　　《外交政策》雜誌全球百大思想家第 18 位
　　　《藝術評論》雜誌最具影響力百大人物第 1 位
　　　德國柏林藝術學院會員
2010　德國卡塞爾《理性棱鏡》公民獎
　　　《藝術評論》雜誌最具影響力百大人物第 13 位
2009　《藝術評論》雜誌最具影響力百大人物第 43 位

個展

2014 According to What? — 美國布魯克林，布魯克林博物館
《葵花籽》— 德國慕尼黑，現代藝術陳列館
2013 According to What? — 美國邁阿密，佩雷斯美術館
《鄂爾多斯》— 法國穆蘭，常青畫廊
Ai Weiwei: Screening Room — 義大利威尼斯，鮑爾酒店
《卑鄙配方》— 新加坡，Galerie Michael Janssen
According to What? — 加拿大多倫多，安大略美術館
Ai Weiwei. Resistance and Tradition — 西班牙塞維利亞，Centro Andaluz de Arte Contemporaneo
Interlacing — 巴西聖保羅，音像博物館
Disposition — 義大利威尼斯，Zuecca Project Space
According to What? — 美國印第安納波利斯，印第安納波利斯美術館
2012 Forge — 美國紐約，Mary Boone Gallery
《艾未未：紐約 1983-1993》— 匈牙利布達佩斯，恩斯特博物館
Ai Weiwei 'Rebar-Lucerne' — 瑞士盧塞恩，麥勒畫廊
《艾未未》— 義大利聖吉米利亞諾，常青畫廊
Ai Weiwei: According to What? — 美國華盛頓，赫希杭博物館雕塑園
Perspectives: Ai Weiwei — 美國華盛頓，史密森尼學會薩格勒藝廊
《十二生肖》— 美國聖地亞哥，當代美術館
A Living Sculpture — 英國倫敦，Pippy Houldsworth Gallery
《艾未未：紐約 1983-1993》— 俄羅斯莫斯科，莫斯科攝影博物館
《十二生肖》— 美國華盛頓，赫希杭博物館
《十二生肖》— 加拿大蒙特利爾，蒙特利爾當代美術館
《十二生肖》— 美國普林斯頓，普林斯頓大學伍德羅·威爾遜學院
《艾未未》— 義大利米蘭，Lisson Gallery
Ai Weiwei: Five Houses — 美國侯斯頓，侯斯頓建築中心
Interlacing — 挪威耶夫納克爾，Kistefos-Museet
《艾未未》— 荷蘭蒂爾堡，De Pont 當代美術博物館
Interlacing — 法國巴黎，國立網球場現代美術館
《艾未未》— 瑞典斯德哥爾摩，Magasin 3 Stockholm Konsthall
《十二生肖》— 美國侯斯頓，赫曼公園
《葵花籽》— 美國紐約，Mary Boone Gallery
2011 Louisiana Contemporary: Ai Weiwei — 丹麥胡姆勒拜克，路易斯安娜美術館
《艾未未：紐約 1983-1993》— 德國柏林，馬丁葛洛比烏斯博物館
《艾未未：缺席》— 台灣台北，台北市立美術館
Dropping the Urn, ceramics 5000 BCE – 2010 CE — 英國倫敦，維多利亞與亞伯特博物館
Art | Architecture — 奧地利布雷根茨，布雷根茨美術館
《艾未未：紐約 1983-1993》— 美國紐約，亞洲協會
Interlacing — 奧地利格拉茨，格拉茨美術館
Interlacing — 瑞士溫特圖爾，溫特圖爾攝影博物館
《十二生肖》— 美國洛杉磯，洛杉磯縣藝術博物館
Ai Weiwei: Works in the collection. — 德國杜伊斯堡，DKM 博物館
《十二生肖》— 英國倫敦，薩默塞特府
《十二生肖》— 美國紐約，普利茲噴泉

《艾未未》— 英國倫敦，Lisson Gallery
《葵花籽》— 瑞士克里，杜尚美術館
《艾未未》— 德國柏林，Neugerriemschneider
Ai Weiwei – Teehaus — 德國柏林，達赫勒博物館
2010 《艾未未》— 丹麥哥本哈根，林冠畫廊
Cube Light — 日本東京，辛美沙畫廊
A Few Works from Ai Weiwei — 德國柏林，Alexander Ochs Galleries
《聯合利華系列：艾未未》— 英國倫敦，泰特現代美術館渦輪大廳
Hurt Feelings — 奧地利維也納，Galerie Christine Koenig
《艾未未》— 瑞士盧塞恩，麥勒畫廊
Dropping the Urn, Ceramic Works 5000 BCE – 2010 CE — 美國波特蘭，當代工藝博物館
《艾未未》— 美國三藩市，Haines Gallery
Barely something — 德國杜伊斯堡，杜伊斯堡美術館
Dropping the Urn, Ceramic Works5000 BCE – 2010 CE — 美國格倫賽德，阿卡迪亞大學畫廊
《美人魚交換》— 丹麥哥本哈根，長堤公園
2009 《艾未未》— 美國紐約，Friedman Benda Gallery
《隨奶—人皆可用》— 西班牙巴塞隆納，密斯·凡德羅臨時展覽館
《世界地圖》— 中國北京，林冠畫廊
《深表遺憾》— 德國慕尼黑，So sorry
According to What? — 日本東京，森美術館
Ways Beyond Art — 西班牙馬德里，Ivory Press Space
Four Movements — 英國倫敦，菲利普斯畫廊
《艾未未：紐約 1983-1993》— 中國北京，三影堂攝影藝術中心
2008 《艾未未》— 英國倫敦，艾比安畫廊
《艾未未》— 韓國首爾，現代畫廊
Under Construction — 澳大利亞悉尼，謝爾曼當代藝術基金會，坎貝爾鎮藝術中心
Illumination — 美國紐約，Mary Boone Gallery
Go China! Ai Weiwei — 荷蘭高寧根，高寧根博物館
"Through" and Video Work "Fairytale" — 澳大利亞悉尼，謝爾曼當代藝術基金會
2007 《碎片》— 瑞士巴塞爾，第 38 屆巴塞爾藝博會：瑞士盧塞恩，麥勒畫廊
《艾未未》— 瑞士盧塞恩，麥勒畫廊
Traveling Landscapes — 德國柏林，AedesLand
2006 《碎片》— 中國北京，麥勒畫廊
2004 《艾未未》— 瑞士伯爾尼，伯爾尼藝術館
Ai Weiwei in Gent, Belgium — 比利時根特，Caermersklooster 藝術與文化中心
《艾未未》— 美國紐約，Robert Miller Gallery
2003 《艾未未》— 瑞士盧塞恩，麥勒畫廊
1988 《舊鞋—性安全》— 美國紐約，Art Waves Gallery
1982 《艾未未》— 美國三藩市，亞裔基金會

## 部分聯展

2014　《太平天國》— 美國紐約，e-flux
　　　State of Emergency — 美國戴維遜，戴維遜學院 Belk Visual Arts Center
2013　Framed — 中國香港，都爹利會館
　　　Ground Zero — 緬甸仰光，Lokanat Gallery
　　　Island — 英國倫敦，Dairy Art Centre
　　　《2013 年多倫多白夜藝術節》— 加拿大多倫多，彌敦菲臘廣場
　　　Emscherkunst 2013 — 德國魯爾 / 埃森，埃姆塞爾河
　　　第五十五屆威尼斯雙年展 — 義大利威尼斯 — 德國館
　　　《不合作方式 2》— 荷蘭高寧根，高寧根博物館
　　　《疫年日志：恐懼、鬼魂、叛軍、沙士、哥哥和香港的故事》— 中國香港，上環文娛
　　　中心展覽廳
　　　Of Bridges and Borders — 智利瓦爾帕萊索，瓦爾帕萊索文化公園
2012　釜山雙年展 — 韓國釜山
　　　《新烏托邦：人權狀況》— 比利時梅赫倫，Kazerne Dossin 大屠殺和人權博物館 / 文
　　　獻中心
　　　Postmodernism: Style and Subversion 1970 – 1990 — 瑞士蘇黎世，瑞士國家博物館
　　　巴塞爾藝博會 — 瑞士巴塞爾
　　　《藝術與城市》— 瑞士蘇黎世
　　　Art+Press — 德國柏林，馬丁葛洛比烏斯博物館
　　　Lifelike — 美國明尼亞波里斯，沃克藝術中心
2011　《劉韡與艾未未：法斯高藏品展》— 中國北京，林冠畫廊
　　　光州設計雙年展 — 韓國光州
　　　DaringDesign – Chinese and Dutch Designers with Guts — 荷蘭鹿特丹，荷蘭建
　　　築學會
　　　Art Parcours in St. Alban-Tal — 瑞士聖阿爾班
　　　《山水》— 瑞士盧塞恩，盧塞恩藝術博物館
　　　Six Rooms — 美國紐約，Friedman Benda Gallery
2010　第 29 屆聖保羅雙年展 — 巴西聖保羅
　　　2010 年威尼斯建築雙年展 — 義大利威尼斯
　　　《阿孔契工作室 + 艾未未：合作企劃》— 中國香港，Para Site 藝術空間
2009　《童話》— 以色列赫茲尼亞，赫茲尼亞當代藝術博物館
　　　Mahjong: Contemporary Chinese Art from the Sigg Collection — 美國賽倫，皮
　　　博迪埃塞克斯博物館
2008　利物浦國際雙年展 — 英國利物浦，泰特利物浦
2007　《第六屆深圳當代雕塑藝術展：透視景觀》— 中國深圳，深圳 OCAT 藝術中心
　　　《原點：星星畫會回顧展》— 中國北京，今日美術館
　　　第 12 屆卡塞爾文件展 — 德國卡塞爾
　　　《假的！》— 中國北京，UniversalStudios
2006　第五屆亞太藝術三年展 — 澳大利亞昆士蘭，昆士蘭美術館
　　　Zones of Contact, 第 15 屆悉尼雙年展 — 澳大利亞悉尼
　　　Territorial. Ai Weiwei und Serge Spitzer — 德國法蘭克福，現代藝術博物館
　　　Herzog & de Meuron. No 250. Eine Ausstellung — 德國慕尼黑，Haus der Kunst
　　　Fill in the Blanks — 中國北京，藝術文件倉庫
　　　釜山雙年展 — 韓國釜山，釜山現代藝術博物館
2005　第二屆廣州三年展 — 中國廣州，廣東美術館

Herzog & de Meuron. No 250. An Exhibition — 英國倫敦，泰特現代美術館
Beauty and Waste in the Architecture of Herzog & de Meuron — 荷蘭鹿特丹，
荷蘭建築學會
2004　第 9 屆國際建築展覽，威尼斯雙年展 — 義大利威尼斯
　　　On the Edge – Contemporary Chinese Photography & Video — 美國紐約，
　　　Ethan Cohen Fine Arts
2002　第一屆廣州三年展 — 中國廣州，廣東美術館
2001　Take Part II — 瑞士盧塞恩，麥勒畫廊
　　　《土木─中國青年建築師展》— 德國柏林，Aedes 畫廊
　　　Take Part I — 瑞士盧塞恩，麥勒畫廊
2000　《不合作方式》— 中國上海，東廊藝術
1999　Innovations Part I — 中國北京，藝術文件倉庫
　　　d'Apertutto, 第 48 屆威尼斯雙年展 — 義大利威尼斯
　　　Modern China Art Foundation Collection — 比利時根特，Caermersklooster 藝
　　　術與文化中心
1998　Double Kitsch: Painters from China — 美國紐約，Max Protetch Gallery
1993　《中國當代藝術 — 星星十五年展》— 日本東京，東京畫廊
1989　《星星十年》— 中國香港，漢雅軒
1987　The Star at Harvard: Chinese Dissident Art — 美國劍橋，哈佛大學費正清東亞研究
　　　中心
1980　第二次《星星畫展》— 中國北京，中國美術館
1979　第一次《星星畫展》— 中國北京，中國美術館外

**建築**

2012    蛇形畫廊臨時展館（與赫佐格特梅隆建築事務所合作設計）— 英國倫敦（已落成）
        Urban Folly — 韓國光州（已落成）
2010    Sanctuary（與 HHF 建築事務所合作設計）— 墨西哥瓜達拉克拉，朝聖之路（已落成）
2009    The Guest House (Tsai Residence)（與 HHF 建築事務所合作設計）— 美國紐約州
        （已落成）
2008    草場地 53 號 — 中國北京，草場地（已落成）
        麗江工作室 — 中國雲南麗江（已落成）
        嘉里中心內部設計（翰海拍賣有限公司）— 中國北京（已落成）
        嘉定馬陸（上海工作室）— 中國上海（落成、拆除）
        丁乙工作室 — 中國上海（落成、拆除）
        鄂爾多斯 100 — 中國內蒙古，鄂爾多斯（方案）
2007    草場地 241 號 — 中國北京，草場地（已落成）
        《童話》宿舍 — 德國卡塞爾（臨時建築）
        Undercover Villa — 中國內蒙古，鄂爾多斯（已落成）
        紅一號院畫廊 — 中國北京，草場地（已落成）
2006    Art Farm（與 HHF 建築事務所合作設計）— 美國紐約州（已落成）
        左右工作室 — 中國北京（已落成）
        左右藝術區 — 中國北京（已落成）
        江南會 — 中國浙江杭州（已落成）
        三影堂攝影藝術中心 — 中國北京，草場地（已落成）
2005    Tsai Residence（與 HHF 建築事務所合作設計）— 美國紐約州（已落成）
        104 號院（麥勒畫廊）— 中國北京，草場地（已落成）
2004    105 號院 — 中國北京，草場地（已落成）
        去哪餐廳 — 中國北京（已落成）
        金華建築藝術公園古陶博物館 — 中國浙江金華（已落成）
        金華建築藝術公園 — 中國浙江金華（已落成）
        運河岸上的院子：九個盒子 — 中國北京（已落成）
        六間—中國江蘇南京（已落成）
2003    艾青中學景觀設計 — 中國浙江金華（已落成）
2002    義烏江大壩景觀設計 — 中國浙江金華（已落成）
        艾青文化公園景觀設計 — 中國浙江金華（已落成）
        艾青紀念館 — 中國浙江金華（已落成）
        國家體育場（與赫佐格特梅隆建築事務所合作設計）— 中國北京（已落成）
2001    長城腳下的公社景觀設計 — 中國北京（已落成）
2000    SOHO 現代城景觀設計— 中國北京（已落成）
        藝術文件倉庫 — 中國北京，草場地（已落成）
1999    艾未未工作室 — 中國北京，草場地（已落成）

        簡歷資料為藝術家提供

# Ai Weiwei

1957      Born in Beijing
Lives and works in Beijing, China

**Selected Activities**

2013      Released first music album The Divine Comedy in June
Participated in the Venice Biennale

2012      WeiWeiCam, a self-surveillance project involving live 24-hour online feeds
from his house and studio, was shut down by Chinese authorities 46
hours after the site went live
Raised 9 million RMB over social media as deposit to appeal fabricated
tax accusations from the Chinese government

2011      Prohibited from leaving Beijing without permission for one year
Detained at the Beijing Capital International Airport, imprisoned without
reason for 81 days
Shanghai studio was demolished in a surprise move by the local
government on January 11th

2010      Placed under house arrest for two days by the Chinese police in order
to prevent a party marking the forthcoming demolition of his newly built
Shanghai studio
Selection of blog entries was published in Chinese, publications in
English, German, Italian, and Portuguese followed

2009      Beaten by the police for trying to testify for Tan Zuoren, a fellow
investigator of negligent construction and student casualties during the
Sichuan earthquake and suffered from a cerebral hemorrhage, which
was linked to the police attack
Blog shut down by Chinese authorities in May after names of victims
and numerous articles documenting the Sichuan Earthquake
investigation were published

2008      Launched "Citizens' Investigation" project, researching information
about students who died in the Sichuan earthquake. It also investigated
government corruption and cover-ups, in particular the corruption
scandal following the collapse of so-called "tofu-dreg schools" in the
Sichuan Earthquake on May 12th, 2008
Curator of the architecture project Ordos 100

2007      Participation in Documenta 12, Kassel, Germany. For his project "Fairytale"
he invited
1001 Chinese citizens to Kassel

2006      Speaker at the World Economic Forum Annual Meeting 2006: Innovation
and Design Strategy

2005      Invited by Sina.com to start blogging

2003 – 2008 Commissioned to design the Beijing's 2008 Olympic Stadium together
with Herzog & de
Meuron, finished construction in 2008.

2003      Founded the architecture studio FAKE Design, Beijing.

2002      Curator of the project Jinhua Architectural Art Park, Jinhua, China.

2000      Co-curator of the exhibition Fuck Off, in Shanghai, together with Feng Boyi.

| | |
|---|---|
| 1999 | Moved to Caochangdi in the northeast of Beijing and build the studio house, his first architectural project. |
| 1997 | Co-founder and Artistic Director of China Art Archives & Warehouse (CAAW), Beijing. |
| 1994 - 1997 | Published Black Cover Book (1994), White Cover Book (1995) and Grey Cover Book (1997). |
| 1993 | Returned to Beijing. |
| 1981 - 1993 | Lived in USA, mainly New York. |
| 1978 | Enrolled at the Beijing Film Academy. Member of the Stars movement. |
| 1957 | Born in Beijing, China. |

**Selected Awards and Honors**

| | |
|---|---|
| 2013 | ArtReview Power 100, rank 9 |
| 2012 | Václav Havel Prize for Creative Dissent of the Human Rights Foundation Honorary fellowship from the Royal Institute of British Architects, London, UK Art Review Power 100, rank 3 |
| 2011 | TIME Magazine Person of the Year 2011, Runner-up Foreign Policy Top Global Thinkers of 2011, rank 18 The Art Review Power 100, rank 1 Membership at the Academy of Arts, Berlin, Germany |
| 2010 | The Prism of Reason, Kassel Citizen Award, Kassel, Germany The Art Review Power 100, rank 13 |
| 2009 | The Art Review Power 100, rank 43 |

## Solo Exhibitions

2014   According to What?, Brooklyn Museum, Brooklyn, NY, USA
Sunflower Seeds, Pinakothek der Moderne, Munich Germany

2013   According to What?, Perez Art Museum Miami, Miami, FL, USA
Ordos, Galleria Continua, Les Moulins, France
Ai Weiwei: Screening Room, Hotel Bauer, Venice, Italy
Baby Formula, Galerie Michael Janssen, Singapore, Singapore
According to What?, Art Gallery of Ontario, Toronto, Canada
Ai Weiwei. Resistance and Tradition, Centro Andaluz de Arte Contemporaneo (CAAC), Seville, Spain
Interlacing, Museu da Imagem e do Som, São Paulo, Brazil
55th International Art Exhibition La Biennale de Venezia, German Pavilion, Venice, Italy
Disposition Zuecca Project Space, Complesse delle Zitelle, Giudecca, Chiesa di Sant' Antonin, Venice, Italy
According to What?, Indianapolis Museum of Art, Indianapolis, IN, USA

2012   Forge, Mary Boone Gallery, New York City, NY, USA
New York Photographs 1983-1993, Ernst Museum (in collaboration with Alexander Ochs Galleries, Berlin | Beijing), Budapest, Hungary
Ai Weiwei 'Rebar-Lucerne', Galerie Urs Meile, Lucerne, Switzerland
Ai Weiwei, Galleria Continua San Gimignano, San Gimignano, Italy
Ai Weiwei: According to What?, Hirshhorn Museum and Sculpture Garden, Washington D.C., USA
Perspectives: Ai Weiwei, The Arthur M. Sackler Gallery, Smithsonian Institution, Washington D.C., USA
Circle of Animals/Zodiac Heads: Gold, Museum of Contemporary Art San Diego, USA
A Living Sculpture, Pippy Houldsworth Gallery, London, UK
Ai Weiwei: New York Photographs 1983-1993, Moscow House of Photography, Moscow, Russia
Circle of Animals/Zodiac Heads, Hirshhorn Museum, Washington D.C., USA
Circle of Animals/Zodiac Heads: Gold, Musée d'art contemporain de Montréal, Montréal, Canada
Circle of Animals/Zodiac Heads, The Woodrow Wilson School at Princeton University,
Princeton, NJ, USA
Ai Weiwei, Lisson Gallery, Milan, Italy
Ai Weiwei: Five Houses, Architecture Center Houston, Houston, TX, USA
Interlacing, Kistefos-Museet, Jevnaker, Norway
Ai Weiwei, De Pont Museum of Contemporary Art, Tilburg, the Netherlands
Interlacing, Jeu de Paume, Paris, France
Ai Weiwei, Magasin 3 Stockholm Konsthall, Stockholm, Sweden
Circle of Animals/Zodiac Heads, Hermann Park, Houston, TX, USA
Sunflower Seeds, Mary Boone Gallery, New York City, NY, USA

2011   Louisiana Contemporary: Ai Weiwei, Louisiana Museum of Modern Art, Humlebaek, Denmark

Ai Weiwei: New York Photographs 1983-1993, Martin Gropius Bau Museum, Berlin, Germany
Ai Weiwei: Absent, Taipei Fine Arts Museum, Taipei, Taiwan
Dropping the Urn, ceramics 5000 BCE – 2010 CE, Victoria and Albert Museum, London, UK
Art | Architecture, Kunsthaus Bregenz, Bregenz, Austria
Ai Weiwei: New York Photographs 1983-1993, Asia Society, New York, NY, USA
Interlacing, Kunsthaus Graz, Graz, Austria
Interlacing, Fotomuseum Winterthur, Winterthur, Switzerland
Circle of Animals, Los Angeles County Museum of Art, Los Angeles, CA, USA
Ai Weiwei: Works in the collection. DKM Museum, Duisburg, Germany
Circle of Animals, Somerset House, London, UK
Circle of Animals, Pulitzer Fountain, New York, NY, USA
Ai Weiwei, Lisson Gallery, London, UK
Sunflower Seeds, Kunsthalle Duchamp, Cully, Switzerland
Ai Weiwei, Neugerriemschneider, Berlin, Germany
Ai Weiwei - Teehaus, Museen Dahlem, Berlin, Germany

2010   Ai Weiwei, Faurschou Gallery, Copenhagen, Denmark
Cube Light, Misa Shin Gallery, Tokyo, Japan
A Few Works from Ai Weiwei, Alexander Ochs Galleries, Berlin, Germany
The Unilever Series: Ai Weiwei, Turbine Hall, Tate Modern, London, UK
Hurt Feelings, Galerie Christine Koenig, Vienna, Austria
Ai Weiwei, Galerie Urs Meile, Lucerne, Switzerland
Dropping the Urn, Ceramic Works 5000 BCE – 2010 CE, Museum of Contemporary Craft, Portland, USA (Travelling Exhibition)
Ai Weiwei, Haines Gallery, San Francisco, USA
Barely something, Stiftung DKM, Duisburg, Germany
Dropping the Urn, Ceramic Works5000 BCE – 2010 CE, Arcadia University Gallery, Glenside, USA (Travelling Exhibition)
Mermaid Exchange, Langelinie, Copenhagen, Denmark

2009   Ai Weiwei, Friedman Benda, New York City, NY, USA
With Milk find something everybody can use, Mies van der Rohe Pavilion, Barcelona, Spain
World Map, Faurschou Gallery, Beijing, China
So sorry, Haus der Kunst, Munich, Germany
According to What?, Mori Art Museum, Tokyo, Japan
Ways Beyond Art, Ivory Press Space, Madrid, Spain
Four Movements, Phillips de Pury, London, UK
Ai Weiwei: New York Photographs 1983-1993, Three Shadows Photography Art Centre, Beijing, China

2008   Ai Weiwei, Albion Gallery, London, UK
Ai Weiwei, Hyundai Gallery, Seoul, Korea
Under Construction, Sherman Contemporary Art Foundation, Campbelltown Arts Center, Sydney, Australia
Illumination, Mary Boone Gallery, New York, NY, USA
Go China! Ai Weiwei, Groninger Museum, Groningen, The Netherlands

2007    Fragments, Art Unlimited, Art 38 Basel, Basel, Switzerland
         Galerie Urs Meile, Lucerne, Switzerland.
         Ai Weiwei, Galerie Urs Meile, Beijing-Lucerne, Lucerne, Switzerland
         Traveling Landscapes, AedesLand, Berlin, Germany
2006    Fragments, Galerie Urs Meile, Beijing-Lucerne, Beijing, China
2004    Ai Weiwei, Kunsthalle Bern, Bern, Switzerland
         Ai Weiwei in Gent, Belgium, Caermersklooster - Provinciaal Centrum voor Kunst
         en Cultuur, Gent, Belgium
         Ai Weiwei, Robert Miller Gallery, New York, NY, USA
2003    Ai Weiwei, Galerie Urs Meile, Beijing-Lucerne, Lucerne, Switzerland
1988    Old Shoes - Safe Sex, Art Waves Gallery, New York, NY, USA
1982    Ai Weiwei, Asian Foundation, San Francisco, CA, USA

## Selected Group Exhibitions

2014   Taiping Tianguo: A History of Possible Encounters, e-flux, New York, USA
       State of Emergency, Davidson College, Belk Visual Arts Center, Davidson, USA
2013   Framed, Duddell's, Hong Kong
       Ground Zero, Lokanat Gallery, Yangon, Myanmar
       Island, Dairy Art Centre, London, UK
       Scotiabank Nuit Blanche 2013, Nathan Philips Square, Toronto, Canada
       Emscherkunst 2013, Emscher river, Essen/Ruhr Valley, Germany
       Fuck Off 2, Groninger Museum, Groningen, The Netherlands
       A Journal of the Plague Year. Fear, ghosts, rebels. SARS, Leslie and the Hong
       Kong story
       Sheung Wan Civic Centre Exhibition Hall, Hong Kong, Hong Kong
       Of Bridges and Borders, Parque Cultural of Valparaiso, Valparaiso, Chile
2012   Busan Biennale, Busan, South Korea
       Newtopia: The State of Human Rights, Kazerne Dossin Museum and
       Documentation Centre of the Holocaust and of Human Rights, Mechelen,
       Belgium
       Postmodernism: Style and Subversion 1970 – 1990, The Swiss National
       Museum, Zürich, Switzerland
       Art Basel, Basel, Switzerland
       Art and the City, Zürich, Switzerland
       Art+Press, Martin Gropius Bau, Berlin, Germany
       Lifelike, Walker Art Center, Minneapolis, MN, USA
2011   Liu Wei & Ai Weiwei, Faurschou Gallery, Beijing, China
       Gwangju Design Biennale, Gwangju Design Biennale, Gwangju, South Korea
       DaringDesign – Chinese and Dutch Designers with Guts, Netherlands
       Architecture Institute, Rotterdam, the Netherlands
       Art Parcours in St. Alban-Tal, St. Alban, Switzerland
       Shanshui, The Museum of Art Lucerne, Lucerne, Switzerland
       Six Rooms, Friedman Benda Gallery, New York City, NY, USA
2010   29th Sao Paulo Biennial, Sao Paolo Biennial, Sao Paulo, Brazil
       2010 Venice Architecture Biennale, Venice Architecture Biennale, Venice, Italy
       Acconci Studio + Ai Weiwei: A Collaborative Project, Para Site Art Space, Hong Kong
2009   Fairytale, Herzliya Museum of Contemporary Art, Herzliya, Israel
       Mahjong: Contemporary Chinese Art from the Sigg Collection, The Peabody
       Essex Museum, Salem, MA, USA (Travelling Exhibition)
2008   Liverpool Biennial International 08: Made Up, Tate Liverpool, Liverpool, UK
2007   Sixth Shenzhen Contemporary Sculpture Exhibition A Vista of Perspectives,
       OCAT Contemporary Art Terminal, Shenzhen, China
       Origin Point: Stars Group Retrospective Exhibition, Today Art Museum, Beijing, China
       documenta 12, Kassel, Germany
       Forged Realities, UniversalStudios, Beijing, China
2006   The 5th Asia-Pacific Triennial of Contemporary Art, Queensland Art Gallery,
       Queensland, Australia
       Zones of Contact, 15th Biennial of Sydney, Sydney, Australia
       Territorial. Ai Weiwei und Serge Spitzer, Museum für Moderne Kunst, Frankfurt

am Main, Germany
       Herzog & de Meuron. No 250. Eine Ausstellung, Haus der Kunst, Munich, Germany
       Fill in the Blanks, China Art Archives & Warehouse, Beijing, China
       Busan Biennial 2006, Busan Museum of Modern Art, Busan, Korea
2005   The 2nd Guangzhou Triennial, Guangdong Museum of Art, Guangzhou, China
       Herzog & de Meuron. No 250. An Exhibition, Tate Modern, London, UK
       Beauty and Waste in the Architecture of Herzog & de Meuron, Netherlands
       Architecture Institute, Rotterdam, The Netherlands
2004   The 9th International Architecture Exhibition, Venice Biennale, Venice, Italy
       On the Edge – Contemporary Chinese Photography & Video, Ethan Cohen
       Fine Arts, New York, USA
2002   1st Guangzhou Triennale 2002, Guangdong Museum of Art, Guangzhou, China
2001   Take Part II, Galerie Urs Meile, Beijing-Lucerne, Lucerne, Switzerland
       Tu Mu. Young Chinese Architecture, Aedes Galerie, Berlin, Germany
       Take Part I, Galerie Urs Meile, Beijing-Lucerne, Lucerne, Switzerland
2000   Fuck off, EastLink Gallery, Shanghai, China
1999   Innovations Part I, China Art Archives & Warehouse, Beijing, China
       d'Apertutto, La Biennale di Venezia, 48. Esposizione Internationale d'Arte,
       Venice, Italy
       Modern China Art Foundation Collection, Caermersklooster - Provinciaal
       Centrum voor Kunst en Cultuur, Gent, Belgium
1998   Double Kitsch: Painters from China, Max Protetch, New York, USA
1993   Chinese Contemporary Art – The Stars 15 Years, Tokyo Gallery, Tokyo, Japan
1989   The Stars: Ten Years, Hanart Gallery, Hong KOng
1987   The Stars at Harvard: Chinese Dissident Art, Fairbank Center for East Asian
       Research, Harvard University, Cambridge, USA
1980   The second Stars Exhibition, National Art Museum of China, Beijing, China
1979   The first Stars Exhibition, outside the National Art Museum of China, Beijing, China

## Architectural Works

2012  Serpentine Gallery Pavilion, designed in collaboration with Herzog & de Meuron, London, UK (constructed)
      Urban Folly, Gwangju, Korea (constructed)
2010  Sanctuary, Ruta del Peregrino, Mexico (constructed)
2009  The Guest House (Tsai Residence), in collaboration with HHF, New York, USA (constructed)
2008  53 Caochangdi, Caochangdi, Beijing, China (constructed)
      Lijiang Studio, Lijiang, Yunnan, China (constructed)
      Kerry Center Interior (Hanhai Auction House), Beijing, China (constructed)
      Jiading Malu (Shanghai Studio), Shanghai, China (constructed, destroyed)
      Ding Yi Studio, Shanghai, China (constructed, destroyed)
      Curator, urban planning, landscape design of Ordos 100, Ordos, Inner Mongolia, China (unrealized)
2007  Seventeen Studios, Caochangdi, Beijing, China (constructed)
      Fairytale 1,001 Dormitory, Kassel, Germany (constructed, temporary)
      Undercover Villa, Ordos, Inner Mongolia, China (constructed)
      Red No. 1 Art Galleries, Caochangdi, Beijing, China (constructed)
2006  Art Farm, in collaboration with HHF, New York, USA (constructed)
      Left Right Studio (Renovation), Beijing, China (constructed)
      Curator Left Right Art District, Beijing, China (constructed)
      Jiangnanhui, Hangzhou, Zhejiang, China (constructed)
      Three Shadows Photography Art Centre, Caochangdi, Beijing, China (constructed)
      Courtyard House (Ma Jia), Beijing, China (constructed)
2005  Tsai Residence, in collaboration with HHF, New York, USA (constructed)
      Courtyard 104 (Galerie Urs Meile), Caochangdi, Beijing, China (constructed)
2004  Courtyard 105, Beijing, China (constructed)
      Go Where? Restaurant, Beijing, China (constructed)
      Neolithic Pottery Museum, Jinhua, Zhejiang, China (constructed)
      Jinhua Architectural Art Park, Jinhua, Zhejiang, China (constructed)
      Nine Boxes, Beijing, China (constructed)
      Six Rooms, Nanjing, Jiangsu, China (constructed)
2003  Landscape Design of Ai Qing Middle School, Jinhua, Zhejiang, China (constructed)
2002  Landscape Design of Yiwu River Dam, Jinhua, Zhejiang, China (constructed)
      Landscape Design of Ai Qing Cultural Park, Jinhua, Zhejiang, China (constructed)
      Ai Qing Memorial, Jinhua, Zhejiang, China (constructed)
      National Stadium, in collaboration with Herzog & de Meuron, Beijing, China (constructed)
2001  Landscape Design Commune by the Great Wall, Beijing, China (constructed)
2000  In Between: Installation, SOHO, Beijing, China (constructed)
      Concrete Landscape Design of SOHO, Beijing, China (constructed)
      China Art Archives and Warehouse, Caochangdi, Beijing, China (constructed)
1999  Ai Weiwei Studio, Caochangdi, Beijing, China (constructed)

Curriculum Vitae Courtesy of Ai Weiwei Studio

# 感謝誌

本展承蒙藝術家、艾未未工作室、榮嘉文化藝術基金會、余德耀基金會等機構，提供豐富的作品及慷慨贊助與鼎力協助，使展覽得以順利完成，本館謹向上述單位及下列個人致上誠摯的謝意！

朱嘉樺 先生
葉榮嘉 先生
Mr. Jeremy Wingfield
Ms. E-Shyh Wong
Ms. Jennifer Ng

# Acknowledgements

We are grateful to the Artist , Ai Weiwei Studio, Yeh Rong Jai Culture & Art Foundation , Yuz Foundation, Jakarta and the following individuals for their kind support to this exhibition.

Mr. Zhu Jiahua
Mr. Yeh Rong Jai
Mr. Jeremy Wingfield
Ms. E-Shyh Wong
Ms. Jennifer Ng

# 艾未未 · 缺席
# Ai Weiwei *absent*

## 展覽

| | |
|---|---|
| 代理館長 | 翁誌聰 |
| 展覽顧問 | 劉明興、蔣雨芳、劉建國、張芳薇、張麗莉 |
| | 林玉明、李秀枝、陳仁貴、白鈺珍 |
| 展覽代組長 | 廖春鈴 |
| 策辦展覽 | 劉永仁 |
| 展覽助理 | 甘霈 |
| 展場設計 | 艾未未工作室 |
| 展覽佈置 | 馮健華、支涵郁、陳宏圖、陳燕山、盧秀英 |
| 國際公關 | 盧立偉、楊舜雯、顏嘉儀 |
| 資訊小組 | 廖健男、江思廣 |
| 攝影 | 陳泳任 |
| 視訊燈光 | 劉崇德、黃煌洲、蔡鳳煌、張裕政、張中平 |
| 總務 | 林玉明、張銘育、廖芸娜 |
| 會計 | 李秀枝、姚雅芬 |
| 印刷 | 佳信印刷有限公司 |

## 專輯

| | |
|---|---|
| 發行人 | 劉維公 |
| 出版單位 | 臺北市政府文化局 |
| 著作權人 | 臺北市政府文化局、臺北市立美術館 |
| 編輯委員 | 林慧芬、李麗珠、郭佩瑜、李岱穎、李順霖、蘇俞安 |
| 主編 | 蘇俞安、艾未未工作室 |
| 編輯 | 劉永仁 |
| 設計 | 劉信宏 |
| 設計助理 | 阮臆菁 |
| 譯者 | 中譯英：韓伯龍、魏安德、韓世芳 |
| | 英譯中：張至維、謬詠華 |

| | |
|---|---|
| 出版日期 | 中華民國 103 年 3 月 |
| 訂價 | 新臺幣 700 元 |
| 統一編號 | 1010300302 |
| ISBN | 978-986-03-8715-5 |

本書為「艾未未 · 缺席」之專輯，展覽於臺北市立美術館展出
展覽日期 100 年 10 月 29 日至 101 年 1 月 29 日

## Exhibition Team

Acting Director: Chih-tsung Weng

Lublishing Committeees: Ming-hsing Liu, Yu-fang Chiang, Chien-kuo Liu, Fang-wei Chang, Lily Chang, Yu-ming Lin, Hsiu-chih Lee, Jen-kui Chen, Yu-chen Pai

Chief Curator: Tsun-ling Liao
Exhibition Curator: Yung-jen Liu
Exhibition Assistant: Pei Kan
Exhibition Design: Ai Weiwei studio
Exhibition Display: Chien-hua Feng, Han-yu Chih, Hung-tu Chen, Yen-shan Chen, Hisu-ying Lu
International Relations: Li-wei Lu, Shun-wen Yang, Chia-yi Yen
Information Technology Department: Chien-nan Liao, Shi-Guang Jiang
Photographer: Yung-Jen Chen
Audio and Lighting: Chung-te Liu, Huang-chou Huang, Feng-huang Tsai, Yu-chen Chang, Chung-ping Chang
General Affairs: Yu-ming Lin, Ming-yu Chang, Yun-na Laio
Accounting: Siou-jhih Li, Ya-feng Yu
Printer: Chia Hsin Printing

## Exhibition Catalogue

Publishing Director: Wei-gong Liou
Publisher: Department of Cultural Affairs, Taipei City Government
© Department of Cultural Affairs, Taipei City Government, Taipei Fine Arts Museum
Editorial Board: Huoy-fen Lin, Li-chu Li, Pey-yu Kuo, Tai-yin Lee, Shun-lin Li, Yu-an Su
Chief Editor: Yu-an Su, Ai Weiwei studio
Editor: Yung-jen Liu
Graphic Designer: Hsin-hong Liu
Design Assistant: Yi-Ching Juan
Translators: Chinese to English / Brent Heinrich, Andrew Wilson, Lydia Han
English to Chinese / Chih-wei Chang, Yung-Hua Miao

Publishing Date: March 2014
Price: NT$ 700
GPN: 1010300302
ISBN: 978-986-03-8715-5